PRAISE FOR *THE THINKING FAN'S GUIDE*
TO WALT DISNEY WORLD: MAGIC KINGDOM

I really enjoyed reading this book. It offers a different way to look at the park and its attractions, not your traditional guidebook route. I was curious going in to see what is considered a Thinking Fan's guide… and as luck would have it they think us geeks think! … Also be sure to spend a few minutes checking out the footnotes. I found many of the observations, references there to be just as interesting as the main pieces of the book.
 Jason Dziegielewski, *DisneyGeek.com*

While I did know a great deal of the information provided, there was plenty of new insight to keep me turning the page. And that's the thing here, *The Thinking Fan's Guide* is insanely readable. Through personal experiences and opinions Wallace is able to keep the reader grounded in the real world, while still taking time to look back at the history of the attraction.
 Andrew Tipton, *Disney Hipster Blog*

While you hardly need to know the history or various possible levels of meaning behind Disney's attractions to enjoy the theme park, it's fun to know that someone took a deeper look.
 Rudy Maxa, *Rudy Maxa's World*

[A] book we would highly recommend to you – all our Readers – regardless of how many times you have personally visited the parks here in Central Florida. In fact, this book will not only increase your knowledge of the rich history and all the great attractions that the Magic Kingdom Park offers, but will also entertain you and give you an overview of the park you love… from another fan's perspective.
 Sam Carta, *Orlando Theme Park News*

I have to say that this might be my favorite Disney book, to date! … I love Aaron Wallace's writing style. It's intelligent, with a hint of humorous mixed in for good measure.
 Heidi Strawser, *Hiedi-Strawser.com*

Personally, I have a new appreciation for several rides (Jungle Cruise, anyone?) thanks to the book.
 Anthony Markham, *WDW Happy Place.com*

The Thinking Fan's Guide to Walt Disney World is like giving every Disney Guest who reads it their own Disney historian as a guide.
Natalie Reiner, *Ink and Paint Blog*

[Wallace] is able to introduce attractions in a way that doesn't make old WDW vets feel as though they are being talked down to, but also allows the uninitiated to understand what they are looking for without even having seen the actual attraction itself.
NJ Biblio

The Thinking Fan's Guide To Walt Disney World:
Magic Kingdom

Aaron Wallace

THE THINKING FAN'S GUIDE TO
WALT DISNEY WORLD: MAGIC KINGDOM

Published by The Intrepid Traveler, P.O. Box 531, Branford, CT 06405
intrepidtraveler.com

First Edition, Second Printing rev.
Printed in the United States
Cover design by Lisa Rennie
Cover photo of Cinderella Castle by Charles Ridgway
Interior design by Alfonso Robinson
ISBN: 978-1-937011-24-6
Library of Congress Control Number: 2012946867
Distributed to the trade by National Book Network

About The Author

Aaron Wallace has always had a passion for Disney, from the movies to the theme parks and everything in between. He first started thinking critically about the company's artistic output during his time at The University of North Carolina at Chapel Hill, where he earned a Bachelor of Arts degree in both Communication Studies (with a concentration in Media Studies) and English.

Today, Aaron is a writer and an attorney, having earned a Juris Doctor degree from Wake Forest University. He is also a professional film and media critic, having published more than two hundred movie, television, and music reviews to an audience of millions. Since 2004, he's been a part of the writing staff at DVDizzy.com, one of the Internet's most-accessed sites for entertainment journalism.

In addition to writing, Aaron hosts *Zip-A-Dee-Doo-Pod*, the web's second-longest-running non-commercial podcast dedicated entirely to Disney. The show is one of the most popular podcasts about Disney and has been repeatedly recognized by Apple as a "Featured Travel Podcast." *Zip-A-Dee-Doo-Pod* can often be found among the top-ranking downloads on the iTunes Travel Podcasts charts. Aaron also appears as a regular co-host on *The Hub Podcast*, another popular show devoted to having fun with Disney.

Aaron lives in Orlando, Florida, where he visits the Walt Disney World Resort on at least a weekly basis and tweets his adventures on his Twitter page, @aaronspod. His website is available at www.AaronWallaceOnline.com.

Dedication

Jesus Christ.
My parents, Rodney and Karen Wallace, and my sister,
Nichole Wallace.
Mike Sullivan. I hope they read books in Heaven.

Table of Contents

Introduction

If I've done my job, you'll never think about theme parks the same way again. This is a different kind of travel book than you're used to, and it's uniquely designed to make a Walt Disney World vacation more rewarding than it's ever been before. Too often, we get caught up in the frenzy of trip planning and then rush into the parks on a mission — to ride everything as quickly as we can. There's some fun in that, but if you stop to think about Disney's rides and shows for what they are — incredibly detailed stories told in a three-dimensional environment — you'll find that there's actually so much more to enjoy than you've seen before. That's true whether you're planning your first trip to a Disney resort or your hundredth, and this book is written with both newcomers and veteran "Disney Freaks" in mind.

I believe it's important to know a little something about the place you're going before you get there. You probably wouldn't plan a trip to Egypt or France without reading a bit about them first. I submit that a Disney vacation should be no different. The Disney parks are the world's most-visited resort destinations and they enjoy that status for a reason. One of the major goals of this book is to investigate and discover the inner appeal that brings millions of people back to these same attractions year after year.

This book, the first in a projected series about the theme parks of the Walt Disney World Resort just outside Orlando,

Florida, focuses on the Magic Kingdom. Of all the theme parks in the world, the Magic Kingdom is the most visited year after year. Setting aside minor diversions for the time being, this book looks at 36 major attractions in the park and explores each of them in depth. You'll learn the intriguing history behind every ride and show. Then we'll take a look together at just what exactly has drawn so many people to them for so many years. And on the rare occasion when an attraction doesn't quite measure up to the high Disney standard, we'll take a playfully irreverent look at what went wrong. In addition to new knowledge and plenty of laughs, this book will offer you a brand-new way to think about every attraction in the Magic Kingdom.

Each attraction description ends with a feature called "WATCH THIS." There, you'll learn about a great movie or television production that relates to that specific attraction in a surprising way. For example, Peter Pan's Flight has something to do with *Peter Pan* the movie, but this book looks a little deeper to uncover an even more intriguing film connection. These aren't necessarily movies that inspired or are referenced in the attraction, but rather films that share the same structure or theme. For those interested in the more direct connections between Disney films and Disney World attractions, I wholeheartedly recommend *From Screen to Theme: A Guide to Animated Film References Found Throughout the Walt Disney World Resort* by Brent Dodge (Dog Ear Publishing, 2010).

Most of the movies I cite are made by Disney and available on home video, but when they're not, there will be a special note explaining where the film comes from and how you can find it. Not only are the chosen movies worth watching for their own sake, they'll actually increase your appreciation for the associated attractions in the Magic Kingdom.

There are six chapters in this book, each devoted to one of the themed "lands" in the Magic Kingdom — Adventureland, Frontierland, Liberty Square, Fantasyland, Tomorrowland, and Main Street, U.S.A. For the most part, we'll move clockwise around the

park, starting in Adventureland, and ending on Main Street, where the park's wonderful nighttime festivities are staged.

That's all you need to know about the layout of this book, but a small dose of Disney basics might be useful too.

The Disney Story in Four Paragraphs

Walter Elias Disney was born in Chicago on December 5, 1901, and moved to the small town of Marceline, Missouri, with his family when he was four. The Disneys faced financial struggles throughout Walt's childhood, much of which was spent moving around the country in search of work. By the time he was 18, Walt had started a career as a cartoonist and found a few small successes over the next ten years. In 1928, his life would change forever with the theatrical release of *Steamboat Willie*, which introduced the world to Mickey Mouse. Mickey was a smashing success and paved the way for the first-ever animated feature film, *Snow White and the Seven Dwarfs*. Widely expected to be a dismal failure, *Snow White* surprised everyone in 1937 by becoming one of the biggest box office achievements of all time, a distinction it retains to this day.

Walt made many more movies after *Snow White* but few of them saw real success until the 1950s, when audiences in America and around the world suddenly started clamoring for almost everything the Disney Studios produced. In addition to a string of popular movies, Walt also hit it big on television, a market most film producers didn't want to touch. "The Mickey Mouse Club" and serials like "Davy Crockett" took the country by storm. It was also during the 1950s that Walt opened Disneyland.

There are two Disney resorts in the United States. The first began as a single park, Disneyland, in Anaheim, California. There had been plenty of small carnival parks before, but Disneyland was the first true theme park the world had ever known. It opened on July 17, 1955. In 2001, a second park, Disney California Adventure, was added along with a new luxury hotel and the Downtown

Disney complex, transforming Disneyland into the Disneyland Resort.

Disney's other U.S. resort, of course, is Walt Disney World, located just outside Orlando, Florida. Originally, there was only one park in Disney World — the Magic Kingdom, which opened on October 1, 1971, and substantially replicated Disneyland on a larger scale and with several beautifully themed resort hotels. Over the years, three more theme parks were added — Epcot, Disney's Hollywood Studios (formerly called Disney-MGM Studios), and Disney's Animal Kingdom. There are also two water parks, a massive outdoor retail district called Downtown Disney, a variety of recreational facilities, and more than 20 resort hotels. Additionally, there are now Disney resorts in Tokyo, Paris, and Hong Kong. In this book, we'll trace the interaction among these theme parks.

A Brief Glossary

Throughout the book, I use a number of terms of art that apply to theme parks in general and Disney parks in particular. They will be familiar to Disney fans and many others, but for the benefit of those who may be new to theme park culture, here are some brief definitions.

Audio-Animatronics. A registered trademark of Disney Imagineering that refers to the robotic technology used to bring life to many characters in shows and rides in the Disney parks.

backstory. A literary device commonly used in books, television, film, and theme parks (especially Disney theme parks, which are known for their attention to backstory). A backstory is a narrative or a collection of facts about the history of a character, an attraction, or a fictional universe. Disney's Imagineers (see below) use these facts to inform their scriptwriting and design work. The backstory may be entirely fictional or based on historical fact. Some attractions reveal the entire backstory for the audience at

the very beginning, as is often the case in Disney's pre-shows (see Stitch's Great Escape!, *Chapter Five*). On the other hand, some of Disney's backstories go unspoken (see Prince Charming Regal Carrousel, *Chapter Four*).

cast member. In Disney parlance, *all* employees, and especially those working in the theme parks, are called "cast members."

dark ride. The term traditionally refers to an attraction in which small, two- to four-person vehicles move slowly along tracks through a darkened interior. Along the way, black-lighted story scenes are used to create atmosphere or tell a story. Today, the term can apply to more brightly lit attractions as well, and to some rides that do not travel on tracks. Dark rides are discussed in greater depth in *Chapter Four*.

E-ticket. Many years ago, Disney admission was sold on a tickets-per-attraction basis, and the most desirable rides required "E tickets" (lesser exhibits took A, B, C, or D tickets). Over the years, "E-ticket" has evolved into a phrase that means "the best of the best."

Imagineer. The term used for the employees of Walt Disney Imagineering (WDI), which is the branch of The Walt Disney Company responsible for planning, designing, and constructing all Disney parks, resorts, attractions, and related endeavors. The division was established as WED Enterprises by Walt Disney himself in 1952 (the acronym a reference to his full name, Walter Elias Disney) but later became WDI. The term "Imagineering" is a portmanteau of the words "imagination" and "engineering," most commonly used in reference to Disney but not necessarily exclusive to the company.

meet-and-greet. An opportunity to meet a character from the Disney universe. These might be masked characters, such as Goofy, Pooh, or Mickey himself, or actors whose faces are visible and engage guests in conversation, like *Tangled*'s Flynn Rider or any of Disney's growing cadre of princesses. Some character encounters happen serendipitously while strolling through the park.

More commonly, however, characters are found in locations specially and semi-permanently designated for the opportunity to meet them. It is this type of encounter that is typically referred to as a "meet-and-greet." When meeting characters, guests often ask for autographs and pose for pictures. Meet-and-greets are labeled on park maps, which are available for free upon entering the park.

queue. A line for an attraction. In Disney parlance, nearly every line and waiting area is officially known as the ride's queue.

weenie. A term used by Walt Disney and adopted by the Imagineers to denote massive landmarks in a theme park that draw visitors' attention from a distance. Cinderella Castle (*Chapter Four*) is a perfect example.

A Note on Style

This book references both attraction names and movie titles. When talking about Disney, the names often overlap. To avoid confusion, I will italicize movie titles (including short films); attraction names will be capitalized without italics. Note, too, that when sub-sections of individual attractions have been given their own titles, those will appear in quotation marks.

A Word on Accuracy

Everything in this book is, to the best of my knowledge and research, accurate as of the time it goes to press. The Disney Parks are constantly changing, however, and that's never been truer than now, with a number of major initiatives underway at both U.S. resorts at the time of this writing. In particular, Walt Disney World's Fantasyland is in the midst of a large-scale renovation that will see the opening of several new attractions and various changes to existing ones. Please visit my website, http://www.aaronwallaceonline.com, for updates. You may also email me directly with suggestions, updates, or corrections at book@aaronwallaceonline.com.

A Little More Magic

Writing and researching this book has been perhaps the most creatively invigorating experience of my life and career. I sincerely hope that you come away from it with a newfound appreciation for what I believe is a very special experience. Should you find anything new to admire about this wondrous vacation kingdom after reading it — and I think you will — I will take great satisfaction in my efforts here. Happy reading!

Aaron Wallace
Orlando, FL

Chapter 1

Adventureland

*"Here is adventure. Here is romance. Here is mystery. Tropical rivers —
silently flowing into the unknown. The unbelievable splendor of exotic
flowers... the eerie sounds of the jungle... with eyes that are always watching.
This is Adventureland."*

Walt Disney, "Dateline: Disneyland," July 17, 1955

Walt Disney reportedly planned to install a plaque with these
words at the entrance to the original Adventureland. It never hap-
pened, perhaps because it wasn't really necessary — Adventure-
land speaks for itself. Nevertheless, the inscription does nicely
capture the essence of the park's most exotic realm.

There are many kinds of adventures, but Adventureland con-
cerns itself only with those that might unfold in the "other" —
other eras, other languages, other cultures, other locales. A blend
of Africa, Asia, Arabia, the Caribbean, and the South Pacific is-
lands, the land is an immersion into everything that is balmy and
foreign to the American mindset. Home to ferocious beasts, bram-
ble, and colonies in the wild, Adventureland is a jungle nook tee-
tering on the dicey edge of civilization. That's the illusion, anyway,
and it's put together by five primary attractions — Jungle Cruise,
Pirates of the Caribbean, Swiss Family Treehouse, Walt Disney's
Enchanted Tiki Room, and The Magic Carpets of Aladdin.

In between them, the sound of steel drums and the smell of pineapple fill the air. Street vendors peddle their market goods and a camel spits at visitors as they walk past thick and flourishing foliage and a towering, thatched pagoda. Expeditions, sword fighting, and tree climbing await. The place feels like Walt once described it — "the wonderland of nature's own design."

Jungle Cruise

Type: Boat ride

Duration: 9 to 10 minutes

Popularity/Crowds: Moderate to High

FASTPASS: Yes

Fear Factor: 1 out of 5 (gun effects; darkness at night)

Wet Factor: None

Preshow: None

Boarding Speed: Moderate

Best Time to Visit without FASTPASS: Early morning, but come back later if you find it very crowded

Every Disney ride begins with a familiar warning — "Keep your hands, arms, feet, and legs inside the vehicle at all times." To enjoy the Jungle Cruise, you'll need to keep your tongue inside your cheek too. That's because the outdoor adventure ride is Disney's most self-deprecating attraction, steadfastly refusing to take itself seriously. Originally conceived as a more grounded encounter with real animals from the wild, Jungle Cruise has evolved into something that revels in its artifice instead. In so doing, Disney not only pokes fun at itself, but at us as well.

The Jungle Cruise is quintessential Adventureland. In fact, the ride is the land's raison d'être. While Walt Disney's career as a film producer is best remembered for its animated classics and live-action musicals and comedies, his studio also made a very successful series of documentaries. The most notable are the films in the *True-Life Adventures* series. Beginning in 1948 and running through 1960, Disney released 17 *True-Life* titles to theaters,

where they were embraced by audiences and critics alike. A full half of them even won Oscars. The documentaries sought to make viewer-friendly narratives out of real-life nature footage, stamped with distinctly Disney music and voice-overs. Their offspring includes a '50s comic strip and a 2009 renaissance that introduced the "Disneynature" brand and its debut film, *Earth*. The series' success, bolstered by Walt's personal affection for it, was also the impetus for the Jungle Cruise.

When plans for Disneyland went into motion, the first section off of the main castle hub was to be called True-Life Adventureland. Its star attraction would be the Jungle Cruise, a boat tour through re-created habitats featuring many of the live animals seen in Walt's *True-Life* films. By the time Disneyland opened in 1955, the real-life animals idea had been dumped in favor of using robotic replicas, and the "encounter with nature" vibe had been dialed down. Today, the ride is more Comedy Central than National Geographic. How did that change come about? It turns out that mixing real people with really aggressive animals isn't the most practical idea, or at least it wasn't in 1955. Decades later, Disney's Animal Kingdom park would make use of more acreage and new technology to return to Walt's original vision of bringing man into the wild. In Disneyland, though, that face-to-face wasn't to be.

There's a certain kind of humor pervasive throughout the Walt Disney World Resort. It's a dry brand of tongue-in-cheek comedy that isn't afraid to come dangerously close to the audience's threshold for corny jokes. It's wordplay; it's parody; it's pointing out the obvious as if it were breaking news. You find it on the hilariously morbid tombstones outside Haunted Mansion. You find it when Statler and Waldorf tell their audience that they're bolted to their chairs in Disney's Hollywood Studio's Muppet*Vision 3D (literally, they are). You find it when the pre-show in Animal Kingdom's DINOSAUR ride warns you that it might get "a little bumpy," as you see a family being flung around and screaming for dear life. More than anywhere else, though, you find it on the Jun-

gle Cruise. There may be no other attraction more representative of the Disney Parks' personality.

When Walt was forced to abandon his more serious attraction ideas and substitute imitations, it was inevitable that his Imagineers' playful sarcasm would get a chance to shine. Pretending that everything in the ride was real would have crippled it with pretense. Walt never underestimated his audiences, nor insulted their intelligence. If replicas were to be used, they had to be brought front and center and celebrated for what they are — fakes. That's the genius of Jungle Cruise. The ride is lavishly detailed and filled with visual treats, but its entire substance is a sendup of those same sights. It didn't take long for Disney's cast to catch on.

More than any ride at Disney World (with the possible exception of The Great Movie Ride, in Disney's Hollywood Studios), the Jungle Cruise experience hinges entirely on the cast member leading it. In this attraction, the cast members play the role of "skipper," the personal emcee for you and your small boatload of co-passengers. They dress in khaki, they steer the boat, they forget to steer the boat, and they deliver one deadpan line after another into a tiny radio microphone at the boat's bow. The skippers' script is a loose one, having evolved over the years thanks to creative contributions from particularly clever guides, who are given considerable improvisational license. The act isn't easy to pull off, but in the hands of a capable comedian, it can make for one of the resort's most memorable experiences.

The trick for skippers is to come off as just cynical enough to sound miserable, but still cheery enough to let on that they're actually having a good time — to add just enough of their own material to make returning guests feel like they've heard something new, but not so much as to make the passengers fear they have a renegade on their hands. If the skipper errs too far to one end, they sound uncomfortably bitter; too far to the other, and the ride becomes saccharine and rather lame. I've seen it all on my many cruises through these peculiar jungles and it's only the very best and the very worst that stay in my mind. Good or bad, that vari-

ance guarantees that the Jungle Cruise will be a different ride each and every time. This is no broken record; it's always a new release. Even for a once-in-a-lifetime visitor who rides the Jungle Cruise only twice during a week in Walt Disney World, that makes an important impression.

No matter whom you have as your guide, there are a few things you can almost always count on hearing during your cruise. Your skipper will lament that the skull-on-a-stick remnants of a tribal gathering is "kind of a dead party." You'll learn that the Nile River got its name because, as the world's longest river, it goes on "for Niles and Niles and Niles..." You'll meet a crocodile named Ginger — "she's a sweet cookie, but watch out! Ginger snaps." And the skippers will be sure to tease you with a carefully timed sequence of water-squirting elephants, which always look like they're about to erupt right beside you... but only occasionally do.

The foundation for that banter is the idea that it's fun to ridicule the absurd — and let's face it, there's something about riding around in a boat on tracks and looking at fake animals that is a little bit absurd. When you embrace it, though, the inherently cheesy premise transforms into a hysterical adventure. That's the kind of adventure that Adventureland promises, the kind that one takes over the course of a day in Walt Disney World — or in any of the other Disney resorts on the globe, for that matter.

Of course, it isn't really the plastic animals we're laughing at. We're laughing at ourselves. Or, rather, Disney is laughing at us by proxy through the skippers and we laugh along with them. As magical, escapist, and even mentally stimulating as the Disney parks are, they're also intrinsically commercial and materialistic. The Magic Kingdom makes its magic by building things and funds those things by selling stuff. There is an emotional bond that guests forge with the park, but at base level, it's all material. It's also all make-believe. To really enjoy the nirvana of dreams come true and wishes fulfilled that makes Disney World so special, you've got to shed your cynicism and buy into that fantasy.

You've got to check your disbelief at the door. The Jungle Cruise is that door.

Geographically, the ride sets itself up to be the first that many guests will encounter. For the rest of your time in Walt Disney World, you're going to embrace all that is faux and farce-funny, but before you do, you've got to come to terms with your own "too cool for school" mentality. How better to do that than to kick things off with a hearty laugh at yourself? That's what the Jungle Cruise does — it proudly presents its just-barely-moving robotic creations and its "hardy-har-har" puns and boasts, "Yes, it's fake, it's a little corny, it's all a little simplistic — but you love it, don't you?" Your defenses melting away, you sheepishly grin and relent with an exuberant "Yes!"

Welcome to Walt Disney World. Please keep your cynicism, skepticism, and disbelief outside the vehicle at all times.

WATCH THIS – The African Queen (1951)

Conventional wisdom might tell you to watch *The African Lion*, a feature-length *True-Life Adventure* documentary that was especially influential in the Jungle Cruise's creation. And if, by the time you're reading this, Disney has finally released its long-awaited, big-budget, Hollywood adaptation of the ride (à la Johnny Depp and *Pirates of the Caribbean*), you'd probably be well advised to watch that one as well.

But if you really want to see the spirit of the Jungle Cruise captured on film, you'll watch a movie that doesn't come from Disney at all. Released just four years before Disneyland opened, *The African Queen* became the leading model for the attraction. One viewing of this classic starring Humphrey Bogart and Katherine Hepburn and you'll see why. The stars spend most of the movie in a small boat, encountering all kinds of peril as they race down a long and winding river. Sound familiar? Ride the Jungle Cruise and it will!

The good news is that now's the perfect time to see this elusive classic. Despite placing on a number of critics' all-time greatest

movies lists, the unforgettable adventure film went years without a home video release in the United States. At long last, though, Paramount opened up its vault and unleashed *The African Queen* on both DVD and Blu-ray in 2010. Now it's easier than ever to experience a little bit of Jungle Cruise at home.

Pirates of the Caribbean

Type: Boat ride

Duration: 8 minutes

Popularity/Crowds: Moderate

FASTPASS: No

Fear Factor: 2.5 out of 5 (darkness; ghosts; weapons; explosions; small drop)

Wet Factor: 2 out of 5 (random "victims" will be lightly splashed)

Preshow: None

Boarding Speed: Fast

Best Time to Visit: Anytime

Unlike most Walt Disney World attractions, Pirates of the Caribbean doesn't tell a story. That's because the ride presents a haunted realm where dead men are in charge, and as Disney informs its passengers, dead men tell no tales. There are memorable characters and captivating action within, but those are simply ingredients used in creating an imaginative story world. There's no express narrative... and that's the point. You see, "dead men tell no tales" isn't just an eerie chant echoing throughout a dark pirate ride, but a promise about the experience that waits inside it.

Pirates of the Caribbean redefined Disney's Audio-Animatronics technology, which allows the park to cast a slew of robotic actors in its rides. No one saw that coming, as Walt's original plans were for a mere wax museum featuring replicas of history's fiercest pirates. The breakthroughs that Disney achieved in developing showcases for the 1964 New York World's Fair became such a sensation, though, that Walt and his team of Imagineers saw fit to create something a bit more extravagant.

Walt was himself intricately involved in the ride's development, which began within just a few years of Disneyland's opening. He even presented storyboards and models to a national audience in a 1965 television special entitled "Disneyland 10th Anniversary." His unexpected death the next year came just three months before the ride's big Disneyland debut on March 18, 1967. By that time, plans for Walt Disney World were already well under way and they didn't include anything like Pirates of the Caribbean. The thinking was that Florida is close enough to the Caribbean as it is, so the Imagineers were instead planning a ride called Western River Expedition.

As it turned out, Pirates of the Caribbean was too successful in Disneyland to ignore in Disney World, which was already drowning in enormous crowds and needed an E-ticket people eater, pronto. The Western River Expedition was scrapped and never resurrected, though it ultimately paved the way for Big Thunder Mountain Railroad.[1] As an alternative, Imagineers went to work on an abridged adaptation of the original Pirates ride, which opened in the Magic Kingdom on December 15, 1973.

Travelers who have visited both U.S. Disney resorts are quick to call Florida's version of the ride "Pirates Light." With Disneyland boasting several additional scenes and nearly double the duration, it's easy to see why. Still, the Magic Kingdom edition has a treasure trove all its own in the queue — not only are there two routes to the loading platform but they are also more elaborately themed than the single queue at Disneyland. In fact, the Magic Kingdom queue is so unique and lavishly themed that it nearly makes up for all the shortcomings of the actual ride.

The non-story begins at the entrance, where we step inside a Spanish fortress called Castillo del Morro.[2] We pass through the barracks that a pirate crew once called home, and along the way, steel bars and dark recesses obscure the sight of bony dungeon dwellers. Whether they are the remains of long-expired prisoners or living skeletons is hard to tell, but their upright posture and a

grueling game of chess suggest that they're something less than dead. If ye be scared of ghosts, ye'd best turn back now.

Once we reach the docks at the rear of the fortress, we board olden boats and drift off into the shadows. Lurking in the foggy darkness are endless waterfalls, ship wreckage, and a few more sword-wielding bags'o'bones. There's also a pervasive, eerie sense of calm. That changes in an instant when we find ourselves toppling over one of those many waterfalls and plunging into the epic crossfire of cannons. The same fortress that served as an entryway to the port is now under siege by pirates! Hold on to your fanny packs, folks, and prepare to be plundered.

From there on, the scene is set with pirates just doing what pirates do. Debauchery and violence are the order of the day. Gulping down one spirit-filled jug after another, bands of buccaneers revel in their lawlessness, oblivious to the chaos surrounding them. Guns fire, men fight, and buildings go down in flames... and still, the carousing goes on. The wayward scoundrels show the ladies in their company even less respect than they show themselves, catcalling a busty redhead while another pirate auctions her off. Once upon a time, a few men chased the women too, but a bout with political correctness led Disney to turn them the other way 'round (now the women chase the men). They never get anywhere, though. They're always running, always chasing, always carousing. There is no beginning or end to this journey, just middle.

By resisting a narrative and concentrating on total immersion in its environment, Pirates of the Caribbean walks us through a day in the life of a pirate. The ride's iconic theme song reflects that mission — "Yo ho, yo ho, a pirate's life for me." Need it say more? That's exactly what this attraction offers — a pirate's life for you. The rest of the lyrics reinforce that same idea, describing with rapid fire the various hobbies of piratedom — "We pillage, we plunder, we rifle and loot... we kidnap and ravage and don't give a hoot." Those aren't storytelling lines, but rather, descriptors of a more general story world. The singing, sets, and scallywags inside

the ride paint a backdrop so perfect and utterly believable that any number of stories could unfold in front of it. Indeed, no less than four already have.

After relatively unsuccessful attempts at bringing its theme parks to the big screen with *The Country Bears* and *Mission to Mars*, Disney struck gold in 2003 with *Pirates of the Caribbean: The Curse of the Black Pearl*. A formidable, star-studded roster was cast for a group of wholly original lead characters, never before seen in the attraction that otherwise inspired the film. Likewise, the story was invented entirely anew. You won't find the kidnapping of a governor's daughter or the vengeance of a cursed vessel in the theme park ride. You will, however, find a number of elements and individual scenes that were lifted from the attraction and translated to the Hollywood adaptation. In effect, the filmmakers turned the ride into a movie set so that they could do what dead men don't — tell a tale.

The staggering, record-shattering success of *Black Pearl* and its three sequels made it inevitable that Disney would revisit its Pirates rides, which by the 1990s had already opened in Tokyo and Paris, too. In fact, guests were practically demanding it, many of them disappointed to find Jack Sparrow and their other favorite movie characters altogether absent from the ride, which had suddenly become enormously popular once again.

In 2006, Walt Disney World welcomed Captains Jack Sparrow and Hector Barbossa to its marauding Caribbean cast. The rival raiders replaced lesser-known figures in many of the attraction's key scenes, and their sophisticated Audio-Animatronics likenesses are accompanied by dialogue from Johnny Depp and Geoffrey Rush. Before we encounter either of them, however, we must first sail through the phantasmal apparition of a third captain, Davy Jones.[3] Materializing in the mist from the waterfalls in the opening scene, Jones interrupts the familiar reverberations of "dead men tell no tales."

"Ah," he snarls, "but they do tell tales. So says I, Davy Jones." He's right... sort of.

With the arrival of Jones and his feature film cohorts came a newfound narrative in the ride, or at least the silhouette of one. Those who haven't seen the movie will gather this much from the added dialogue — Jack Sparrow is a wanted man. Beyond that, there's still not much plot. Apart from the movie, Davy Jones is just another ghostly voice in the caverns and Barbossa doesn't do much that the random pirate he replaced didn't do before him. Some purists were incensed by the modifications but, truth be told, they didn't change the essence of the ride. Instead, the additions pay a fitting tribute to a beloved film franchise that is itself a valentine to the attraction. By merely hinting at a story that really requires seeing the movie to follow, the alterations simply underscore the adaptability that made the attraction so mesmerizing in the first place. If the ride's fictive landscape hadn't been so remarkably and authentically saturated with detail, there could be no movie... or at least not one that rings so true.

Most folks seem to embrace Captain Jack's commandeering of the ride, probably because the film elements feel like a natural part of the scenery. Just like Haunted Mansion, Pirates of the Caribbean blends lightheartedness with a grim darkness, enlivening the experience with a truly affecting tone. Good times and revelry are set against depravity and mayhem. The ever-present theme song is a duet between a scary-sounding bass singer and a rather silly, warbling, hiccupping fool. Heedless rapscallions grin adorably to get a laugh. That kind of contrast is echoed in the movies, which are steeped in a similarly wry sense of humor. The lead characters are nearly all antiheroes. Chief among them is Jack Sparrow, an untrustworthy cad the viewer can't help but root for. Both the ride and the film series encourage their audiences to keep their wits about them, uncertainty always holding them on edge. They must have a little of what Jack Sparrow calls "savvy." In mixing good with bad, the Pirates of the Caribbean experience ingeniously calls on its guests to employ a little of the same prudence that real pirates needed to survive in a world populated by other criminals, ne'er-do-wells, and of course, ghosts.

Ah yes, the ghosts. It's somehow both terrifying and exciting to flirt with the paranormal, and we're thrust into that courtship during our voyage on this ride. Ghosts were a part of pirate lore long before Walt Disney was born, but his personal fascination with adventure and the supernatural led him to present the undead as an integral part of a pirate's life. The danger of the unknown along these haunted Caribbean shores is positively irresistible. The Disney Studios built their Pirates film series around a ghost story precisely because cursed spirits are such a crucial motif in the ride.

But beyond the appeal of mystery and unease, there's also a pervasive spirit of adventure in the attraction. The action-packed scenes set these pirates and poltergeists apart from, say, Hook's crew over in Fantasyland, or Haunted Mansion's ghosts in Liberty Square. Swashbuckling, bullet-blazing commotion imbues Pirates of the Caribbean with the clamor and peril that define Adventureland. The nighttime setting, so impressively conveyed by a moonlit canvas high above the stage, enhances the mood because everything seems more dangerous at night. Danger really sets the climate in this attraction, and in any attraction that shows Adventureland at its best.

Developing a plot is only one part of writing a story. Pirates of the Caribbean takes care of all those other parts — mood, tone, exposition, irony (or in pirate talk, "arrrrony"), setting, and detail. The ride offers a jolly roger of a good time, but it also delves into the art of story building… just not storytelling. Walt and his team, led by Imagineer Marc Davis,[4] created one of the most engrossing story worlds in all of fiction, with the bold goal of letting guests indulge in the world for what it is, leaving the tale-telling to our imaginations. The particular stories that screenwriters Ted Elliott and Terry Rossio conjured up for the blockbusting film series are but examples of the innumerable sagas that could unfold within that universe. The writers were able to use this fully realized environment to develop plotlines so popular that the masses demanded their addition to the ride that inspired them in the first place. That

achievement is a credit to Davis's and Disney's extraordinary success in not telling one heck of a story.

WATCH THIS – Blackbeard's Ghost (1968)

Released to theaters less than a year after Pirates of the Caribbean opened in Disneyland, this pirate comedy begins when a young man named Steve Walker (Dean Jones) moves to the North Carolina coast, where he's been offered a position as the local high school's new track coach. He happens to arrive during a rally to save Blackbeard's Inn, a local hotel under threat of acquisition by a casino developer. While rummaging through some of the inn's artifacts, he stumbles upon an old spell book and accidentally summons the ghost of Blackbeard himself (Peter Ustinov). As luck would have it, Walker is the only one who can see or hear the famous pirate's apparition.

Like Pirates of the Caribbean, *Blackbeard's Ghost* is a heartily fun adventure that shows an interest in the supernatural side of buccaneering. Ustinov's interpretation of Blackbeard also could have easily been an inspiration for Johnny Depp's Jack Sparrow (although Depp *actually* based his portrayal on Rolling Stones guitarist Keith Richards). Both of these legendary actors lend a delightful blend of silly and unsavory to their conniving captains.

Swiss Family Treehouse

Type: Walk-through environment

Duration: Usually 10 to 15 minutes, but tour at your own pace

Popularity/Crowds: Low

FASTPASS: No

Fear Factor: 1 out of 5 (heights)

Wet Factor: None

Preshow: None

Best Time to Visit: Anytime

Like any large and sprawling tree, the Swiss Family Treehouse[5] has roots centuries old. This being a man-made arbor, they aren't roots in soil, but in literature and pop culture instead. The Treehouse has its origins in 1719, when Daniel Defoe published *Robinson Crusoe*, believed by some to be the first proper novel written in English. Defoe's famous adventure story was retold nearly a hundred years later, when Johann David Wyss published his adaptation, *The Swiss Family Robinson*, in 1812. Wyss' rendition has itself been adapted dozens of times since then, never more notably than in Walt Disney's 1960 live-action classic with the same name.

Two years after its theatrical release, Walt introduced his film to Disneyland with the Swiss Family Treehouse, which was recreated when Walt Disney World opened. That makes the Magic Kingdom's Treehouse the clone of a model inspired by a film version of a retelling of an original English novel (which was itself based on several pre-existing true-life accounts[6]). Phew! With that many popular iterations out there, one might assume Swiss Family Treehouse is as familiar-feeling an attraction as any in the Magic Kingdom. On the contrary, I'd wager that many guests remain oblivious to the connections with Walt's film, making the attraction unique not only for its design but also for its lack of commercial relevance.

Swiss Family Treehouse doesn't fit into any of the usual theme park attraction categories. Neither ride nor show nor playground nor really even an exhibit, the walk-through tour is exactly what its name suggests, a tree house. Then again, "tree house" might imply playfulness to many, while the Swiss Family monument offers only a slow-moving expedition up and down a long series of stairs, with minimal interactivity along the way. Guests moving through the tree house, which consists of numerous platforms built on several levels, will find the eponymous family's imaginatively makeshift living quarters. Bedrooms, a kitchen, china sets, musical instruments, and an elaborate pulley system for fetching water all create the appearance of home life. There are also small

signposts along the way that provide a minimalist recounting of the *Swiss Family Robinson* story.

When the Treehouse opened in 1962, *Swiss Family Robinson* was fresh off an overwhelmingly successful box office run. Walt was a master promoter, and in-park exhibits trumpeting his newest movies were hardly uncommon. *Babes in Toyland* and *20,000 Leagues Under the Sea* had each gotten their own, and even Sleeping Beauty Castle, the park's icon with a diorama tour inside, was designed to promote a movie that wouldn't hit theaters for another four years. But while the *Leagues* and *Toyland* sets stuck around just long enough to create a little buzz for those movies and capitalize on their success, the Swiss Family Treehouse has stayed much, much longer. Of course, those smaller exhibits paled in comparison to the grandiosity of the Treehouse. It is so massive and impressive a structure that its removal even decades later would be an enormous and surprising undertaking.

Still, Disney makes a point of keeping its parks current, which sustains guests' interest and allows the company to sell merchandise in a way that feels organic. Unlike *Mary Poppins* (which, incidentally, doesn't have a theme park attraction anywhere in the world, save a very short scene in The Great Movie Ride), *Swiss Family Robinson* has not endured as a fan favorite and you'll be hard-pressed to find it celebrated in any but the most comprehensive Disney anthologies. There's no gift shop at the Treehouse's entrance or exit, no surprise cameras inside with instant printouts sold as souvenirs, nor even a small booth at the end with copies of the movie on DVD.

Why keep the Swiss house around, then? That's a question Disney executives have asked themselves before and in fact, they've answered it both ways. Disneyland closed its original Treehouse in early 1999 and reopened it four months later under a new name, Tarzan's Treehouse. Ditching the Robinsons and adopting then-current *Tarzan* characters as residents instead, the new attraction differed little from the original, adding only some

window dressing, a stronger storybook framework, and a few additional interactive elements. When the attraction was built for Hong Kong Disneyland's 2005 opening, the *Tarzan* version was put in place from the get-go. So why has Walt Disney World kept the original presentation intact?

Maybe the mixed reaction to Tarzan's Treehouse in Disneyland persuaded Disney executives that the change would be unwelcome. Maybe keeping the classic Treehouse was Disney World's tradeoff with Disneyland, which got to keep its original Enchanted Tiki Room show (discussed below). Or, with three other theme parks to worry about, including the then-brand-new Animal Kingdom, maybe Walt Disney World couldn't justify spending any money on the overlay at the time.

Whatever the reason, the Swiss Family Robinson storyline lives on in the Magic Kingdom, where guests continue to enjoy the attraction despite the fact that many of them probably have only distant memories of the movie at best. Familiarity with the source material really isn't necessary to fully appreciate the Treehouse anyway. The attraction's real allure is its ability to confront the individual guest with his or her own potential to adapt, innovate, and survive.

The Robinsons found themselves shipwrecked and alone, forced to work with what little they had in order to survive. The spectacle of the expansive and fully functioning home they constructed inside this broad and beautiful tree is a veritable wonderment, and though the family itself is largely a work of fiction, the real-life possibility of such a tree house is apparent to the guests as they walk through one and see it working before their very eyes. As so many castaway adventure stories have done, the Swiss Family Treehouse encourages visitors to ponder their own capacity for inventiveness and resourcefulness, should they ever be summoned to harness it in this technological age of convenience.

That theme can find its way to the park-going audience through many stories, *Tarzan* included. In *Swiss Family Robinson*, however, that theme isn't just incidental, it's paramount. Guests who take

the time to read the story-guiding signposts will appreciate all the more that this survival story emerged out of necessity for its characters. Kudos go to Walt Disney World for keeping the original storyline intact. With a big-budget remake of the original film supposedly now on the way,[7] the Magic Kingdom just might reap the benefits of the Swiss seed it sowed and nurtured all these years, bringing newfound commercial import to an underrated Magic Kingdom classic at last.

WATCH THIS - "Lost" (2004)

Common sense dictates that those who want to fully appreciate the Treehouse but haven't seen *The Swiss Family Robinson* should do so, especially since it's available on an excellent "Vault Disney Collection" DVD. There is, however, another popular Disney title on home video that makes for a perfect thematic match with the Swiss Family Treehouse — "LOST." The TV drama-adventure series, produced and distributed by Disney and broadcast on Disney-owned ABC, has little to do with tree houses. But like the Robinsons, the castaways in this show find themselves stranded on a mysterious island after a crash landing — the modern day equivalent of a shipwreck. Faced with their own mortality, they tap instincts they didn't realize they had, making the most of meager resources and one another in order to survive.

Walt Disney's Enchanted Tiki Room

Type: Theater show

Duration: 12 minutes

Popularity/Crowds: Low to Moderate

FASTPASS: No

Fear Factor: 2 out of 5 (darkness; storm effects)

Wet Factor: None

Preshow: Outdoor, standing-room-only dialogue between two Animatronic birds

Best Time to Visit: Anytime

For more than a decade, guests avoided Adventureland's only theater performance like the plague — or, to use a more appropriate metaphorical epidemic, the avian flu. That's because corporate meddling had turned the park's once-beloved bird show into a caustic schlockfest. As luck would have it, the unpopular edition ultimately went down in flames — literally — prompting cheers from parkgoers as Disney deigned to return the show to its original glory. Phoenix-like, a whole new bird arose from the ashes of disaster. This is the story of the Enchanted Tiki Room.

When it opened in Disneyland in 1963, the Enchanted Tiki Room marked Disney's first use of Audio-Animatronics, the robotic creatures that populate many of its attractions today. What was originally to be an interactive restaurant experience became a theatre-in-the-round instead, with a harmonious host of birds cracking wise and singing songs from the rafters above the audience. It's been substantially the same ever since in Disneyland, where it lives on as a perpetual favorite of the California park's daily guests.

Florida's Magic Kingdom called its version of the show Tropical Serenade, but it was essentially identical to California's original. The East Coast performances were warmly welcomed when they began in October 1971, and they ran mostly unchanged for more than a quarter century. By the mid-1990s, though, attendance at Florida's Tiki Room had slumped while California's stayed strong enough. In response to the decline, Walt Disney World closed its Tiki Room in September 1997 and reopened it seven months later with a new name and a brand-new show inside.

The Enchanted Tiki Room — Under New Management presented a "hipper," more contemporary twist on the original production, or at least that was the idea. In the new version, Iago from *Aladdin* and Zazu from *The Lion King* were the stars of the show. Tackling the declining popularity of the original production head-on, the brightly feathered headliners announced that they'd been recruited to bring renewed life to the Tiki birds' dying act.

That was Corporate Disney's way of saying, "Out with the old and in with the slightly less old."

By the time Under New Management opened in 1998, *Aladdin* and *The Lion King* had already left the New Release shelves. While both properties remained unquestionably popular (and still are), the assumption that these supporting characters could alone rejuvenate interest in an attraction that had very little to do with them was far from bankable. It didn't work out.

Instead, audiences resented the changes. Loud-mouthed Iago was now interrupting the perennially adored theme song to brashly declare that it (and, by implication, anyone who still loved it) was washed up and lame. Rude! It didn't help that the production felt instantly dated either.

The new show came across as a musical game of badminton, with birdies bouncing back and forth from classic to contemporary and frequently getting lodged in the mid-'80s in between. Its soundtrack included radio relics "Hot, Hot, Hot," "Conga," and "Get on Your Feet." Of all the songs ever made, that Disney chose three that are relegated to local car sales commercials and the back of karaoke books is indicative of the low standards for the Tiki Room reboot. And with no disrespect to Gloria Estefan's talent and success, one can't help but question the use of not one but two of her songs back-to-back. The latter half of the show turned into some kind of Fowls' Salute to the Miami Sound Machine, and you started to wonder if you were even in Walt Disney World anymore.

For a long time, the most exciting thing about Under New Management was the race it launched between my eyes and Walt Disney in his grave to see which could roll faster. That changed on January 12, 2011, when a small fire broke out in the attic of the Tiki Room and forced guests inside to evacuate. The doors closed, and the interrupting Iago would never be heard from again.

Disney remained tight-lipped about the fire's cause and origin, though fans were quick to espouse theories of their own.[8] What-

ever happened, the damage was severe enough to keep the Tiki Room closed for seven months, during which time the resort announced plans to reopen a close approximation of the original show later in the year. To Disney fans, this was divine intervention. One of the park's most despised attractions had — quite randomly and without explanation — burned down, and Disney was pledging to bring back the esteemed original in its place. Even better, rumor had it that the infamous Iago Audio-Animatronic was nearly completely destroyed in the fire. This must have been how Dorothy felt when the Wicked Witch melted.

At long last, on August 15, 2011, the attraction reopened as Walt Disney's Enchanted Tiki Room. The founder's name in the title signaled a return to form. In Disneyland, it had been called Walt Disney's Enchanted Tiki Room because it was literally Walt Disney's — he owned the attraction himself, separate and apart from Walt Disney Productions.[9] Obviously, that's not the case today, but Florida's newest incarnation certainly has the tone and quality of Walt's personal touch. Save for a few unfortunate but ultimately minor abridgements, the new Magic Kingdom edition mirrors its Disneyland counterpart almost exactly. Only the outdoor preshow is significantly different.

Standing in a covered lanai while waiting for the doors to open, guests meet two toucans named Claude and Clyde. Their witty waterfall banter reveals that they and their winged friends haven't always been able to talk. They were apparently spellbound while living deep down the rivers of Adventureland (in the Jungle Cruise, perhaps?), but a gong beckoning entry into the Enchanted Room interrupts them before they can finish their story. We never get to find out exactly what led to their enchantment, only that it has something to do with the room we're about to enter, a room they call the magical Sunshine Pavilion.[10]

All we really need to know is that what we're in for is anything but a real-life bird show. These are fantastical fowls, after all, and they enjoy some sort of mysterious relationship with the easily stirred Tiki gods. That's of little concern when we first enter,

however. The Sunshine Pavilion is beautiful, lush, and exotic inside. The low lighting, bright colors, and instant air conditioning extend an immediate invitation to relaxation. We take our seats on backrest-equipped benches and settle in for what turns out to be a lighthearted and admittedly strange variety show.

The casual parkgoer might be surprised, upon seeing Walt Disney's Enchanted Tiki Room for the first time, that this is what all the fuss was about. There is nothing especially show stopping about the attraction. Modestly mobile birds sing a few simple songs, and then the audience goes on its merry way. The seats do not move. There are no sudden surprises and no 3-D. Not a single princess waltzes in for brand recognition. Even the jokes are pretty gentle and unlikely to prompt guffaws. So why was anyone demanding to see this thing again?

The Tiki Room's magic lies not so much in its fanfare or technological razzle-dazzle — though it did receive a number of upgrades and a remastered soundtrack when it reopened in 2011 — but in the way it transports our subconscious to Hawaii. The show is a concert of soothing music set to seductive rhythms, and the entire building is constructed to bring those sounds to life. The wood on the walls opens its eyes to become a living Tiki totem. Flowerbeds descend from their high-up perches to coo calming harmonies. All around us, nature sings. That's what Polynesia feels like, or at least what we fantasize it to feel like. By cueing those connections in our mind, and massaging our senses with breezy lullabies, the crooning cast of Tiki dwellers can coax us into a Hawaiian state of mind.

The attraction doesn't necessarily set out to simulate a tropic retreat. There's no exposition to that end in the script or its backstory, and on a surface level, the show is focused more on the novelty of singing birds than the theme of Polynesian paradise. And while the room does draw from the isles of that region — principally Hawaii, Fiji, Tonga, and the Cook Islands — the central theme song incorporates Latin American and European influences, too. But as we take respite from all the walking we've done

outside and enjoy the crisp air conditioning in a darkened room, letting those easy tempos and choral, floral melodies wash over us, our imaginations drift to a place of tropical pampering. The Tiki Room is a vacation from our vacation, even if for only twelve minutes at a time.

The production also reminds us of a different era, largely because it is the product of one. From the subtle references to jazz singers like Louis Armstrong to the relative primitiveness of its technology, the Tiki Room is alive with the zeitgeist of the 1960s. Fortunately, its humor is universal enough and the arrangement of its score organic enough for the presentation to avoid falling over the fine line between "classic" and "dated." With emphatic announcements for each successive act, the script almost seems to expect its audience to be more wowed by the sights and sounds than they are likely to be today — a reminder of a time when we were perhaps less insistent on major spectacle for our entertainment.

José, the lead Animatronic, begins each program by waking from an ever-shortening siesta and greeting the real-live-person cast member as "señorita," regardless of his or her gender.[11] The salutation is simultaneously campy in its lack of sophistication and verging on politically incorrect in its disregard for the cast member's identity. The same can be said for French fowl Pierre's catcall to the women in the audience during the early part of the show, a whistle he ostensibly intends for waking up his friend but winkingly directs toward the ladies. Those exchanges are likely harmless enough to avoid seriously offending anyone. In fact, many may even find them charming or amusing in an ironic way. Whether they are insensitive or not, they certainly contribute to the yesteryear allure of the Tiki Room. Such quips probably wouldn't find their way into a newly scripted production, so it's interesting to return to a time when they could. We aren't just traveling to Hawaii, we're traveling to 1960s Hawaii. It's two trips in one.

All the romance of a 1960s aloha gets shaken ever so slightly,

however, when later in the show those aforementioned Tiki gods start to rouse. Chanting, wailing, and the quickening beat of drums turn the tone almost violent during the luau finale, capped off by a veritable storm inside the theater. Here, nature is singing again, but this time it's a different kind of song. Storms on the shore always have a beautiful drama about them, and this scene taps into that feeling with its memorable Tiki cloudburst. Tropical thunder is as important as seaside serenity in getting the full Polynesian experience.

You can find plenty of luaus like this throughout Hawaii, but you won't come across one done by talking, singing birds. That only happens at Disney. Now that the original show has been resurrected from its enchanted Tiki tomb, audiences can again enjoy an experience that is thoroughly unusual and yet also quintessentially Walt. That's especially true in the closing moments of the show, when the birds rush the audience out to the tune of "Heigh-Ho," the anthem from Walt Disney's very first movie and a song as timeless as the Tiki Room now feels again. It is a bit of a shame that things had to end this way, with the otherwise likeable Iago burned up and his audiences burned out. Perhaps the Imagineers could still find a place for him to be a part of the show — locked in a cage on your way out, maybe. If nothing else, it would serve as a reminder that some things are best left unchanged.

WATCH THIS – The Even Stevens Movie (2003)

An unusual recommendation for an unusual attraction. "Even Stevens" (1999 - 2003) ran for 65 episodes on The Disney Channel before bowing out with a feature-length TV movie. The series was one of the network's best, but you need not have seen a single episode to understand and enjoy this adventurous comedy, which stars Shia LaBeouf, Christy Carlson Romano, and "SNL" alum Tim Meadows, along with a cameo appearance by "Full House" star Dave Coulier. The harmlessly dysfunctional Stevens family gets talked into taking

an exotic getaway to an uncharted island, its region not quite specific — but then that's part of the mystique. Once they arrive, they soon find, among other things, that the wildly wardrobed natives are less than friendly. Throw in the occasional Tiki idol and you've got yourself a screwball escapade on the order of Walt Disney's Enchanted Tiki Room! There's even some corporate meddling to make a mess of things in the middle. It's like a page right out of Adventureland history.

The Magic Carpets of Aladdin

Type: Flying, steerable carpets

Duration: Under 2 minutes

Popularity/Crowds: Moderate

FASTPASS: No

Fear Factor: 0.5 out of 5 (moderate heights)

Wet Factor: 0.5 out of 5 (spitting camel squirts the occasional guest)

Preshow: None

Boarding Speed: Slow

Best Time to Visit: Anytime, but come back later if you find it crowded

The Magic Carpets of Aladdin hasn't had a warm reception among many Magic Kingdom fans. Of course, Aladdin himself didn't strike anyone as particularly worthwhile either, but he soon proved there was more to him than meets the eye. The same might be said for his Magic Carpets in Walt Disney World. While it's no diamond in the rough, there *are* some hidden gems in this ride experience. You'll just have to overlook the inherent simplicity and redundancy to find them.

The Magic Carpets of Aladdin is a ride like several others in the Walt Disney World Resort, most notably Dumbo the Flying Elephant. These rides are carousel-type attractions in which each vehicle is attached to a central, spinning hub. When the hub begins to move, the vehicles rotate around it and can move up and down. Unlike a conventional carousel, however, the ride isn't

grounded and has no awning above it, creating for passengers the illusion that they are flying. A lever inside each vehicle allows the guest to control how high or low their slow-moving vehicle "flies" during the very short rotation. The Magic Carpets of Aladdin is essentially the same ride as Dumbo with a few enhancements, only there are magic carpets in place of flying elephants.

When the ride opened in the Magic Kingdom in 2001, the park already had not only Dumbo in Fantasyland but also another very similar ride, Astro Orbiter, in Tomorrowland. That same year, Disney's Animal Kingdom opened its own version with TriceraTop Spin. For a resort that specializes in the unique and impossible, that's a whole lot of a very simple ride in one place. It's not surprising that many criticized Magic Carpets as an unimaginative copycat, arguing that Adventureland would have been better off with a less congested walkway instead of a repetitive attraction that required substantial reorganizing around the new ride's chosen location.[12] While the merit of walkway width is worthy of debate (Disney World's propensity for spacious paths stands at odds with Disneyland's intimate and clustered design), The Magic Carpets of Aladdin fares better in a carousel-for-carousel comparison than its reputation might suggest.

The most striking improvement Aladdin offers over its kin is functionality. The Magic Carpets seat four, for starters — and comfortably, I might add. Anyone who's flown on Dumbo knows that even two is a tight squeeze there. There's also the benefit of added control, since the carpets feature joysticks that not only raise and lower the vehicles but tilt them forward and backward too! It's hard to argue that older incarnations are more worthwhile when the Magic Carpets are inviting whole parties to ride together and giving them more to do during their flight.

There's also more to take in. While all of these hub-and-spoke rides employ some beautiful scenery as a backdrop, The Magic Carpets of Aladdin really uses the land around it to bring its narrative to life.

In the annals of storytelling, there are many kinds of adven-

ture — ones that take place inside other realms, in space, in the imagination, and so on. Adventureland is focused on very particular adventures, though, the kind that unfold in far-off and exotic locales. Sometimes it's the jungles of Africa and Asia, sometimes the Caribbean, sometimes a deserted isle. This time, it's Agrabah. The fictional city, filled with street vendors, crowds, and canopies, originated with 1992's *Aladdin* but took its cue in part from *One Thousand and One Nights*,[13] perhaps better known as the "Arabian Nights" tales. With the construction of The Magic Carpets came an entire village within Adventureland, one that houses gift shops that do a very good job masquerading as the actual streets of Agrabah. The effect is that guests aren't just flying in circles around Genie's lamp in order to get a bird's-eye view and hear a few Alan Menken[14] tunes — they're getting the chance to fly over the same city that Aladdin and Jasmine flew over and on what appears to be the very same rug. In this way, the otherwise simple ride is very effective at bringing a memorable story to life.

So at the end of the day, while The Magic Carpets of Aladdin hardly takes guests to "A Whole New World" of ride technology, its integration with a nicely detailed perimeter area brings the attraction out of "diversion" status and makes it a fully realized experience. Undoubtedly, magic carpet escapism could be better achieved in a more dazzling ride (to borrow from Epcot and Disney California Adventure, a "Soarin' Over Agrabah" attraction could be an E-ticket), but this centerpiece of Adventureland makes do with what it has. Given three wishes, I doubt you'd use one of them to ride this, but at least it gets you close to the lamp.

WATCH THIS – The Thief of Bagdad (1940)

One Thousand and One Nights has inspired many a film, with every Aladdin, Sinbad, and Ali Baba movie among them. One of the most notable is the 1940 British fantasy, *The Thief of Bagdad*, which uses the old-style spelling of modern Baghdad. The film is distributed by

United Artists and is available on DVD today as part of the esteemed Criterion Collection.

Disney's *Aladdin* borrows liberally from *Bagdad*. The animated hero is actually a composite of the 1940 film's two central protagonists, King Ahmad (John Justin), who takes care of the princess wooing, and Abu (Sabu[15]), who isn't a monkey as in Disney's version, but rather an adventurous young man in the role of Ahmad's thieving, street-rat sidekick.

Bagdad's influence is especially apparent in some of *Aladdin*'s mirror-image scenes. When the evil vizier Jaffar (Conrad Veidt[16]) attempts to convince the Sultan (Miles Malleson) to give him the Princess' (June Duprez) hand in marriage, for example, or when Abu enters a cave to steal a treasured gem, the older movie will feel familiar to younger generations better acquainted with Disney's telling. One of the most notable differences is the role of the magic carpet, which appears much later in *Bagdad* than in *Aladdin*, but assumes greater significance in the former, making this a suitable companion piece for a ride on The Magic Carpets of Aladdin.

Chapter 2

Frontierland

"Frontierland: it is here that we experience the story of our country's past — the color, romance and drama of Frontier America as it developed from wilderness trails to roads, riverboats, railroads, and civilization — a tribute to the faith, courage, and ingenuity of our hearty pioneers who blazed the trails and made this progress possible."

Walt Disney, "Dateline: Disneyland," July 17, 1955

Walt and his team designed Frontierland to "give you the feeling of having lived, even for a short while, during our country's pioneer days." It's easy to think about Frontierland as a place for action, where they put the extra "wild" in the Wild, Wild West. More than that, though, it is a living period piece. In Frontierland, life moves at more of a saunter than a gallop.

Oversized porches and rope-bound logs make up the storefronts and walkways of Frontierland, where the wooden plank sidewalks are raised off the ground to keep all that imaginary dirt off the lads' boots and the lasses' billowing dresses. The steady-flowing river and its slow-rolling watercraft set the pace for this olden town, and so does its music.

With peacefully plodding tunes like "Home on the Range," "Git Along, Little Dogies," and "Oh My Darling, Clementine," there is an attractive laziness in the climate here. At home, you

could fall asleep to the background music loop, but in the park you'll be engrossed in the ambience of Frontierland and its five cardinal attractions — Country Bear Jamboree, Big Thunder Mountain Railroad, Frontierland Shootin' Arcade, Splash Mountain, and Tom Sawyer Island. It's a place for slinging guns and toppling over waterfalls, for woodland hoedowns and do-si-dos. It's a place for eating cinnamon-coated churros like there's no tomorrow. And at the end of the day, it's a place for loafing in the take-it-easy tempo of Disney's American Frontier.

Country Bear Jamboree

Type: Theater show

Duration: 11 minutes

Popularity/Crowds: Low to Moderate

FASTPASS: No

Fear Factor: None

Wet Factor: None

Preshow: None

Best Time to Visit: Anytime

If you're like me, you just don't get the Country Bear Jamboree. Or, I should say, if you're like I used to be. The attraction is a disappointment to many, a glorified Chuck E. Cheese where the pizza must be eaten before you come inside and the only arcade game in sight is a simple, not-included-in-the-price-of-admission shooting gallery that even the NRA might pass up. During my many jaunts through Frontierland, if I went inside (and usually I didn't) it was because a travel buddy of mine insisted on it or because I needed an air-conditioned nap.

In the not altogether unlikely event that you haven't taken your own journey inside the Country Bear theater, all you need to know is that the roughly 11-minute show parades a series of bears on and off a multi-platform stage as they perform one old-time ditty after another. A top hat-wearing bear named Henry serves as emcee,

engaging his fellow bears in "simple folk" banter that is the very paradigm of campy humor.

That hillbilly tour de force never appealed to me, thus my infrequent attendance. Over the years, though, my reluctant jamborees added up, and after countless rounds of forced laughter and sarcastic applause, I one day found myself doing something I hadn't done before — I was singing along. Through no fault of my own, my subconscious had tuned in and learned every twangy word to every corny song in the show. No sooner had I found myself synchronized with the bears than another, more sickening realization dawned upon me: I wasn't just participating. I was enjoying it. *"Heaven help me,"* I thought, *"I'm a sellout."*

Years of ardent derision gave way to a healthy, moderate appreciation for what is perhaps Walt Disney's World's most divisive, love-it-or-hate-it experience.[1] That appreciation isn't necessarily easy to share, particularly if your first visit to Walt Disney World came under the presidency of anyone after Jimmy Carter. If that's you, then allow me to draw from my own Country Bear journey to change the way you think about the Jamboree so that you, too, can anxiously await its next stale punch line with bated breath.

Walt Disney himself worked on the Country Bear Jamboree but died before he could see its debut as part of the Magic Kingdom's grand opening on October 1, 1971. A Frontierland original, the show enjoyed instant popularity, becoming an integral part of the new Disney World experience that the media devoted so much attention to in the early '70s. That warm embrace led not only to a replica in Disneyland the next year but also an entire land in the California park dedicated to the show's stars, Bear Country.[2] Various incarnations have come and gone on both coasts over the years but while Disneyland's closed its doors for good at the dawn of the millennium, the original show still runs every day in Florida's Magic Kingdom.

The show opens with the promise that it will be a "jamboree featuring a bit of Americana, our musical heritage of the past."

That places the attraction very nicely in the crook between nostalgia for our own past and reverence for historical traditions that frame the Magic Kingdom. Musically, the show is reminiscent of the recordings of "old timey" traditional folk music made popular in the 1930s and '40s. The Carter Family comes to mind. Of course, the Carters and their ilk were artists of a not-so-distant past for the parents and grandparents visiting Walt Disney World in 1971. For many, the show was likely a pleasant reminder of the homegrown musicianship they knew before the rock era and the vast reach of mainstream radio. Naturally, those who know traditional country music as an important part of popular culture are fewer and farther between today. The diminished relevance that the passage of time casts upon the genre showcased in the attraction might in part explain why its popularity has also faded with time.

But even to those who are hearing the plunk of a banjo for the very first time inside the Country Bear theater, the music still has something important to offer. The lands of the Magic Kingdom are each designed to transport its guests to a different point in time. That goal is most effectively achieved by a drastic change in aesthetics — take one step out of Adventureland and into Frontierland and everything you see and hear is suddenly radically different. As any Disney parkgoer can tell you, music is a pivotal part of that experience. That's where the Country Bear Jamboree comes in.

"The American Frontier" probably most accurately describes the first three quarters of the nineteenth century and accordingly, Disney's Frontierland attractions set their sights primarily on the mid-1800s. The Country Bear Jamboree is therefore a kind of live soundtrack for the world you've entered. You might very well have seen this kind of show somewhere in the Midwest in 1875, so it makes sense to sit down and enjoy it while you're pretending you've gone back in time. Granted, you wouldn't have found singing bears back then, but if anthropomorphic animals breaking into song are too far out there for you, you really need to spend your vacation time somewhere else.

There's something Jim Henson-esque about these bears. Henson's Muppets are, after all, a motley crew of well-meaning creatures intent on staging a show and entertaining an audience but failing spectacularly in the attempt. The Country Bears are doing the very same; they want to stage a musical revue but keep falling short. Like the Muppets, their charm lies in their capacity for failure. That's why the absolute highlight of the show, a slurred ballad called "Blood on the Saddle" performed by the laughably oversized Big Al, scores Al-sized laughs every time.[3] Kermit and his gang fail because they're either too self-absorbed (Miss Piggy, Sam the Eagle) or too talentless (Fozzie Bear) to get the job done. Henry's bears fail because they're just a little too backwoods and a little too bottom-of-the-class to keep things together. As an audience, we know they mean well, though, so their efforts make them adorable, no matter the result.

There's also something to be said for the value of country music in the show. The country-western genre works because it speaks to the common problems of the everyman, and it does so in a simple and honest way. Twang isn't everyone's cup of tea but few will struggle to find songs in the country music repertoire that they can easily relate to. That innate appeal is central to the Jamboree, a showcase for the early country-western style. Self-deprecating lyrics like "My woman ain't purty but she don't swear none; she's kind of heavy, don't weigh a ton" and "All the guys that turn me on turn me down" are funny because they speak to anxieties that most people have connected with at one time or another.

But for all the charm I've recently found in the Country Bear Jamboree, there's no denying that the show continues to bewilder a good portion of its audience. That the attraction isn't going to be the hit sensation in 2013 that it was in 1971 is arguably inevitable, but for years, the theater was a bit of a fix-me-up. Lyrics and puns were hard to make out thanks to an audio system that couldn't compete with the factory speakers in most cars. I suspect that the lackluster technical presentation has been a significant

factor in the underwhelming of many guests over the last decade or so. Of course, the pace dragged just a tad, too.

Fortunately, the attraction finally received a woefully overdue refurbishment in the fall of 2012, reopening on October 17th with brighter lights, more vivid colors, newly enhanced audio, and an entire cast of dazzlingly redesigned Animatronics. Bits of clever dialogue were regrettably truncated, two of the show's less memorable songs were completely excised, and several other performances were slightly abridged, but that all seems a small price to pay for a new lease on life. Change is never easy for fond-hearted fans, but at the risk of bruising their nostalgic affections, I can't help but think that guests might actually start to care about this show again now that it feels zippy, bright, and alive. And if the public doesn't start caring, well, I shudder to think that the Bears' act might someday fold up for good.

I wouldn't endorse the update if I thought it didn't retain the heart and soul of the original presentation, but in my evaluation, it does. The Bears are still showing us that even their very best is a bit of a laugh, and it's as easy as ever to fall in love with them along the way.

Of course, there's no guarantee that a shorter show and new polish will change the public's puzzlement regarding the Country Bear Jamboree. It remains something of a cultural head-scratcher for many. Maybe there's more Disney could do to prevent the show from drifting into the realm of the "A-ticket," once allocated for the park's least-in-demand items. For starters, welcoming food into the theater could breathe new life into the place. With no counterpart to Disneyland's Golden Horseshoe Saloon,[4] the Magic Kingdom is in need of a dinner theater. Why not let an old favorite fill that much-needed role? Granted, an 11-minute show doesn't allow a lot of time for Disney's many food-loving guests to stuff their faces full to satisfaction. With the Pecos Bill Tall Tale Inn and Café right next door, though, and plenty of snack carts around, inviting guests to bring their outside food indoors for an 11-minute show should make for a happier and ultimately less dis-

appointed audience. After all, the way to a tourist's heart is through his or her stomach.

That said, a few minutes without food haven't kept millions from embracing the attraction for nearly 40 years. There's a reason that the Country Bear Jamboree is one of the best-known productions in Disney Parks history, but if that reason has eluded you until now — well believe me, I can relate. The next time you're passing by the log cabin with those tired old bears inside, though, give it another try. If you're a first-timer, go in with an open mind. Pay attention to the understated throwaways, clap along when the beat feels right, and allow yourself to enjoy the sometimes silly, sometimes droll entertainment that the Animatronic performers are serving up for you. If you do all that while thinking about the show in the context of the Magic Kingdom and its presentation of the American Frontier, you just might find it more ...er... bearable than you ever have before.

WATCH THIS - Westward Ho, the Wagons! (1956)

Sure, there is a Disney movie out there called *The Country Bears*, directly inspired by the attraction... but if its measly $16.9 million domestic gross and 30% Rotten Tomatoes score[5] are any kind of a gauge, you probably won't like it (although I happen to like the movie more than most). Instead, try this slightly more obscure Disney film — if you can find it. *Westward Ho, the Wagons!* is a grandiose Western musical made in Technicolor and Cinemascope, two beautiful filmmaking processes that were expensive and rare in 1956. Originally written for TV, Walt upgraded the movie to theaters following the enormous success of "Davy Crockett" and "The Mickey Mouse Club" (*Wagons* stars Fess Parker[6] alongside a slew of Mouseketeers).

After they left theaters, Disney movies in those days were often broadcast as an edited, two-part TV special and featured on the popular "Disneyland" anthology series. That's how *Wagons* made

its TV debut in February 1961. When the movie later came to VHS in 1986 (and again in 1997), it was only in its TV form, edited for time and cropped from Cinemascope. The VHS is long out of print today and the movie has never been revisited for DVD, perhaps due to its sometimes-unflattering portrayal of Native Americans. Eager viewers are in luck, though, as this rather enjoyable film often turns up as an inexpensive rental through Amazon.com's Video on Demand service (still only as the TV edit). That's good news because *Westward Ho, the Wagons!* is a great primer for Country Bear Jamboree. For starters, the Country Bears sing the "Davy Crockett" theme as part of their show. That song doesn't turn up in *Wagons* but the man who played Davy Crockett does sing a number of tunes that fit right into the Country Bears' musical palette. Even though some of the movie's better numbers were dropped for the TV airing, there's enough remaining to give viewers a meaningful taste of simple folk songs in their native Frontier setting. Besides, if you watch the movie before seeing the Jamboree, Disney will reward you with a subtle nod. On your way out of the Country Bear theater, you'll see a clever little wink across the way: a food wagon with a sign that reads "Westward Ho Refreshments." Eat, sing, and be bear-y!

Big Thunder Mountain Railroad

Type: Roller coaster

Duration: 3 to 4 minutes

Height Restriction: 40 inches or taller (adult riders can switch off)

Popularity/Crowds: E-ticket

FASTPASS: Yes

Fear Factor: 3 out of 5 (sharp turns and slight drops at moderately high speed; heights)

Wet Factor: 0.5 out of 5 (occasional light mist)

Preshow: None

Boarding Speed: Moderate to Fast

Best Time to Visit without FASTPASS: Early morning or late night

Big Thunder Mountain Railroad is perhaps the Magic King-
dom's most conventional roller coaster. That's saying something,
given that the mega-popular ride zips through a lavish and tower-
ing structure that beckons guests to Frontierland from the park
entrance and provides passengers with breathtaking scenery.
When in Walt Disney World, it seems, even convention gets
spruced up with panache. The level of visual detail permeating
Big Thunder gives the coaster an "it" factor that turns this super-
sized upgrade of the standard mine train[7] ride into the "wildest
ride in the wilderness."

The first Big Thunder Mountain opened at Disneyland on
September 2, 1979. One year later, an even bigger one boomed at
Walt Disney World. Since then, Tokyo Disneyland and Disney-
land Paris have each added the attraction to their respective
mountain ranges as well. But even though it officially debuted in
California, the attraction actually has its origins in Florida's park.

Big Thunder is the brainchild of Tony Baxter,[8] a leading Imag-
ineer and a Disney legend in his own time. After Pirates of the
Caribbean opened in Disneyland's New Orleans Square in 1967,
Disney wanted a ride-through experience of the same scale that
would give East Coast America a glimpse of the West in the same
way that Pirates had given West Coasters a taste of the Caribbean.
Plans began for a major "cowboys versus Indians" ride that would
serve as Disney World's answer to Disneyland's Pirates hit. The
new ride would be called The Western River Expedition. When
heavy attendance in Florida required rapid production of crowd-
swallowing attractions, though, Disney decided to scrap those
plans. The Imagineers pulled out the ready-to-go Pirates blue-
prints instead and built an economy-sized replica as a quick means
of crowd control.

Still needing an E-ticket, Disney World asked its Imagineers to
fill the large plot of Frontierland with something special. Tony
Baxter listened and thus Big Thunder Mountain Railroad — his
first major Imagineering project — emerged from the plans for
what was once to be The Western River Expedition. But because

science fiction was all the rage in the 1970s, Disney's attention shifted to the Space Mountain project in Florida, putting Big Thunder on the back burner. That's how Baxter's mine train ended up in Disneyland first. The Magic Kingdom didn't wait too long, though, opening its own version in the fall of 1980.

At Disney World, the mountain is modeled after the famous Monument Valley in Utah. Those who have seen the Valley (or who've at least seen it in films like John Ford's classic *Stagecoach*) know that Disney's structure bears a striking resemblance to its earth-toned sandstone towers and buttes. The attraction immediately impresses with its man-made majesty, the secret of which is that the roller coaster housed within the mountain is barely visible from the outside. Baxter's primary objective in designing the ride was to make the rock look like it existed before the rail track was put in place. His success in realizing that vision sets Big Thunder apart from other mine train coasters.

Standing at the foot of the mountain, one can catch only fleeting glimpses of a reckless locomotive careening around one of the mountain's many bends, creating the appearance that the train is actually traveling across a real rock formation. The illusion continues aboard the train itself, where there's far more rock than track to be seen. Passengers are treated to sweeping vistas of intricately striated columns as they barrel in and out of the mountain's caves. Where the track is visible, it's disguised as aged wood set atop the rock surface.

That attention to detail jells superbly with the attraction's mythology. Big Thunder's backstory is never made readily apparent to the railroad traveler and there are numerous differing accounts out there, each with its steadfast adherents. The central gist remains the same in most, however, and it's surprisingly easy to follow, even while holding onto the safety bar for dear life. This is Disney's Gold Rush ride, an homage to an essential part of the American Frontier.

The ride is set in the fictional town of Tumbleweed, established as a gold mining site in the late 1800s. The settlers built a mine

train and enjoyed some success, but unfortunately for them, a Native American curse on the land ensured that the good fortune was short-lived. Tumbleweed was destroyed and the miners haven't been heard from since, save for an elderly rainmaker who still hangs around. Their train track lives on, though. You see, just like that creepy mansion across the Rivers of America, Big Thunder Mountain is haunted by spirits from regions beyond. The Native American curse that caused the settlers' demise also keeps the now-possessed trains racing around the mountain and through the ruins of Tumbleweed. Lucky you, you get to climb aboard for a wild survey of the wilderness.

Populating the landscape are props that bring this narrative to life. Abandoned buildings, old equipment, and animal bones are scattered throughout the mountain. Whether guests know the backstory before boarding the train or not, there are enough visual cues to inform them that there is a definite theme to the environment they've entered. The beautiful design of the attraction and Disney's faithful adherence to a solidly developed story work together to create a very organic experience.

In the fall of 2012, Disney enhanced the ride's narrative with a post on its website, recounting the fictional tale of Barnabus T. Bullion, president of the Big Thunder Mining Company. This newest layer of the ride's mythos posits that the mines we encounter when we board the ride are part of Bullion's ongoing efforts to uncover the mountain's hidden gold, which he believes to be his family's birthright. Unfortunately, Big Thunder's curse keeps getting in his way... but that hasn't stopped him from trying. To contribute to the Bullion tale, the Imagineers created an interactive queue for the ride (still under construction as this book goes to press), which includes, among other things, a portrait of Barnabus Bullion himself. Incidentally, he looks almost exactly like Tony Baxter.

Big Thunder Mountain Railroad is a classic example of Disney magic (that is, attention to detail) at work. Plenty of amusement parks offer a mine train roller coaster but at the Magic Kingdom, guests ride rock rather than steel — or at least, that's how the

story goes. The wonderful thing about Disney is that they make the story so very easy to believe.

The visual richness and believability of the mountain are the attraction's primary appeal. But there's also something intrinsically thrilling in the ride's evocation of lost control. Walt Disney World runs on two things: boats and trains. To enter the Magic Kingdom, you travel on either a monorail train or a ferryboat. The first attraction you pass is the Walt Disney World Railroad. From then on, you'll spend a good part of your day in the park either on water or rail (or both). Walt Disney himself had a lifelong fascination with trains and that interest manifests itself in the theme parks he created. His millions of guests in the years since have been able to relax and enjoy themselves while onboard his trains because they're generally smooth and easygoing. But in the back corner of the Magic Kingdom is Big Thunder Mountain Railroad, an attraction that is all about trains — and premised on the idea that they've gone completely out of control. What could be more delightfully terrifying than a challenge to the very sense of security that gets you through your time in the World?

Above all else, Big Thunder offers a rollicking good time. On the thrill-o-meter, this roller coaster is a relatively tame one. But then, there's no thrill bigger than fun, and the intentionally jostling experience of Big Thunder makes this a ride that even hardcore thrill seekers will have to admit provides ample excitement. A fast-moving expedition that starts up a new hill just when you think you've gone down the final one, Big Thunder is a particularly gratifying attraction. And thanks to Tony Baxter's dedication to making a real mountain out of the thing, it quite literally rocks too.

WATCH THIS – The Apple Dumpling Gang (1975)

While ABC's "Big Thunder Mountain" TV series, inspired by the attraction, is under development for possible production, you can get a taste of the Wild West with Disney's classic live-action comedy, *The Apple Dumpling Gang*. In it, Russel Donavan (Bill Bixby) agrees

to pick up a shipment for an old friend but soon regrets it when the package turns out to be a bundle of three orphans. He reluctantly agrees to care for them until his friend returns, attracting the assistance of the no-nonsense delivery lady, Magnolia (Susan Clark). For some reason, her name amuses Russel, and a strange kind of romance quickly blossoms.

Meanwhile, their town is targeted by a bumbling pair of would-be crooks, Theodore and Amos (Don Knotts and Tim Conway, respectively). The hilariously inept criminals are in search of gold and the kids take an interest in it too. Set in California during the mid-1800s, that makes this a Gold Rush story, and we can describe Big Thunder Mountain Railroad the same way. Both the movie and the ride spend a lot of time inside structurally unsound mines, and the village the children live in bears a striking resemblance to Tumbleweed. The movie even includes a great runaway mine cart scene!

Frontierland Shootin' Arcade

Type: Shooting gallery

Duration: A few minutes per session (play at your own pace)

Popularity/Crowds: Low

FASTPASS: No

Fear Factor: 1 out of 5 (gun play; ghosts)

Wet Factor: None

Preshow: None

Best Time to Visit: Anytime

Special Comments: $1 per session (not included in park admission)

Walt-less Disney has always been a little gun-shy. In the last few decades, for instance, *Melody Time* came to DVD with its shootout segment missing and the Jungle Cruise has seen its skippers' fully functioning guns come and go. Throughout all the trigger trepidation, one bit of armament has held its ground — the Frontierland Shootin' Arcade. One of the rare Disney attractions to charge a small fee on top of admission, it's left off many a vaca-

tioner's itinerary. Tucked between the Diamond Horseshoe Saloon and Country Bear Jamboree, the wooden veranda looks at first glance like a mere sideline diversion, but there's more to this graveyard arcade than you might think.

For starters, a round of target practice there connects us with a surprisingly rich tradition of interactive Disney arcades. Guests visiting Disneyland in 1955 had three arcade options (four if you count the Crystal Arcade, but that's always been just a shop hiding behind the façade of an arcade). Let's take a quick look at those three, only the first of which was ever replicated in Florida.

That was the Main Street Penny Arcade, home to old-timey and inexpensive gaming. When Florida's Magic Kingdom opened in 1971, its Main Street also had a Penny Arcade, but that closed in the spring of 1995 to allow for a larger Emporium. California's Penny Arcade, on the other hand, stands to this day but has evolved into more of a place to shop than play.

In 1955, Disneyland also welcomed the Main Street Shooting Gallery, a small toy-gun firing range, and the Davy Crockett shooting gallery. The Main Street Shooting Gallery lasted until 1962, when it was folded into the Penny Arcade. The Davy Crockett gallery is technically still open, albeit as the all-retail Davy Crockett Pioneer Mercantile, a name it assumed in 1987 after a two-year stint as the Davy Crockett Frontier Arcade. Neither gallery was ever replicated in Florida.

The fourth arcade at Disneyland, The Frontierland Shootin' Gallery, didn't open until 1957. It is the only gun arcade still operating in Disneyland, where it's been known as the Frontierland Shootin' Exposition since 1985. A similar gallery has always been a part of Florida's Magic Kingdom, however, where it's been called the Frontierland Shootin' Arcade from Day One.

A myriad of others have come and gone in the parks through the years. Among them were a Country Bear joint with games custom-made for the show, a pirate-themed shooting arcade with electric guns, and the Jungle Cruise's safari-themed version of the Frontierland gallery. While there are still a few video game par-

lors to be found on both coasts, the Frontierland Shootin' Arcade and its California counterpart are the last remaining vestiges of what were once among Disney's more popular pastimes. For the price of one dollar, guests today get a chance to relive a time when costumed outlaws staged gunfights atop the roofs of Frontierland and guests were so musket crazy that Disney put up nearly as many shooting galleries as food carts. It's a gun blast from the past.

In fact, the attraction is a time machine in more ways than one. Besides looking back into Disney history, the gallery also sets the scene for the Wild, Wild West, making it the perfect primer for Frontierland. The firing range is set against a sprawling desert backdrop, the towering buttes in the horizon instantly reminiscent of Big Thunder Mountain. There's a jailhouse, a shabby bank, and a rickety hotel. This little village in the middle of the arcade is a veritable microcosm of Frontierland itself. It also calls to mind the unforgettable Western scene in The Great Movie Ride at Disney's Hollywood Studios. While small they may be, the tiny boondocks we find here are as authentically detailed as any full-scale Disney environment.

Surrounding the township are also more than a few tombstones. And vultures. And giant spiders. And skeletons pulling themselves out of their sandy graves. Just like any Western village, right? Well, not exactly, but this clearly haunted desert does foreshadow the bedeviled town of Tumbleweed, through which the Big Thunder Mountain Railroad is eternally doomed to travel. There's even a bit of railroad track in the arcade diorama, and the creepy sounds bellowing over the gunfire are quite like Big Thunder's bat, coyote, and storm effects.

As we'll see later, the Tomorrowland Transit Authority Peoplemover is an important but oft-overlooked prelude to Space Mountain. Likewise, the Frontierland Shootin' Arcade provides a very special way for guests to raise the curtain on Frontierland, and on Big Thunder in particular. The attraction welcomes its patrons to this part of the park by throwing them in the middle of the action and tossing them a gun for protection. They'll need it. It's a wild

wilderness out there and a cowboy's gotta know how to handle his pistol. The Frontier's a'crawlin' with bandits and spooks. Here's your training ground — a place to hone your survival skills and fully indulge yourself in the illusion of Frontierland from the get-go. Who says you can't get anything for a dollar?

WATCH THIS - The Adventures of Bullwhip Griffin (1967)

There are probably at least one hundred live-action Disney movies that most people haven't heard of, let alone seen. One of the better ones is *The Adventures of Bullwhip Griffin*, a charming Western featuring a cast of Disney regulars, including Suzanne Pleshette, Roddy McDowall (as Bullwhip), and Hermione Baddeley (*Mary Poppins'* sassy housekeeper, Ellen). Another Gold Rush comedy, this one follows an English butler (McDowall) as he mistakenly finds himself westward bound and in search of gold. He and one of the children in his care manage to get their hands on a treasure map, but when the villainous Judge Higgins (Karl Malden) swipes it, they have to change their itinerary in order to get it back.

Bullwhip Griffin doesn't have as much gunfire in it as, say, the "Pecos Bill" portion of Disney's *Melody Time*, but it does feature some very clever dialogue, including a sharp exchange between Bullwhip and Judge Higgins on the rules of gunmanship. The movie is even more notable, however, for its wonderful Western vibe. This is far more a family adventure story than a traditional Western film, but just as the Shootin' Arcade serves as an ideal overview for all of Frontierland, *Bullwhip Griffin* beautifully illustrates the area's atmosphere.

Splash Mountain

Type: Log flume ride

Duration: 10 to 11 minutes

Height Restriction: 40 inches or taller (adult riders can switch off)

Popularity/Crowds: E-ticket

FASTPASS: Yes

Fear Factor: 4 out of 5 (steep drops; tall heights; deliberate suspense)

Wet Factor: 4 out of 5 (most riders get a little wet; some get soaked)

Preshow: None

Boarding Speed: Moderate to Fast

Best Time to Visit without FASTPASS: Early morning or late night (or during mid-day to cool off, but expect crowds)

Splash Mountain is the world's most popular attraction based on a movie that nobody has seen. The elaborate log flume ride is faithfully inspired by *Song of the South*, Walt Disney's hit 1946 musical that, like any successful and acclaimed film, is kept under lock and key where the public can't find it. There's a politically charged taboo that surrounds the movie. Yet that hasn't kept its thrill-ride representative from being one of Disney's most celebrated attractions. The paradoxical relationship that Splash Mountain shares with the film it's based on is arguably the most interesting facet of the whole experience — but it's one amazing ride, too.

Following two quasi-movies that were produced with educational and promotional aims, *Song of the South* was Walt Disney's first real effort at a full-length live-action film. Released in the fall of 1946, the movie adapts the famous Uncle Remus folk tales popularized by folklorist Joel Chandler Harris,[9] which recount the adventures of Br'er Rabbit and his adversarial briar patch brethren. James Baskett plays the live-action Remus, who introduces animated segments each time he tells a story to young Johnny, played by Bobby Driscoll (the first actor to enter into a long-term contract with Disney, the future voice of Peter Pan, and a tragic case of a child star fading into drug-ridden anonymity).

The film was a box office success and landed two Oscars, including a special award given to James Baskett, making him the first black actor to win an Academy Award. Also starring in the movie is Hattie McDaniel, who just a few years earlier became the first black actress to take home an Oscar, having won the Best

Supporting Actress honor for *Gone with the Wind*. Under normal circumstances, one might expect those milestones to be celebrated today as major accomplishments for black artists at a time when segregation was alive and well (Baskett couldn't attend the world premiere of his own film, held in Jim Crow-era Atlanta). Instead, *Song of the South* is entirely unavailable on U.S. home video and hasn't seen a public release since its 1986 theatrical reissue.

The prohibition on the film is self-imposed by Disney. Despite common parlance, popular belief, and urban legend, the movie isn't "banned." There's no legal action preventing its distribution. Bill Cosby did not buy the rights to block its release. And the NAACP does not officially oppose it today. Then why is this in-demand classic so hard to find? Well, the brouhaha stems from Uncle Remus's portrayal as an indisputably happy guy in the film, brimming with whistling, song-singing cheeriness — all this despite the fact that he's a black man living and working on a white-owned plantation in the American Deep South sometime after the Civil War.[10] While he isn't a slave, he is living in conditions that probably didn't elicit the same gleeful contentment from most who were leading that life.

The controversy has been around as long as the movie itself and while the NAACP registered some criticism about the rose-colored depiction of Remus at the time of the film's release, the organization takes no position on it today. Numerous film critics have called for *Song*'s release, including noted Disney historian Leonard Maltin, but then Roger Ebert (probably the world's most famous film critic) has opined that it should be made available to adult audiences only, given that children are prone to literal readings of stereotypes. In Europe, where the movie has been released on VHS, many who see it are underwhelmed by its relative lack of shock value after their expectations were set so high by the decades of hype — *The Birth of a Nation* this is not. Having been out of the public eye for so long, the prevailing obstacle to a wide release probably has more to do with the *perception* that the movie is offensive as opposed to whether or not the content *actually* is.

(Truth be told, most people today don't have an opinion as to whether it is or isn't, as they haven't been able to see it.) That leaves Disney with a tough choice from a public relations standpoint — release it, hope no one gets too mad, and make some money on the Blu-ray sales, or keep it in the vault while the stigma grows with the passage of time and shareholders complain about lost revenue from shelving an in-demand property. (The company reevaluates its stance every few years, but so far it's opted for the latter position.) Uncle Remus contemplated just such a scenario in *Song of the South*'s famous "tar baby" sequence: a sticky situation that just gets stickier the further in you go. In essence, Disney is battling a tar baby all its own.

The tension surrounding the movie hasn't kept it from living on as one of the company's most valuable properties. Take, for instance, the soundtrack's Oscar-winning number, "Zip-a-Dee-Doo-Dah." There is perhaps no song better known in the whole Disney repertoire, no anthem more quintessential to the Disney legacy. Louis Armstrong, Rosemary Clooney, The Jackson 5, Miley Cyrus, Paula Abdul, and Taylor Swift are among the many who have recorded cover versions. One of the best-known movie songs of all time, it's clearly taken its place in the Great American Songbook. Yet despite knowing the tune by heart, few likely know its origin. The song's source often goes uncredited, as if the composition magically appeared in the Disney songbook one day. In fact, tourists without a sound sense of history are apt to conclude the song comes from Splash Mountain.

That's because Splash Mountain is a rather faithful adaptation of *Song of the South*, incorporating the Br'er characters, the catchy songs, and the memorable stories — everything except Uncle Remus. *South*'s main character and narrator is nowhere to be found in the dips and recesses of the enormous, thorny mountain. Of course, Johnny and all the other live-action characters are missing too. Remus isn't just absent, though; he's *replaced*. In his stead is Br'er Frog, a minor character from the movie who plays a big part in Splash Mountain, where he serves as recurring narrator.

Whether that's a good or bad thing is up for debate, but more interesting than that surface-level question would be a study of what Remus's absence means in Splash Mountain's context as an adaptation of literature.

Many of the same criticisms leveled against Walt's film were leveled against Joel Chandler Harris' original stories too, and today, that written work is often kept as far away from school libraries as Disney keeps the movie from store shelves. Children's literature has historically welcomed racial tensions like those found in Mark Twain's *Adventures of Huckleberry Finn*, but Splash Mountain offers an adaptation of the Uncle Remus stories (traditionally considered works of children's literature) that eliminates their title character and the racist stigma attached to him. What kind of history does the attraction then represent? How does it relate to children's literature and the way new generations of young people should approach it? Is this social responsibility or misleading dilution? In these questions, we find a need for critical thought and study about this important piece of our cultural heritage.[11] That's part of what I love about Splash Mountain — it perfectly illustrates why theme park attractions are as deserving of careful scholarly examination as any other significant cultural artifact. We will return to the relationship of Disney rides to children's literature when we take a look at Fantasyland in a later chapter.

Fortunately, neither familiarity with nor a favorable opinion of *Song of the South* is required to appreciate the grand spectacle that is a ride through Splash Mountain. The attraction first opened in Disneyland in 1989, part of the Eisner/Wells revolution[12] that took the Mouse House to new heights that year. *The Little Mermaid* and *Honey, I Shrunk the Kids* were topping the box office. Walt Disney World dropped the rope on Disney-MGM Studios and Typhoon Lagoon. Disney television had two new hits in "Chip 'n Dale Rescue Rangers" and a "Mickey Mouse Club" relaunch. Their Touchstone[13] subsidiary even had a big success with

Dead Poets Society. Suddenly, Disney was on top of the entertainment game for the first time since Walt's death.

At a reported cost of $75 million, the incredibly expensive Splash Mountain project was the big headline in Disneyland that year. It borrowed Audio-Animatronics from the just-closed America Sings attraction to populate its many scenes. Soon after, in the fall of 1992 (another big year for Disney), slightly different versions opened in both Tokyo Disneyland and Walt Disney World.

The ride is designed with a deliberate fear factor in mind and the psych-out begins before you even get in the line. Splash Mountain is one of the Magic Kingdom's key "weenies," a term applied to massive landmarks that draw big crowds from far away. The Frontierland path leads directly to the foot of the mountain, a journey set to the far-reaching sound of screams as one log full of guests after another drops 52 feet at a 45-degree angle before your very eyes. There's no hint in that spectacle of the epic ten-minute ride that precedes the terrifying plummet, and therein lies the little surprise that makes Splash Mountain the absolute favorite of so many parkgoers.

Before boarding the log that will be our mountain vessel, we wander through a long and winding queue that is appropriately lined with rock and knotted wood, dark corners, and discomforting signs warning of a waterfall ahead. Given the long waits that quickly accumulate at this perennial favorite, the queue is the ideal breeding ground for anxiety. When finally arrived at the loading zone, we find a freshly soaked seat opening up for us and a dark entrance directly ahead. Two questions become of pressing importance at that moment: "How wet will I get?" and "When do I drop?" First-timers have no reason to expect the stomach-turning uncertainty that will prolong the answers to those questions as they are treated to an unforeseen, ride-along narrative.

Disney doesn't cut to the chase, opting instead to take its guests through the trials and tribulations of Br'er Rabbit as he runs from and outwits Br'er Fox and Br'er Bear. The scenes here are length-

ier and more elaborate than anything found in the dark rides of Fantasyland, and the atmosphere is initially marked by levity. Animals laugh and sing along to peppy music that has the whole log toe tapping. Br'er Rabbit cracks wise as his would-be captors fail and Br'er Bear amuses with his propensity for putting his posterior on display. Having seen the big splash that is coming sooner or later, the happiness has a kind of sick irony to it, but the good mood is irresistible. As the ride progresses, it becomes increasingly foreboding. The path takes dips and turns that each look like they must be "the big one" and stomachs are already halfway up nervous guests' throats before they realize a steeper fall awaits them still. Disney makes an art of the classic fake-out. And all the while, you either find yourself getting wetter or casting looks of relief at those around you who didn't share in your narrow escape from a random splash.

As talk about a mysterious and not altogether funny-sounding "laughing place" increases, the music takes an eerie turn. The click-clack of an inclined track can be heard in the distance. Thunder booms above. At last, vultures appear (yes, vultures — Disney really goes for the gut). In a sinister voice, they advise you to turn around. The joke's on you, I'm afraid, because you can't. That must be why they call this "the laughing place" but, as the vultures are only too happy to point out, you aren't laughing anymore. As your log makes the slow climb to the tip-top of the mountain, you're treated to just a moment's pause in which you can take in the thick and thorny briar patch that awaits you below — far below — and the absence of any steadily declining ramp to get you there. And then, at long last, just as you're praying it won't, the log drops. Fast. With you in it.

Splash Mountain absolutely revels in suspense. On the one hand, the whole experience is a series of teases. On the other, it's an epic three-dimensional incarnation of truly entertaining stories. On both counts, chances are good that you'll end up wet and delighted at the end. But just as there was more to the attraction's beginning than met the eye, there's more to its ending than an-

ticipated, too. It just so happens that the grand finale is not the plunge, but a grand pageant of Animatronic animals making a gospel revival out of "Zip-a-Dee-Doo-Dah." The uplifting finish serves as soothing relief to jangled nerves still aflutter from the hyped-up drop.

After emerging from the log and seeing apprehensive guests on the other side eye your drenched T-shirt nervously as they sit down for their first ride, it becomes easy to appreciate the grandeur of what you've just experienced. This is Disney showmanship at its very finest. Like its signature song says, the attraction provides a "wonderful feeling" for a "wonderful day." That's when you realize that you found your laughing place inside the mountain after all — and you can't wait to go back.

WATCH THIS - Mary Poppins (1964)

Mary Poppins isn't the first movie that comes to mind when you ride Splash Mountain, but Walt's most enduring live-action classic has a lot in common with *Song of the South*. Uncle Remus's role in his movie is not unlike Mary Poppins' in hers. Both are mysterious guardian types who tend to make the best of a child's despair, and they share an uncanny ability to summon animation out of live-action's thin air. While Disney keeps *Song of the South* in the farthest corner of their vault for the time being, simply understanding the Mary Poppins character can at least help modern audiences appreciate Uncle Remus's value to the story.

We might also compare Splash Mountain itself to *Mary Poppins*. Just as the latter is the benchmark of Disney filmmaking, Splash Mountain is a standard against which all other theme park rides can be compared. Both show us that Disney's creative teams know how to leave a lasting impact.

Tom Sawyer Island

Type: Walk-through exhibit

Duration: Unlimited

Popularity/Crowds: Low, but the rafts have very limited capacity

FASTPASS: No

Fear Factor: 1.5 out of 5 (optional dark caves; optional gun play)

Wet Factor: None

Preshow: None

Boarding Speed: Slow due to limited raft capacity

Best Time to Visit: Anytime, but the island closes by dusk

Special Comments: Plan on a bare minimum of 20 minutes to get there, see it, and travel back (30 to 40 or more if you really want to explore)

Tom Sawyer Island is marketed as a place to kick back and put up your feet. If you happen to visit Walt Disney World in the dead of winter, that might not be a bad idea. During the rest of the year, relaxation is the last thing you'll find there. Sure, you'll be putting your feet up — onto stairs, bridges, and hills. Hoping to settle down in a rocking chair? You'll have to beat the crowd to snag one of the very few available on the island, though there are plenty of rocks for you to walk across if you don't. Looking for shade? Crawl inside a dark cave and it's all yours! Just beware the droppings of children who mistook the space for a bathroom (no kidding).

Truth be told, there's a lot to get out of Tom Sawyer Island. Good ole "R&R" just isn't part of the package. That's because the island, billed as an attraction, boils down to a playground. Being part of Disney, of course, it's a vast and elaborate playground themed to a great work of literature — but far from a haven for relaxation, it's probably the most exhausting experience in the whole resort.

For starters, the entire attraction is outdoors. For those who struggled in Geography and need a refresher, Florida is hot. And humid. Tom Sawyer Island also happens to be... an *island*, which means (again for those geography dunces) it's surrounded by wa-

ter, which doesn't help the whole humidity thing one bit. It's fair to say, then, that the place is pretty stuffy for most of the year. The only way to get there is on a log raft, the line for which forms in Frontierland and stays put until the next raft moseys back to the shore. On crowded days, you could put a dent in *The Adventures of Tom Sawyer* while waiting. When the raft finally arrives, you'll be packed onboard nice and tight as one island seeker after another follows. With the sun beating down, you'll wonder how it could take so long to travel across the seemingly narrow Rivers of America that separate the attraction from the rest of the park.

Once there, you'll have the whole island to yourself (well, you and everyone else). You can travel its great length by crossing rope bridges, climbing stairs, and tunneling through caves until you reach a two-story gun outpost at the end. There *is* the scenic Aunt Polly's Dockside Inn, a covered spot for ice cream and apple pie with a stunning view of Haunted Mansion across the water. In theory, parents could relax there while their kids romp about, but the restaurant is rarely open and Tom Sawyer Island is simply too big to let children wander far out of sight. In short, the attraction is best visited in the morning hours (nighttime won't do, as safety requires the island to close at dusk). Then, with the right expectations in mind — that is, either ice cream or exploration and not relaxation — the grounds actually offer a rewarding escape into a fully realized literary universe.

Disneyland's island was in place at the park in 1955 but it wasn't open to guests until officially debuting as Tom Sawyer Island in 1956. Likewise, the Magic Kingdom's version was there in 1971 but rafts didn't run to it until 1973. The islands at both parks are substantially similar. Disney World originally named its pioneer outpost Fort Sam Clemens in honor of Mark Twain's real name, while Disneyland's was simply titled Fort Wilderness. After the box office success of *Tom and Huck* (1995), the Magic Kingdom in 1997 redubbed its outpost Fort Langhorne, which appears in the movie and was inspired by Twain's actual middle name. Disneyland's Fort Wilderness was demolished in 2007 and the island

there largely abandoned its Tom Sawyer theme for a *Pirates of the Caribbean* overlay. That makes Florida's Magic Kingdom and Tokyo Disneyland the only two parks to retain a true Sawyer Island (Paris and Hong Kong have radically different themes for theirs).

The attraction is right at home in Frontierland, one of three Magic Kingdom sections set in historic United States of America. The inspiration here comes from Mark Twain's *The Adventures of Tom Sawyer*, one of the most enduring American adventure stories every written. Twain's sequel, *The Adventures of Huckleberry Finn*, is widely accepted as a "Great American Novel," a work so influential (and controversial) that it birthed a national literary identity. That such a cornerstone of Americana would get a big plot of land all its own inside this recreation of The American Frontier is fitting. It's also surprising. While most Disney attractions are either original creations or inspired by the studio's own films, Disney didn't attempt a movie adaptation of Twain's most famous adventure stories until 1993's *The Adventures of Huck Finn*; Tom Sawyer wasn't tapped until 1995's *Tom and Huck* — both of them made long after Tom Sawyer Island had already opened in three Disney parks. Like Abraham Lincoln and Charlie Chaplin, though, Mark Twain was a personal hero for Walt Disney. The real surprise isn't that Walt wanted a Tom Sawyer attraction in his parks, but that he didn't make a major motion picture to go along with it.

Tom Sawyer is one of the more famous fictional explorers, his adventuring carried out along the mid-1800s Mississippi River in St. Petersburg, Missouri. The attraction honors that spirit of adventure and wide-eyed wonder, wherein one finds the magic in this woodsy excursion. Walt Disney World is generally a rigidly controlled environment. Guests walk along the paths paved for them, go in and out the doors they are directed to, and wait for a cast member's okay to board the next ride vehicle. Tom Sawyer Island is a fascinating exception to those rules. While you can rest assured you won't find anything on the island that you aren't meant to find (notwithstanding the aforementioned child poo), the direction and duration of your visit is entirely up to you. Any

number of paths will take you from the front of the island to the back and you can even jump from one trail to the next along the way. In fact, if you want to see everything the island has to offer, you'll have to, and you'll need to devote plenty of time to doing so. Without a map to guide you, it's easy to get lost and if you find yourself moving in circles, you won't be the first. Caves, buildings, and an occasional homage to the source material are hidden around rocky bends and many doors actually open and invite you inside.

That sprawling and intricate design creates an irresistible invitation to exploration, a delightful contrast to the otherwise prescribed nature of your vacation. You're not just exploring any old island, either — you're exploring a familiar and beloved storybook world brought to life. There's nothing more gratifying to a Mark Twain fan than walking down a path along the river and stumbling upon a half-painted fence, a nod to one of Sawyer's more entertaining scams.

The invitation to look around also makes this one of Disney's most interactive creations. The island offers no shortage of hands-on opportunities. Fort Langhorn is a particularly engaging area. Guests can climb stairs to pick their favorite view of the island itself, as well as of Big Thunder Mountain across the river. Inside the outlook are guns that actually fire audible blanks, a real treat for kids and excitable adults alike. There's even a secret passageway!

Tom Sawyer Island is a unique treasure of the Magic Kingdom. Like any great book, it requires a time commitment and an open and alert mind to appreciate it. With your sleeves rolled up and breathing room in your touring schedule, you'll find it's surprisingly fulfilling. Just make sure you get there before the sun hits its peak.

WATCH THIS - Tom Sawyer (1973)

Disney's *Tom and Huck* might be the most exciting adaptation of Twain's *Tom Sawyer* ever put on film, but there's an older movie that's even more in touch with Tom Sawyer Island. 1973's Oscar-nominated musical, *Tom Sawyer*, was produced by Reader's Digest, distributed by United Artists, and brought to home video by MGM. That's a lot of companies for one movie and you'll note that Disney isn't one of them.

With nine songs and a screenplay all written by the legendary Disney songwriting team, the Sherman Brothers, the movie sure feels like a Disney production, even if it isn't one. The cast also features a host of Disney film veterans, assembled alongside a young Jodie Foster and Johnny Whitaker ("Family Affair") in the lead. Music phenom John Williams collaborated with the Shermans on the film score, paving the way to an Oscar nomination and a Golden Globe award. I could throw even more big names your way, but the movie's stunning assemblage of talent isn't even the most important reason to see it.

The adventuresome film sets are positively bursting with Frontierland atmosphere. The movie really plays up a number of the story scenes emphasized on Tom Sawyer Island and there are times when you'd swear it was filmed inside the Magic Kingdom — especially when a big white riverboat goes swimming by Huck Finn's fort. If that's not enough of a connection for you, consider the timing as well. *Tom Sawyer* hit theaters less than two months before Tom Sawyer Island opened in the Magic Kingdom. The movie is a contemporaneous take on Twain's tale in 1970s style. Indeed, it's entirely possible that some guests saw the movie in theaters and attended Tom Sawyer Island's grand opening on the very same day.

Chapter 3

Liberty Square

"Past this gateway stirs a new nation waiting to be born. Thirteen separate colonies have banded together to declare their independence from the bonds of tyranny. It is a time when silversmiths put away their tools and march to the drums of a revolution, a time when gentlemen planters leave their farms to become generals, a time when tradesmen leave the safety of home to become heroes. Welcome to Liberty Square!"

Plaque at Liberty Square

Unlike the other five lands in Magic Kingdom, Liberty Square is exclusive to Walt Disney World. Because it wasn't included in Disneyland, Walt obviously didn't prepare a dedication for this area as he did with the others. No matter... the Imagineers created the above inscription themselves and engraved it on a plaque at the brick-paved entrance to Liberty Square.

Liberty Square and Frontierland are really one in the same. Disney counts them as separate entities and to be sure, each exhibits a distinctive ambiance. There is a reason, however, that the two lands sit side by side. They are bound together by history, and determining just where one ends and the next begins can be a challenge if we're to accept that each of the Magic Kingdom's six lands is a world unto itself.

To walk from the beginning of Liberty Square to the end of Frontierland[1] is to take a linear stroll through American history. Guests crossing the bridge from the Cinderella Castle hub into Liberty Square enter Colonial America, just on the cusp of the Revolution. The house number on each building is said to coincide with the year of its construction, signaling the passage of time through the Declaration of Independence, the war, the Articles of Confederation, and finally, the Constitution. The guests' next steps take them into the next chapter of history, The American Frontier. The dating of buildings continues in Frontierland, beginning in the early 1800s and moving through the nineteenth century.

More of an intersection than a square, the Magic Kingdom's smallest area is nevertheless as detailed in its theme as any other. You'll find colonially garbed cast members wearing tricorn hats and bonnets. Replicas of the Liberty Bell and the Liberty Tree serve as centerpieces, and not far from them are the stocks, where you can be locked up and humiliated for taking flash pictures on that ride when they *told* you not to (just kidding).

Liberty Square has a distinct and delicious personality all its own... and I do mean literally delicious, provided you pay Ichabod Crane a visit and scarf down a warm funnel cake or waffle sandwich from Sleepy Hollow Refreshments. There are only three attractions here, but each is unique and especially fascinating — Liberty Square Riverboat, The Hall of Presidents, and Haunted Mansion. When you're not experiencing those, you'll hear the music of fifes and drums and feel like you're on the brink of battles for freedom, as though Paul Revere might come riding through at any time. Indeed, his "two if by sea" lamps are hanging in one of the windows. You've come by land, though, because that's the only way to get to Liberty Square, and that fact is of some importance to our first attraction here...

Liberty Square Riverboat

Type: Boat ride

Duration: 16 to 18 minutes

Popularity/Crowds: Low

FASTPASS: No

Fear Factor: None

Wet Factor: None

Preshow: None

Boarding Speed: Boards quickly, but only once every 30 minutes (usually on the half-hour and hour)

Best Time to Visit: Anytime, but the boat sometimes closes at dusk

The Liberty Square Riverboat provides the perfect illustration of the identity crisis between Liberty Square and Frontierland; in fact, this waterborne attraction is its primary cause. The border between the two is very much an open one and the Liberty Square Riverboat crosses it freely.

The beautiful triple-decker paddle steamer, the *Liberty Belle*, travels the Rivers of America, a body of water encircling Tom Sawyer Island. Guests roam as they wish about the slow-moving ship while the voice of Mark Twain narrates the journey. Highlights include hard-to-come-by views of Big Thunder Mountain Railroad, Haunted Mansion, and the island itself. There's not much here you can't get from a walk through Frontierland and a half-hour on Tom Sawyer Island, but the photo-ops and serenity the ride can provide on a nice day make it well worth the trip. There are also some sights that are visible only from the River-boat and the Walt Disney World Railroad — frontier settlers' cabins, grazing Animatronic animals, and a Native American village, for example.

If that description sounds a lot like the Old West, you won't be surprised to learn that the "Liberty Square" Riverboat actually has its origins in Frontierland. Disneyland had something just like it in 1955 — the Mark Twain Steamboat — and it's still there.

That one circles Tom Sawyer Island along the Rivers of America, too, but it's officially a Frontierland attraction — there is no Liberty Square in Disneyland.

The Magic Kingdom counterpart opened on the park's second day and was a Liberty Square attraction from the get-go. The original riverboat was named the *Admiral Joe Fowler*. That was later replaced by a second boat, the *Richard F. Irvine*, which actually ran alongside the *Fowler* for several years before the attraction returned to a one-ship operation in 1980. The *Irvine* is still sailing today, though Disney rechristened it *The Liberty Belle* in 1996, as if to say, "See, this does belong in Liberty Square — just look at the name!" So as it stands now, the Liberty Square Riverboat is the attraction that hosts the *Liberty Belle* paddle steamer, which has its entrance in Liberty Square even though its themes have little to do with "liberty."

In fact, paddle steamers were icons of Mississippi River travel in the nineteenth century and the Mark Twain narration puts us smack-dab in the middle of the 1800s. So why is the *Belle* a part of Liberty Square? The most honest answer is probably that without it, the land would have only two attractions, one of which has little to do with liberty *or* the Revolution — but more on that later. Disney, it seems, holds its parks to the equivalent of that old grammar standard that says any paragraph must have at least three sentences. Two attractions do not a "land" make; there must be at least three.

The better question is does it matter whether the *Belle* belongs in Liberty Square or not? The best answer is probably "no." After all, as already noted, Frontierland and Liberty Square are really one in the same and the border separating the two (which happens to lie fairly close to the Riverboat) is an ambiguous one. We could even argue that the attraction quite appropriately embarks in Liberty Square and sails into the future. Steamboats were around in the late eighteenth century, even though we don't associate them with that era now, so it isn't really improbable that we board our cruise at the very beginning of Constitutional America. That

reading does require us to ignore the fact that the ride ultimately drops us right back off in Liberty Square, but then life's about the journey and not the destination, right?

Whether you like the attraction where it is or not, it certainly presents an interesting case study for the narrative hodgepodge that is intrinsic to the Magic Kingdom. The park aims to bring historical fact and fantastical fiction equally to life within the same experience. By popular consensus, it succeeds. The resort's success comes from its storytelling but unlike the source fables it adapts, the stories here zig and zag from one time period and plot line to another. The favorable response to this jumbled presentation surely says something about how different cultural narratives work together to create our American identity. Narratives of patriotism, national history, and exploring new territory can coexist for us in a theme park because they coexist for us in our cultural subconscious. We embrace the idea that exploration (one might even say conquest) is patriotic because our nation was founded upon it. So the whole idea of receiving a history lesson as we move from a tribute to our nation's founding into a tribute to our nation's expansion doesn't seem particularly weird.

It can be argued that this interwoven experience is "postmodern." If the murky and contested idea of postmodernism is essentially about genre-bending, blended narratives, and disrupted continuity, then Walt Disney World is about as postmodern as you can get. And if you buy into the academic argument that we live in a "postmodern era," those very qualities might explain why Walt Disney World continues to resonate with millions of people each year — it's a form of entertainment that appeals to our disjointed sensibilities.

On the other hand, postmodernism is also supposed to challenge the basic idea of historical truth and, on that score, the Magic Kingdom begs to differ. As jumbled as its stories and lands may be, the park holds fast to historical orthodoxy and stands in proud and patriotic defense of its reverent vision of America. Depending on your own sentiments, that perspective might strike

you as either idealized or dead-on accurate, but the park seems to sincerely do its best to present its viewpoint without offense.

If you're able to set such academic quibbles aside long enough to enjoy a 15-minute boat ride (and I suspect that you are), you'll find plenty else onboard to stimulate you. The *Belle*'s charm stems from many of the same attributes that bring Tom Sawyer Island to life. Like that sprawling playground of adventure, this attraction invites guests to explore. The freedom to move about the vessel, discover almost-hidden compartments, and get a bird's-eye view of the massive paddle wheel at the stern makes for entertainment all its own. The ship appears remarkably authentic, having all the outward markings of the real deal. Most guests likely exit still believing the boat is free-floating, self-propelled, and manually steered. They're partly right — the *Belle* is a fully functioning steam-powered vessel — but it moves along an underwater track and therefore isn't actually piloted by the captain.

Seating is hard to come by on the Riverboat, but even without it, the experience is a relaxing one. That's doubly true if you catch a cool breeze while you're aboard. Here guests can find the quick refuge from hustle and bustle that they might have mistakenly hoped to discover on Tom Sawyer Island. Just know that if you plan to keep an eye open for the way Frontierland intermingles with Liberty Square, your mind won't get as big a break as your body.

WATCH THIS – A Kid in King Arthur's Court (1995)

This is the second of Disney's three feature-length adaptations of Mark Twain's *A Connecticut Yankee in King Arthur's Court*, following 1979's *Unidentified Flying Oddball*. (We'll discuss the third, 1998's *A Knight in Camelot*, in *Chapter Four*.) Awkward teen Calvin Fuller (Thomas Ian Nicholas) is playing baseball in 1995 when an earthquake hits and he falls through the middle of the Earth, suddenly finding himself thrust into Camelot during the days of King Arthur and his round table. Dazzled by Calvin's portable CD player and

other modern gadgetry, the locals are soon convinced that he's a wizard of great power.

This very fun (and admittedly dated) movie doesn't exactly have a Liberty Square tone to it, but the collision of timelines and national origins mirror to some extent the tensions we find aboard *The Liberty Belle*. The movie also marks just one of many intersections between the Disney legacy and that of the ride's supposed narrator, Mark Twain.

The Hall of Presidents

Type: Theater show

Duration: 23 minutes

Popularity/Crowds: Moderate

FASTPASS: No

Fear Factor: None

Wet Factor: None

Preshow: None

Best Time to Visit: Anytime

Special Comments: Giant theater usually means long lines aren't an issue

Deep inside Liberty Square, there is a sprawling chamber haunted by the ghosts of dead men. Their voices call out from the grave to remind us of their stories. Never resting, they constantly search among the living for a new soul to join them. Every four to eight years, they find one. If you think I'm talking about the ghouls living inside Haunted Mansion, think again. These illustrious spirits (and their surviving successors) hail from the White House. I'm talking, of course, about the Presidents of the United States.

The Hall of Presidents has been a part of the Magic Kingdom — and *only* the Magic Kingdom — since its very beginning. In it, guests are given an overview of American history, from the Revolution to the present day. The prelude is a feature film, presented in widescreen *so* wide that the canvas actually gets *wider* as the na-

tion expands. Once the lineage of presidential power catches up to modern times, the curtain rises to reveal the 43 Presidents[2] themselves, poised with pride before guests' very eyes. Blinking, breathing, and occasionally speaking, these men each nod in turn, greeting guests when their name is called. Washington and Lincoln even give stirring speeches from beyond death's door, followed by a rousing statement from our current leader in the finale.

Walt Disney had originally planned a very similar attraction for Disneyland, where "Liberty Street" was to open as an offshoot of Main Street and run parallel to it, ending in Liberty Square (later renamed Edison Square in light of a new focus on innovation). Walt's plans were partly inspired by his studio's 1957 feature film, *Johnny Tremain*, in which his daughter had a small role. He wanted Liberty Street to recreate Revolutionary life, as the movie had done, in the hope of reconnecting his guests with the national heritage he feared they'd forgotten. He made a lot of progress toward opening Liberty Street, readying a number of replicas and even advertising his plans for a 1958 debut. But the project never really got off the ground.

One of the key reasons for Liberty Street's cancellation was insufficient technology for what Walt hoped would be its signature attraction — One Nation Under God. In it, life-sized replicas of the U.S. Presidents (there had been only 33 of them then, counting Cleveland just once) would move and talk for the audience. At the time, however, Disney's Audio-Animatronics technology was in its infancy and there didn't seem to be any practical way to achieve the effect with mere wax dummies. Unsatisfied with the tools available to them, Walt and his team put the whole project on hold until they could create what they wanted... and so work began on what would become Imagineering's first Audio-Animatronics humanoid — President Abraham Lincoln.

Walt had always felt a great personal fondness for Lincoln and often spoke of his admiration for him. Along with Charlie Chaplin and Mark Twain, Lincoln was one of the great heroes of history for Walt. Indeed, Walt was absolutely in love with his country

and the story of its birth and development. He was a noted patriot who devoted much of his career in entertainment to national service, ultimately earning the Congressional Gold Medal in 1968 for his efforts.

Walt once said, "If you could see close in my eyes, the American flag is waving in both of them, and up my spine is growing this red, white, and blue stripe." That deep respect for the United States, and for the might of history, is evident in much of what he created in his parks and films, which are often underpinned with his personal patriotic sentiments. He considered Abraham Lincoln an embodiment of the influence and independence that make America great. So even though One Nation Under God was originally scripted with George Washington in the spotlight, Lincoln was the logical choice for Walt's first Animatronic model of a human being.

The technology the Imagineers were developing for Lincoln was so advanced that it merited a special exhibition all its own. When the time came for the State of Illinois to host a pavilion at the 1964 New York World's Fair, in which Disney was already heavily involved as a creator, there was no better fit than Walt's tribute to President Lincoln, an Illinois native. The World's Fair that year was dedicated to "peace through understanding" and went down in history as a showcase for emerging technology. The Lincoln show served both those themes, its speech an eloquent meditation on liberty and its presentation of the former President so believable that audiences were reportedly convinced it was an actual actor on stage. Like Walt's other attractions at the Fair, the Illinois exhibit was a smash success, warranting its import into Disneyland the following year.

That show became the famous Great Moments with Mr. Lincoln attraction, operating to this day on Disneyland's Main Street, not far from what would have been the Liberty Street intersection. However, the time wasn't right for a full-fledged "Liberty" area inside Disneyland. With the new "Florida project" well underway, those plans were moved to Walt Disney World instead. By

the late 1960s, more than a decade after Liberty Street was to have opened, Disney finally had the technology it needed to bring One Nation Under God to life. The show, renamed The Hall of Presidents, opened in the Magic Kingdom in 1971, one of the park's 23 original attractions.

The Hall of Presidents had the same basic structure then that it has today: a film was followed by the Presidential roll call, which ended with then-President Richard Nixon. At the time, Lincoln was the only President given his own speech, largely a mirror of the Great Moments dissertation. Ford, Carter, Reagan, and Bush were added in turn, their Animatronic likenesses joining the stage crowd upon each new President's election. When Bill Clinton took office, the attraction underwent its first major overhaul, introducing a new script narrated by Maya Angelou and an additional show component, the incumbent President's address. Clinton therefore became the first of America's leaders to record his own speech for the attraction, a tradition that continued with George W. Bush and now Barack Obama.

Think about that — so important has Walt Disney World become to our national consciousness that one of the earliest acts a new President must undertake is recording his Hall of Presidents address. The speech will be one of his first as President and is likely to become one of the most frequently heard, a fact that illustrates the degree of influence Disney wields in the national dialogue.

The Hall of Presidents underwent its second major rewrite following the election of Barack Obama. In addition to a seriously spruced up audio/video system, the attraction introduced a brand-new feature film, narrated by Morgan Freeman and refocused to emphasize populism and the American everyman. A third speech was also added, this one given to George Washington, the President whom Walt had originally intended to be the lone orator.

Lincoln's remarks come in the middle of the movie. Instead of the original speeches previously written for him, he now recites the Gettysburg Address verbatim. His delivery of that speech comes on the heels of an enthralling, on-screen portrayal of the

Battle of Gettysburg. The juxtaposition puts Lincoln's address, one of the most famous ever given, into its gripping context. Obama's speech is also notable because it is the attraction's first to include the Oath of Office — without, of course, the famous flub on Inauguration Day.[3]

Today, the stage is occupied by 43 of the most important people who ever lived — ten more than had held the office when Walt first designed the attraction. Their assemblage is a stunning sight that almost always elicits an audible gasp from the audience when the curtain is raised. In that moment, the show brings new meaning to the idea of "living history."

But gasps aren't the only things you'll hear from the audience inside The Hall of Presidents. There's also plenty of cheering, booing, scoffing, and snoring. That's because the attraction is in many ways a reflection of the political process — engaging, divisive, and occasionally tiring.

Disney has gone to great lengths to be nonpartisan in its presentation but that doesn't change the ideological baggage that informed citizens bring with them. Guests know that politics and history are the subject matter at hand and, accordingly, many feel a heightened sensitivity about their political values even before the show begins.

There's a distinctly inspirational tone in Morgan Freeman's voice and the script he reads is a particularly sentimental one. By the time the Presidents take the stage, the audience members — especially those who are U.S. citizens and politically inclined — are swept up in feelings of pride and conviction as the roll call begins. The room remains fairly tranquil, even reverential, while the first three dozen names (give or take a few) are called. At some point, though — and it's usually right around Richard Nixon — there's an unmistakable change in the atmosphere, as if you could hear the sound of several hundred people's facial muscles scrunching into either a smile or a frown.

By the time Ronald Reagan is named, someone in the audience has usually made some kind of audible noise. And everyone else in

the audience has noticed. And a few of them have reacted. For every Republican who cheers for Reagan, a Democrat defiantly cheers for Clinton, prompting a mix of booing and applause for George W. Bush and another round of the same for Obama. Murmuring begins and it's not until the speeches drown them out that order is restored.

Despite the politically charged atmosphere in which the country currently conducts its discourse, The Hall of Presidents audience manages to keep its cool, that brief battle of boos and bravos notwithstanding. That's probably a credit to Disney's ability to more or less remain neutral in spite of the fragile topic. When the show closed for the addition of President Obama's Animatronic, some speculated that it would be changed to remove all of the Presidential speeches and the audience's outspokenness along with them. Fortunately, that didn't happen.

The Hall of Presidents is the one part of the Magic Kingdom that doesn't transport guests away from reality, at least not completely. The attraction serves as Walt Disney World's town hall meeting, a quintessential function of democratic self-governance. How appropriate that such a convention unfolds inside Liberty Square, a land dedicated to the early, small-town exercise of American freedom. By confronting their own political identities and the opposing stances of those sharing the same room, guests play an important role in Liberty Square's story: that of the concerned townsperson. Inside the theater, they're given a chance to take a side when the emotional stakes are high, just as the folks living in the late eighteenth century might have done.

Of course, just like the real members of our Congress, people can choose to take a nap during the proceedings — and more than a few do. Hey, it's dark inside. The Presidents understand, right? Well, I doubt they notice... but try to see the show when you're alert enough to stay awake.

This is Revolutionary democracy in action, after all. As the heart of Liberty Square, the attraction is a glimmering example of a Disney illusion made real — in a way, guests become citizens of

Liberty Square's fictional colonial town by taking an interest in its affairs. Sure, the present-day issues may be the ones stirring their passions, but the themes of discourse and free assembly are universal and span the centuries.

The Hall of Presidents, and all of Liberty Square along with it, abounds with First Amendment optimism. This is the very thing Walt wanted out of One Nation Under God — a way to reconnect his guests with their heritage. Thinking about his original plans for the attraction calls to mind yet another great speech — not from a President, but the one Walt himself gave on Disneyland's opening day. In it, he dedicated his park "to the ideals, the dreams, and the hard facts that have created America." The Hall of Presidents consecrates those very ideals, dreams, and hard facts within the Magic Kingdom, ensuring that the park continues its creator's vision and works toward achieving his goals.

WATCH THIS – The One and Only, Genuine, Original Family Band (1968)

Set during the 1888 U.S. Presidential Election, this Sherman Brothers musical is probably Disney's most political movie, but also one of its lightest and most charming. The eponymous family is mostly made up of hardcore Democrats and supporters of President Grover Cleveland, currently seeking reelection. When they move to the Dakota Territory, they spar with the largely Republican populace, which hopes to see the territory admitted as two separate states — North Dakota and South Dakota — so that they can send four Republican Senators to Congress instead of just two.

Among the many great songs in this movie are two of Disney's more popular numbers, "'Bout Time" and "Ten Feet off the Ground," both famously covered by Louis Armstrong. The cast is one of film history's most interesting. In a very small role, Goldie Hawn makes her film debut here as a young girl, starring alongside a boy who would grow up to be the father of her children, Kurt Russell. The movie is

also the second theatrical outing for both Lesley Ann Warren and John Davidson, who had made their film debuts one year earlier in Disney's *The Happiest Millionaire*. They played one another's love interest in both films before going on to enjoy long and vibrant entertainment careers. The all-star cast also includes legendary actors Walter Brennan and Buddy Ebsen, who both worked on other high-profile Disney projects during their careers.

The movie's political bantering does start to get a mite tedious before it ends, but the town square discourse and the rarely explored historical setting make the film extremely interesting, even unique. The local fervor for the political process depicted so memorably in the movie is the atmosphere conjured up by The Hall of Presidents.

Haunted Mansion

Type: Dark ride

Duration: 9 minutes

Popularity/Crowds: Moderate to High

FASTPASS: At press time, no. However, Haunted Mansion has offered FASTPASS at times in the past and may again in the future.

Fear Factor: 2.5 out of 5 (darkness; spooky effects; some dramatic intensity)

Wet Factor: None

Preshow: The graveyard queue acts as a sort of preshow (guests may bypass the graveyard and use a shorter queue instead); additionally, all guests proceed on foot through foyer and elevator scenes before boarding the ride vehicles

Boarding Speed: Very fast

Best Time to Visit without FASTPASS: Anytime, but come back later if you find it very crowded

Special Comments: One of the best, yet least scary, haunted houses you'll find

There's a perverse joy we find in scaring ourselves and theme parks specialize in the kind of fear that puts a smile on your face. You need look no further than the top of an impending roller coaster plunge to find pearly whites on wide display. If you've ever exchanged gleefully nervous looks with a friend in the moments

before some serious G-force comes your way, you know just the kind of smile I'm talking about. Disney calls this involuntary response "grim grinning," a term the park applies to the 999 ghosts dwelling inside Haunted Mansion. Like the best roller coasters, the Magic Kingdom's slow-paced open house tour through the lifestyles of the rich and departed also plays on that sick satisfaction of foreboding. In Haunted Mansion, however, the thrills come not from plummets, but from poltergeists.

The Mansion tour begins inside a doorless chamber, where pale-faced ushers herd us into the "dead center" of the room. Standing inside that small space with seemingly no way out, claustrophobia might start creeping in. Before that happens, the enclosure suddenly starts to grow. While the bone-chilling voice of Disney legend Paul Frees[4] delivers an unforgettable welcoming speech to his helpless guests ("Your cadaverous pallor betrays an aura of foreboding" might be the best sentence ever constructed), the room actually begins to expand as the portraits on the wall crawl toward the ceiling, revealing a surprising bottom half to each painting and a lot more wall than there seemed to be before. As the self-appointed Ghost Host, Frees mocks his mortal prisoners. "It's almost as though you sense a disquieting metamorphosis," he says, and then asks tauntingly, "Is this room actually stretching or is it your imagination?"

When the chamber comes to a halt, the host shows the captives exactly how he crossed over to his ghostly state. The lights go out and high above us, we see a hanging corpse and hear a blood-curdling scream. When the lights return, the once impenetrable walls have given way to a long hallway, at the end of which ever-moving "Doom Buggies" are ready for our reluctant boarding.

That lengthy proceeding is but the introduction to Haunted Mansion, one of Walt Disney World's most successful attractions, and at times, one of the grimmest. Frees' morbid narration, the sense of helplessness guests experience, and the gruesome display in the rafters all add up to one of the darkest sequences in the usually cheery Magic Kingdom. The ride that follows is considerably

less morose. In fact, the show becomes much more a comedy than a horror as the tone grows increasingly playful and the spirits are sent up for laughs.

That friction between haunt and hilarity was born of an underlying tension between the two men heading up the ride's design. Background painter and concept artist Claude Coats[5] wanted to stage a downright scary show, while classic Disney character guy Marc Davis[6] wanted to adopt the studio's signature whimsy. In the end, both won out. What had begun in the 1950s as a walking tour and adjacent restaurant slowly grew into an elaborate ride that didn't materialize (no pun intended) until 1969, nearly four years after Walt Disney's death. By the time the Mansion's doors formally opened to Disneyland guests, Imagineering legend X Atencio[7] had masterfully scripted a ride-through show inside that incorporated both Coats's unsettling sense of the supernatural and an abundance of Davis's comic relief. Two years later, Walt Disney World's version opened along with the Magic Kingdom itself on October 1, 1971. Since then, Haunted Mansion has made its way to Tokyo and Paris, too, and is the only Disney attraction to exist in a different themed land within each of those four resorts (plans for Hong Kong Disneyland call for a fifth mansion in yet another land[8]).

In the Magic Kingdom, we find this ride in Liberty Square. The building is arresting both in its ornate beauty and its eerie aura. The gothic architecture is inspired by nineteenth century homes along the Hudson River, which supposedly makes Liberty Square the attraction's ideal setting. While that may be true, there's no getting around the fact that the mansion has very little in common with the appearance of every other building in that land, or that a haunted house bears no immediate relevance to Colonial America. Consider also that while Disneyland built a Southern antebellum manor for its Haunted Mansion in New Orleans Square and Disneyland Paris built an abandoned Old West home for its Frontierland version of the attraction, the Fantasyland man-

sion in Tokyo Disneyland looks exactly the same as the one in Magic Kingdom's Liberty Square.

Thematically, there seems little question that Fantasyland would make a better fit for Haunted Mansion than does its current home, Liberty Square. Hauntings are inherently fantastical and there's a whole lineage of Disney cartoon shorts — like those that have inspired other Fantasyland attractions — that address ghosts with the same levity as Haunted Mansion (see *Lonesome Ghosts* and *The Skeleton Dance* for examples). The attraction's darker elements would also feel right at home in Fantasyland, where edgy entertainment born from the terrifying traditions of children's literature is the order of the day. Why Liberty Square, then? As with the *Liberty Belle*, the answer probably lies in the need for something to go inside Liberty Square. The Imagineers probably figured Haunted Mansion was close enough to fit the bill.

Given that Fantasyland is unlikely to annex the attraction anytime soon, the mansions of the Hudson River will have to suffice as the thematic connection, but that little nugget is not to be dismissed — that Disney cares enough about storytelling to ensure that the ride's placement is credible is what makes the park so stimulating. There might also be something to the notion of housing the Magic Kingdom's most noteworthy nod to the afterlife in an area dedicated to national heritage, given that belief in the supernatural has historically been an integral part of the American experience.

Whether the attraction jells with Liberty Square narratively is hard to say. Touring the mansion, one does get the idea that there's a backstory at play. We see that our Ghost Host hanged himself. Later, we ride by what looks like an abandoned funeral. There are lots of discarded wedding portraits as we enter the attic and, at the tip-top of the house, we find one very violent ghost bride waiting for us to round the corner. Exactly how those pieces fit together is never really made clear, though there have been many attempts to craft a definitive storyline (most involving Mr. Gracey, the appar-

ent master of the home, his young bride, and one of those two killing the other and/or themselves). While X Atencio could have scripted a bit of narration to clear up these details, all we're told instead is that the mansion is now inhabited by 999 ghosts who are looking for one more to join them ("any volunteers?"). In some ways, Haunted Mansion is, like Pirates of the Caribbean, less a navigable story and more a story world. And yet it clearly puts enough plot points in place to suggest that there is one series of events that connects the dots — we, the audience, just don't know what those events were.[9]

Like true explorers, we find only the aftermath when we enter these ruins a century (or more) later, and it's up to our imaginations and powers of observation to figure out exactly what happened. Like the greatest works of art, Haunted Mansion is enduringly ambiguous. The effect of that uncertainty is twofold. First, it generates a need to go back inside again. As with cryptic films and novels, we feel compelled to take another look to see how much more we can figure out, especially since the time-controlled tour allows no more than a fleeting glance at any of the many clues. Second, the mystery produces a fear of the unknown. The suggestion that more has gone on inside the mansion than we understand, things nefarious and otherworldly, creates suspense and uneasiness just as that same device — teasing the audience with the unknown — has in mystery novels for ages.

The theme of paranormal investigation at work in the ride is aided by the lavish and accurate detailing of the building's interior. While the ominous façade visible from Liberty Square has, in actuality, nothing to do with the real building guests ride through once they're inside, the disconnect is never apparent. Indeed, the attraction goes to great lengths to preserve the open house premise of the ride. The Doom Buggies begin their tour by ascending a staircase, then moving through actual hallways while peering down others (including one that never ends). The Buggies wind from room to room, through all the spaces one might expect to find in an extravagant home — a library, a conservatory, a ball-

room, and even a cluttered attic. Along the way, little details like wall paintings (most of them possessed) and pieces of furniture add to the illusion that this is a once-lived-in home.

For the ride's finale, the Doom Buggies enter the graveyard outside the house and the perceptive passenger will note that they actually fly out of a window and descend through the nighttime air to the haunted grounds below, where a recreated exterior of the mansion they've just supposedly exited can be seen behind them.[10] Again, the attention to detail bolsters the idea that the house really might have once been a home for this unfortunate family.

The ride stands out for its special effects, which also add to the believability of the experience and its creep factor. A hovering candelabra, a disembodied head calling out incantations from inside a floating crystal ball, and footsteps that walk in all directions through a seemingly unending series of stairways are all part of the "how'd they do that?" awe that the attraction so skillfully inspires. The latter two effects are the results of recent enhancements to the attraction (following earlier ones at Disneyland) that not only provided a much-needed refurbishment but also enhanced the experience with effects that feel newly state of the art. Haunted Mansion's most remarkable special effect, however, has been part of the attraction since it opened: the dancing apparitions in the ballroom scene that materialize before our very eyes and have the fully animated and transparent appearance of actual ghosts.

The ride's memorable music works both to enhance the chilling mood created by the special effects and to counter it with the light-heartedness that emerges as the attraction's prevailing sentiment. That's thanks to "Grim Grinning Ghosts," the theme song that appears in one form or another throughout most of the ride. Sometimes it's played on a slow and haunting organ, other times it sounds like a merry little jingle with lyrics performed by "happy haunts" and a barbershop quartet.

The term "grim-grinning ghost" originated in Shakespeare's poem *Venus and Adonis*,[11] but the rest of those funny, very clever lyrics were written by none other than X Atencio himself, having

tried his hand at songwriting after Walt Disney encouraged him to do so. Among the voices singing the song is Thurl Ravenscroft[12] (the voice of Kellogg's Tony the Tiger and the deep baritone responsible for "You're a Mean One, Mr. Grinch"), who leads the quartet of singing busts in the graveyard.

But for all its frivolity, Haunted Mansion remains undeniably spooky. If Disney would allow it, I'd challenge those who say otherwise to take a stroll through the mansion alone, on foot, during the night. Perhaps that's why the attraction has fostered zealous fans and a tome's worth of urban legends over the years. You need look no further than online communities like DoomBuggies.com to find evidence that the attraction has taken on an (after)life of its own. Rumors range from wedding rings buried in the cement outside the mansion[13] to the actual ghosts of children whose ashes were spread inside the ride by parents seeking to carry out their last wishes. Search the Internet and you'll find some unsettling night vision photographs.[14]

Haunted Mansion has cultivated a mythos all its own, made possible by the pervasive eeriness that has made it a travel staple for decades. For the skeptics, the ride's ample comedy still infuses it with plenty of charm. Whether they come for the grim or the grinning, first-timers, thrill seekers, and manic Mansion devotees alike keep clamoring for another tour time after time. That's because they know Haunted Mansion will send them out scared — or at least scared silly — and there's nothing more fun than that.

WATCH THIS - Candleshoe (1977)

Naturally, *The Haunted Mansion* (2003) starring Eddie Murphy is a good place to start... or maybe not so good, given its critical reception. It was a modest box office success, however, and in all fairness, what the movie lacks in most other areas, it makes up for (a little) in set design and atmosphere. In 2010, Disney announced that yet another *Haunted Mansion* movie is on the way, this time produced, written, and likely directed by the visually emphatic Guillermo

del Toro (*Pan's Labyrinth*). The new film will be darker in tone than the Murphy vehicle and will establish itself as a reboot rather than a sequel (and may even cross over with the upcoming *Magic Kingdom* film, which is discussed in *Chapter Six*). As this book goes to press, del Toro's screenplay is reportedly nearing completion, but production and release are likely much farther down the road. In the meantime, let's look at a forgotten classic from Disney's live-action stable: *Candleshoe*.

A teenage Jodie Foster stars as Casey Brown, the street-smart American girl picked up by a couple of con artists who plan to pass her off as the long-lost granddaughter of Lady St. Edmund (Helen Hayes, in her final big screen appearance). The scammers aren't after the St. Edmund fortune, though — as we soon learn, that disappeared a long time ago. No, they want to crack a code that will lead them to an ancient treasure they believe to have been concealed inside Lady St. Edmund's Candleshoe estate long ago. They have one clue to start with: "For the sunrise student, there is treasure among books." Once they get Casey inside Candleshoe, she'll search for the next clue in hopes of finding the hidden gold.

Disney used the real-life Compton Wynyates manor in Warwickshire, England as Candleshoe in the movie. The beautiful Tudor home is made of red brick with numerous gables and turret-like chimney stacks and bears an immediate resemblance to Walt Disney World's Haunted Mansion. The house isn't haunted but Casey's search for clues does lend the massive home a sense of mystery, appealing to our curiosity in much the same way that Haunted Mansion does.

Chapter 4

Fantasyland

"Here is a world of imagination, hopes, and dreams. In this timeless land of enchantment, the age of chivalry, magic, and make-believe are reborn, and fairy tales come true. Fantasyland is dedicated to the young and the young in heart, to those who believe that when you wish upon a star, your dreams do come true."

Walt Disney, "Dateline: Disneyland," July 17, 1955

That was the final dedication that Walt read out in his live-from-Disneyland telecast at the park's grand opening. With a beautiful, instrumental version of "When You Wish Upon a Star" playing behind him, the words sounded even more poignant than they do on paper... or would have been in stone had they been engraved, as this is another plaque that was never planted.

Fantasyland is the centerpiece, pinnacle, and shining star of the Magic Kingdom. It is home to one of the most famous sites in the world, Cinderella Castle, and is the dwelling place of the Disney Company's most precious creations — its magical fantasy films. One of the Resort's most powerful fantasies is that of a return to childhood, the idea that here is a place where kids can be kids... and adults can, too. Fantasyland's bright-colored tapestries and abundant desserts go a long way toward making it feel like the

park's most special land, but it's the indulgence in unadulterated escapism that really seals the deal.

There are more attractions here than in any other part of the Magic Kingdom, with more on the way. With the exception of It's a Small World and the Barnstormer, the rides and shows here are adaptations of classic fairy tales, short stories, and literary greats. Their corporeal interaction with the written word gives them deeper meaning and illuminates their power to enchant. Literature and fantasy were always at the root of the Disney legacy. Fantasyland is where that ethereal "Disney magic" lives, and it is where the Magic Kingdom's heart beats.

Note: In 2010, Magic Kingdom began a massive expansion of Fantasyland, nearly doubling the area in size. The resort is advertising the project as "New Fantasyland," though this book will continue to refer to the entire land by its simpler, official title, Fantasyland. Much of the new development is covered in this book, though some of the attractions were not open prior to publication.

With the new project, Fantasyland now consists of three primary "boroughs" (my term, not Disney's) — the Castle Courtyard, Storybook Circus, and the Enchanted Forest. The Castle Courtyard includes all of "old" Fantasyland, with one additional attraction slated to open there in 2013, Princess Fairytale Hall, a character meet-and-greet area.

Storybook Circus officially opened in 2012, taking over the area previously occupied by Mickey's Toontown Fair (no longer considered a separate land). The new attractions there include: Dumbo the Flying Elephant; The Barnstormer featuring Goofy as the Great Goofini; and two minor diversions that are not extensively covered in this book, Pete's Silly Sideshow and Casey Jr. Splash 'N' Soak Station.

The Enchanted Forest is the largest part of the expansion and officially opened on December 6, 2012. New attractions within Enchanted Forest include Enchanted Tales with Belle, an interactive walk-through experience in which the audience, with the help

of an Animatronic Lumiere, helps to reenact the *Beauty and the Beast* story for Belle; Under the Sea: Journey of the Little Mermaid, a new "dark ride" adaptation of Disney's *The Little Mermaid*; Ariel's Grotto, a meet-and-greet with the eponymous Little Mermaid; and the Seven Dwarfs Mine Train, a major roller coaster inspired by *Snow White and the Seven Dwarfs*, expected to open in 2014. Additionally, the area is home to two new dining locations. The first, Be Our Guest Restaurant, is a grand-scale dining experience located inside the new *Beauty and the Beast* castle and the first in the Magic Kingdom to serve wine and beer. Next door is Gaston's Tavern, home to a new signature beverage, LeFou's Brew, an apple-marshmallow-mango concoction that is presumably designed to rival the very popular and equally delicious Butterbeer beverage at Universal Orlando's Wizarding World of Harry Potter. Together, the "New Fantasyland" additions signal the dawn of a new era in the already wondrous Fantasyland realm.

Peter Pan's Flight

Type: Dark ride

Duration: 3 to 4 minutes

Popularity/Crowds: High, verging on E-ticket

FASTPASS: Yes

Fear Factor: 0.5 out of 5 (moderate heights)

Wet Factor: None

Preshow: None

Boarding Speed: Slow

Best Time to Visit without FASTPASS: Very first thing in the morning or very end of the night. Thank goodness for FASTPASS.

Special Comments: An absolute must-see, despite the long waits

"You can fly! You can fly! You can fly!" So goes the touchstone lyric in Disney's 1953 film, *Peter Pan*. There are few super powers as invigorating to the imagination as that of flight, probably because it is so thoroughly unachievable. To fly is to do the impossible. But as Walt Disney once said, "It's kind of fun to do the

impossible." There in a nutshell is the allure of Peter Pan's Flight — having fun while doing the impossible.

The ride begins when we board a flying pirate ship, powered by pixie dust. It floats into the Darling family nursery, where we meet Wendy, John, and Michael. We see the eldest child telling her younger brothers a story, which is interrupted when Peter Pan shouts out the words we really want to hear — "Off to Neverland!" Then, in a subtle scene change, our ship actually flies out of the nursery window and into what feels like the open evening air. Our vessel is suspended from the ceiling, moving along a track above us, and we find ourselves peering down on a tiny-looking London far below. Traffic moves in grids, lights twinkle from bedroom windows, and Big Ben glows in the distance. Car horns are audible, along with that beautiful *Peter Pan* score and anxious barks from Nana, the Darlings' matronly pet dog.

We head toward the moon and see the shadows of our companions in flight (Peter and the children) cast upon it. A right turn two stars later and we've made our way into the hidden realm of Neverland. The mermaids, the crocodile, Tiger Lily's tribe — they're all here. And so is Captain Hook. He, Smee, and his band of pirates cross swords with Pan and the Lost Boys aboard the *Jolly Roger*, all just below our feet.

You might say that Peter Pan's Flight is the most influential attraction in Disney history. There were more than 30 things open to guests on Disneyland's Day One but only three of them were what are known in the trade as dark rides.[1] The trio consisted of Snow White's Scary Adventures, Mr. Toad's Wild Ride, and Peter Pan's Flight.

Today, the dark ride has become the Disney Parks' defining attraction, the type of experience most closely associated with the Disney brand of amusement, especially inside the Magic Kingdom and its global equivalents. Fantasyland in particular is a dark ride haven, so much so that some Disney enthusiasts insist that the same ride in any other land can't be called a "dark ride" at all.[2]

I don't have any empirical studies to support it, but I get the

distinct feeling that of the original dark rides, Peter Pan's Flight is the most special to the public. Certainly, the ride is the only one still running in its (more or less) original form at both U.S. resorts. In Magic Kingdom, the attraction is sure to build longer lines faster than any other Fantasyland ride each day. There also seems to be a fairly high "awww" factor surrounding it when people bring it up. That reaction probably has something to do with the pure and unmitigated fantasy they find in their flight over Neverland.

Inspired by J.M. Barrie's 1904 stage play, *Peter Pan* is more fantastical than any of Walt Disney's other animated movies.[3] Released on the heels of World War II and its aftermath, the film's journey from London to a magical world where people never grow up resonated with an audience in need of an escape. Following a decade of turmoil at his company, Walt needed an escape too. *Pinocchio*, *Fantasia*, and *Bambi* had all been box office disappointments, his animators had gone on strike, and the government had essentially taken over his studios in order to produce cartoon shorts that would support the war effort. *Dumbo*, released in 1941, turned a big profit, but largely because he'd been forced to make it on the cheap. In the years immediately following the war, he was resigned to producing "package features" — films that barely qualified as full-length, comprised as they were of disjointed cartoon shorts stitched together. These brought in just enough money to keep the company afloat. All the while, Mickey Mouse's star was fading.

Despite having produced four of what we now consider to be the greatest animated movies ever made, the 1940s weren't kind to Walt. We shouldn't be surprised, then, that he kicked off 1950 with something as lavishly imaginative as *Cinderella*, introducing his audience to an era of fantasy that would define the rest of that decade. *Peter Pan* was the third release in what we might now call the Second Golden Age of Disney Animation[4] and kicked the magic into high gear. The film's spirit of fantasy and adventure drives the theme park ride, too.

Wendy, John, and Michael are whisked away from their boring nursery to a place where youth is eternal and adventure abounds. Children live alone, take up arms, and have little responsibility beyond fending off grown-up pirates. Of course, Hook and his crew fear the children and consider them their greatest adversaries. Like the most enduring children's entertainment, the film (and Barrie's original play) empowers children by making them the focus of the narrative. That's especially true for boys.

Peter Pan isn't just a fantasy, it's a male fantasy. Peter crows his dominance as mermaids fawn over him, Wendy and Tinker Bell spar jealously for his affection, and the Lost Boys revere him as a sword-wielding action hero and their leader. The story entices the male audience with an idyllic boyhood that lasts forever. That's not to say that it doesn't speak to girls, too, or adults. Peter's dedication to rescuing Wendy plays on the same romantic themes that have traditionally appealed to young women — and let's not forget that the role of Peter was historically played by a woman (a convention that Disney's adaptation is largely responsible for turning on its head[5]) — while the promise of never having to grow up allows all of us to believe that we can hold onto our childhoods forever.

Still, there is an undeniably pervasive machismo in Barrie's original play. Literary scholars have written at length about Barrie's fixation on masculinity and its impact on his writing, especially in the *Pan* stories.[6] Those themes inevitably made their way into Disney's adaptation.

The masculine appeal in the play and film is no less relevant in Fantasyland, where Peter Pan's Flight happens to be the only ride with a backstory designed primarily with the male in mind. Fantasyland is located in Cinderella's backyard, after all. Whereas Adventureland is primarily interested in piratedom and calamity, Fantasyland looks and feels like a royal soiree. Peter Pan's Flight is unique in that it represents a hybrid of the two — one part cannonball, one part pixie dust. The ride's high-flying pirate parade

keeps young boys' interest alive in Fantasyland while princesses and fairies otherwise rule the roost.

Ultimately, however, the attraction's profound sense of escape is universal. And isn't escape what all of us seek in a Disney vacation? The physical thrill of simulated flight frees us, in a sense, from whatever weighs us down. "Off to Neverland!" is a call to leave the real world behind and fly to somewhere much more exciting. If *Peter Pan* is an enchanting fantasy on the screen, it's all the more spellbinding when made real.

Isn't that what Fantasyland is all about — the magic of fantasy coming to life all around us? Disney's Imagineers locate the emotional heart of Walt's films and translate them into three dimensions, making the imaginary tangible by identifying the sentiments that made us fall in love with the story in the first place and making them manifest. Now we don't have to merely read about Neverland or see it on a TV set. We can actually *go* there. For the precious few moments we spend inside, the adults among us are children again, forever young. The girls are Wendy, on their first big adventure, or Tinker Bell, using their pixie power to lift us all into flight. The boys have come home.

I remember the first time I rode Peter Pan's Flight. In my five-year-old mind, I was sure I'd be attached to some kind of wire and sent flying through the air, a very sharp hook waiting for me on the other side. Nothing could have been more terrifying. Little did I know that I should have been afraid of the ride breaking down instead, because that's exactly what happened. A half-hour suspended in the air gave new meaning to the idea of "never land." While my childhood perception of the ride turned out to be not entirely accurate, it wasn't so far off, either.

Even as adults, we find ourselves in Peter's place, hanging high and growing ever closer to one of the world's most famous villains — Captain Hook. The ride is remarkable because it makes elaborate use of special effects — most of them more than a half-century old — to create an experience that lives up to the stories we've

read and that we might imagine on our own. Those special effects are Disney's real-life pixie dust. And as the song tells us, that's all it takes to fly — faith, trust, and just a little bit of pixie dust. Disney supplies the last ingredient through the magic of Imagineering. We make up the rest with our willingness to cast off our cares and have a little fun while doing the impossible. The film's lyrics set up the premise for us — "Think of all the joy you'll find when you leave the world behind and bid your cares goodbye." If we're willing to do that and engage our imaginations, we'll achieve the escape that's made *Peter Pan* such an inviting fantasy for more than a hundred years.

WATCH THIS - Finding Neverland (2004)

Disney's *Peter Pan* never really endeavors to explore the psyche of its characters, which are so ripe for exploration. Still, what the movie lacks in depth, it mostly makes up for with its affecting spirit of adventure. Walt's film is even easier to appreciate when we bring our own outside knowledge about Peter to the table, knowledge we glean not only from the original written works, but from other excellent films such as Universal/Columbia's vivid 2003 version starring Jeremy Sumpter, Spielberg's *Hook*, and the Disney-produced *Finding Neverland*.

J.M. Barrie's life story, told with cinematic finesse in *Finding Neverland*, brings invaluable context to *Peter Pan* in all its various iterations. In this creatively vivid biopic, Johnny Depp brings the conflicted dramatist to life with an air of real humanity. The movie, which was nominated for seven Oscars including Best Actor and Best Picture (it won for Best Score), keeps an eye on *Peter Pan* at all times, ensuring that the story never wanders far from the reason people are watching it — that is, to learn about the mind that created one of our most captivating fantasies. The many themes and messages found in Barrie's original *Pan* stories, Disney's movie adaptation, and the Peter Pan's Flight ride are all the easier to discern

after having seen this outstanding film, which was distributed and co-produced by Miramax back when it was part of the Disney Studios empire (the movie is now distributed on home video by Lionsgate Home Entertainment).

It's a Small World

Type: Boat ride

Duration: 11 to 12 minutes

Popularity/Crowds: Moderate to High

FASTPASS: No

Fear Factor: None (unless singing dolls give you nightmares)

Wet Factor: None

Preshow: None

Boarding Speed: Fast

Best Time to Visit: Anytime, but come back later if you find it very crowded

It's a Small World[7] is kind of a tough sell. Just try asking someone if they'd like to get on a little boat that slowly circles hundreds of identical child dolls as they sing the same jingle over and over in different languages. That doesn't exactly sound exciting. Actually, it's kind of creepy. And yet, It's a Small World is one of the best-known and most enduringly popular theme park attractions in the world. Why? Well, gluttony for punishment is one theory, but I think there's more to it than that.

Dubbed "the happiest cruise that ever sailed," Small World takes its guests around the world, drifting from one continent to the next, a cast of children dancing modestly in each one. The wardrobe, set dressing, and language change for each country but the children and the song stay the same. There is essentially no narrative, just an inspiring message — "a smile means friendship to everyone."

True to its word, the ride delivers on the promise of smiles and friendship before it even begins. A Disney cast member waves enthusiastically to just-boarded passengers from her perch in a con-

trol tower, for example. Just around the river bend, diners inside The Pinocchio Village Haus restaurant look down at the travelers with a nod and a smile. The face on the clock tower offers an enormous grin to those waiting for their boat to arrive.[8] If they're standing there long enough, they'll see an impressive time change on every quarter-hour, but at It's a Small World, every hour is Happy Hour... just not *that* Happy Hour, of course. The only spirits in the Magic Kingdom, remember, are the happy ones at Haunted Mansion.[9] No worries, though... the experience awaiting inside is as intoxicating as anything you'll find at what's left of Pleasure Island, the once-bustling, now-downsized nightlife district at Downtown Disney.

It's a Small World lulls its passengers into a stupor all its own. Like a snake charmer's flute, the marriage of motion and music in the ride enchants everyone inside it. The attraction's methodology is not unlike the hypnotist's. The steady rhythm of the music and the boat as it gently rocks on the water is immediately relaxing. The colors on the stage are fluorescently bright but everything else is pitch black, directing your focus toward the dolls and their mesmerizingly cadenced movements. The plaque at the entryway, calling this the happiest cruise that ever sailed, suggests that you should be receptive to the good vibes that will soon be wafting your way. Before long, you've entered a Small World state of mind. Hypnotists use many of the same techniques to mesmerize their subjects — relaxation, fixation, and suggestion. Small World passengers may not reach precisely the same level of manipulability, but they're similarly susceptible to the ride's sensory persuasion. The slightly altered consciousness is one of Small World's most alluring qualities, and it's also the thing that allows its message to sink in.

The mood inside Small World is a tranquil one. Basking in the serenity, guests are apt to become a bit more meditative than they might have been out in the hustle and bustle of Fantasyland. In those moments of reflection, the lyrics and the visuals begin working together to impress upon the voyagers a poignant moral.

"It's a Small World" is considered by many, including The Sherman Brothers (who wrote it), to be the most-performed and most-translated song in history. It's undoubtedly among the best known. A veritable earworm, the composition is wildly addictive, made all the more indelible in our minds by the fact that it plays ad infinitum in five locations around the world. The lyrics are quite simple, but in their simplicity, they're also quite meaningful. "There's so much that we share that it's time we're aware it's a small world, after all." Those words are a reflection of the historical moment in which they were written.

It's a Small World is another of the attractions that Walt Disney debuted at the 1964 New York World's Fair. Originally called Children of the World, the ride opened in the fair's Pepsi pavilion, a notable moment in Disney's history with Coca-Cola and Pepsi, a subject worthy of a discussion all its own.[10] The original plans called for multiple national anthems to play all at once but as it turned out, a musical clash was counterproductive to the whole "global *harmony*" idea. Walt called on The Sherman Brothers to write something more pleasing to the ear. They came back with the lyrics we all know now, only they were set to a beautifully wistful ballad. Realizing he'd need a cheerier sound, Walt asked them to write something a bit more upbeat, and boy, did they deliver!

Listening to the song now, one can almost hear them saying, "You want cheery? We'll show you cheery." In a radical transformation that puts Cinderella's rags-to-riches to shame, the once-wistful "Small World" became the happiest, most buoyant song ever composed, and the music and the ride together became an instant hit. After closing at the World's Fair, the attraction opened in Disneyland on May 28, 1966, and in the Magic Kingdom on its opening day in 1971. Tokyo, Paris, and Hong Kong all have their own versions, too. Fantasyland is the attraction's home in all five of those theme parks, an interesting fact when one considers that an international troupe of dancing children is not, strictly speaking, a thing of fantasy.

In fact, It's a Small World could just as easily belong to Adventureland, by virtue of its voyage round the world theme, or to Tomorrowland, given its message of hope for the future. So why Fantasyland? Well, besides the fact that Epcot's World Showcase didn't open until 1982, long stretches of the song have a distinctly European sound, linking it nicely to Fantasyland's European setting. A large part of the score even has a Swiss quality about it, what with the yodeling and all, which connects it geographically with the Matterhorn Mountain in California's Fantasyland. But beyond the music, the Small World ride presents a different notion of "fantasy" from the fanciful enchantment we typically associate with that term.

The attraction opened in the World's Fair at the peak of the civil rights movement, mere months before the Civil Rights Act of 1964 became law. The nation was facing a new future of integration in spite of lingering prejudice and racial divide. Meanwhile, international tensions were high as the Vietnam War escalated. Whether Walt and The Sherman Brothers intended it as a commentary on the changing sociopolitical climate or not, the ride and its song grew out of that especially tumultuous period in time. The fantasy in the attraction is one that imagines a more loving and cohesive world than existed in the 1960s. While strife stemming from racial and national barriers dominated the headlines of the day, the attraction contemplates humanity's potential to overcome those barriers. The Small World fantasy, then, is not a fictive realm of magic and dragons, but a dream — the same kind of dream that Dr. Martin Luther King, Jr. famously described the year before, a dream in which little children are not judged by the color of their skin.

Small World's bold, post-racial optimism is underscored by the decision to use only children in its performance. Their appearance together in the ride calls to mind the unforgettable lyrics in Rodgers and Hammerstein's *South Pacific*.

You've got to be taught before it's too late
Before you are six or seven or eight
To hate all the people your relatives hate
You've got to be carefully taught

The ride's design is tailored to communicating that same idea. The children look alike for a reason, to emphasize the underlying sameness that makes us all human. They sing the same song in various languages to demonstrate that our different tongues can express the same ideas. They're happy, and happiness is a thing of love. Like "You've Got to Be Carefully Taught" in *South Pacific*, "It's a Small World" espouses a hope that the next generation of children will grow up full of love and free of prejudice and hate. They just need to be taught that it really is a small world, after all.

WATCH THIS - The Boys: The Sherman Brothers' Story (2009)

The Sherman Brothers are Disney's most famous and accomplished songwriters (Alan Menken is close behind them), but while everyone knows their music, few knew their story... that is, until their sons got together to direct this documentary, co-produced and distributed by Walt Disney Pictures and executive produced by none other than funnyman Ben Stiller. We find out that the brothers hadn't really gotten along since they were kids and were barely speaking by the time the movie was released, each then in his eighties and living apart in different countries. Sadly, the elder brother, Robert B. Sherman, passed away on March 5, 2012, at the age of 86, not even three years after the documentary's debut, making the family's estrangement feel all the more unfortunate.

In the course of investigating the rocky relationship, however, the film does a marvelous job of chronicling their career, including the parts of it that ventured outside the Disney Studio walls. Special at-

tention is paid to what are arguably the Brothers' most well-known productions: *Mary Poppins* and It's a Small World. Many celebrities and insiders are on-hand to share their perspectives on the attraction and its unforgettable soundtrack, making this a superb tribute to the brothers and their work.

Prince Charming Regal Carrousel

Type: Carousel

Duration: 2 to 3 minutes

Popularity/Crowds: Moderate

FASTPASS: No

Fear Factor: None

Wet Factor: None

Preshow: None

Boarding Speed: Slow

Best Time to Visit: Morning or late night (or you might luck out and find a short wait during the day)

You wouldn't know it to look at it, but Prince Charming Regal Carrousel[11] represents the very spark of life for the Disney theme parks around the world. Walt was first inspired to build Disneyland when taking his daughters to Griffith Park[12] in Los Angeles during the 1930s and early '40s. Every Sunday, he'd wait on the sidelines while his two little girls enjoyed the carousel there. He decided an amusement park should offer more for parents and children to enjoy together, a line of thought that would culminate in the world's most-visited vacation destinations. The ride appropriately sits in the middle of Fantasyland, spinning just as Walt's mind did as he created all the other elements surrounding the ride. I suppose it's curious that his parks would end up including a carousel when that very type of ride left him unsatisfied in the first place, but Walt didn't ignore problems so much as fix them.

Walt's original merry-go-round, called the King Arthur Carrousel, opened along with the rest of Disneyland in 1955. The ride

there hasn't changed much since then, though it's adopted more of a *Sleeping Beauty* theme over the years. Similarly, the Magic Kingdom opened with its very own merry-go-round, originally titled Cinderella's Golden Carrousel. Like King Arthur's in Disneyland, Cinderella's was one of the most outwardly gorgeous rides in the Magic Kingdom. In fact, it still is, except it doesn't belong to Cinderella anymore. In 2010, with relatively little fanfare, Magic Kingdom retitled the attraction Prince Charming Regal Carrousel. (For the record, Disneyland's version officially remains the property of King Arthur, even if he is a rather absent owner, never showing his face anywhere in the park).

The new name on the sign aside, nothing about the ride looks very different. Eighty-six stunning horses and a chariot still populate the beautiful merry-go-round, which still rotates to the sound of Disney songs performed on a calliope. Illustrations from *Cinderella* still revolve beneath the canopy. Adults still pull a muscle when trying to mount their steed. Nothing has really changed. What seems like a negligible alteration, however, is actually quite substantial. The ride's rebranding reflects a new approach to storytelling (and merchandising) in the newest era of Fantasyland and brings renewed meaning to the park's identity as a kingdom.

With the new name came a new backstory,[13] something Cinderella's Golden Carrousel never clearly seemed to have. Prince Charming, better known as Cinderella's main squeeze, is a bit of a jouster as it turns out. Who knew? Apparently, after returning from his honeymoon (where do Cinderella and Prince Charming go for a honeymoon, anyway?), Charming set up a training device made of carved horses, upon which he could practice ring-spearing, a noble game that later became known as "carrousel." His contraption was all the rage in the kingdom, so much so that the villagers, apparently oblivious to their station in life, demanded that the prince give them a turn. Benevolent ruler that he is, Charming commissioned a second carousel for the commoners to enjoy, this one to be more conveniently located in the castle court-

yard and spruced up as befits its royal locale. That's how the Prince Charming Regal Carrousel came to be — a shining example of grassroots activism in the monarchy. Now we, the commoners, can live the life of a prince for just a few minutes at a time.

Fantasyland was always supposed to be the real-life home of Walt's characters. The carousel story affirms that vision and adds new depths to Fantasyland by telling us a little bit about their life there. Granted, unless they're taking the opportunity to do some research on their smartphones, guests who aren't already in the know almost certainly won't discern this storyline while they're on the ride. That the whole experience plays into an existing, albeit unspoken, narrative is nevertheless enough to set it apart from any ordinary spin on a merry-go-round. Once you know the backstory, the ride experience becomes immeasurably richer.

The new name and backstory were widely criticized as random and unnecessary within the Disney fan community, but while the change did come about rather suddenly, there's a lot to like about it. For starters, Prince Charming — long overlooked in his own kingdom — is finally getting some recognition beyond being just Cinderella's obligatory armrest in any given parade. Through the new narrative, we now know something about the "real" Prince Charming. Much more than just a prince (and a pushover), he's also an athlete, an equestrian, and an engineer. With all those skills, he's clearly a Renaissance man in more ways than one! And let's face it, Cinderella never really seemed like the horse-riding kind. She was more likely to sing to a horse than ride one, or else let them pull her around while she kicked back in the comfort of a pearly pumpkin. Jockeying in preparation for a jousting tournament is a more credible premise, even if we aren't given lances when we climb aboard. Actually, there is a sword sitting right beside the carousel, but it's stuck in a stone.

The idea that there are villagers in Fantasyland, with a prince and princess ruling over them, lends further credibility to the idea that this is a kingdom we're visiting. And the suggestion that there's a countryside somewhere out there beyond the berm, with

Charming's original wooden carousel in it, dovetails with the development of the new Enchanted Forest in the back half of Fantasyland, which has a more lush and natural-feeling landscape. Prince Charming Regal Carrousel was essentially the first completed step in the "New Fantasyland" transformation. The ride's backstory makes even more sense now that there's a forest in Fantasyland; we can easily imagine a sprawling countryside just beyond it.

The attraction also joins Peter Pan's Flight in creating a more readily apparent masculine appeal within Fantasyland — the new name alone extends an invitation to those who might be put off by all the gowns and glitter. That's a significant step on Disney's part because some fans decried New Fantasyland's initial blueprints, with their emphasis on Tinker Bell and the princesses. Acknowledging Prince Charming as a part of the emerging Fantasyland helps to relieve fears that marketing that area to girls and Adventureland to boys might segregate the Magic Kingdom. The entire castle courtyard also becomes much more convincing once we know that not only Cinderella but also Prince Charming (and their loyal subjects) have a part to play in it. They would if they really existed, after all.

Walt was probably put off by the carousel he visited with his daughters because there's nothing inherently enthralling to the grown mind about slowly trotting along in a circle. With a few minor touches of detail, though, he was able to tie the simple ride into the world of fantasy he'd been creating in his feature films. A carousel means more when it's King Arthur's Carrousel... or Sleeping Beauty's, or Cinderella's, or her husband's. The connection to the movies, however meager it may be, is enough to make the ride special. The new theme for the Magic Kingdom's carousel goes one step further with a more elaborate tie into the story world. Even without knowing the narrative, anyone can appreciate the regal beauty of the horses and their gold-plated shelter, but like the prince himself, the imaginative new context makes the ride that much more... charming.

WATCH THIS – A Knight in Camelot (1998)

Following *Unidentified Flying Oddball* (1979) and *A Kid in King Arthur's Court* (1995), this Wonderful World of Disney TV movie is the studio's third (and most recent) feature-length adaptation of Mark Twain's *A Connecticut Yankee in King Arthur's Court*. The incomparable Whoopi Goldberg plays Dr. Vivien Morgan, a scientist who mistakenly transports herself to Camelot, where she impresses King Arthur (Michael York) and locks horns with Merlin (Ian Richardson). In a premise similar to the one Disney had used in *A Kid* just three years prior, Vivien employs modern technology to save herself and the royal court.

In their third treatment of Twain's enduring novel, Disney switches the lead character's gender for the first time, casting Goldberg in a role previously played by men. Gender swap in a Disney fantasy? Where else have we seen this? Oh yeah, Prince Charming Regal Carrousel! The movie seems even more at home here, given that Camelot feels a lot like the royal countryside Prince Charming would probably joust in. And let's not forget that a King Arthur story is somewhat native to this attraction in the first place — it began as King Arthur Carrousel in Disneyland, and was once also home to the Magic Kingdom's daily Sword in the Stone ceremony, in which Merlin selected one lucky child to unsheathe Excalibur and become the new king of Camelot. (The show was discontinued in 2006 but the sword still sits in the stone for brawny guests to tug on.) This funny, distinctly 1990s comedy is sure to entertain and makes a nice companion to Disney's latest redressing of the venerable carousel ride.

Mickey's PhilharMagic

Type: 3-D theater show

Duration: 12 minutes

Popularity/Crowds: Moderate to High

FASTPASS: Yes

Fear Factor: 1.5 out of 5 (3-D images; surprise in-theater effects)

Wet Factor: 0.5 out of 5 (in-theater misting effects)

Preshow: None

Best Time to Visit without FASTPASS: Anytime

Special Comments: Giant theater usually means long lines aren't an issue

Every now and then, a Disney attraction comes along that seems to strike all the right chords. Mickey's PhilharMagic strikes them and more, putting them together in a spirited symphony of musical magic. Borrowing from the best of Fantasyland's past, this 3-D theater show gathers Disney's characters for a very special family reunion, one bound together by the kind of kinship that only a near-century's worth of beloved personalities could have. Their assembly shows that while blood may be thicker than water, animator's ink is even thicker than blood. That's the ironclad bond that makes the Disney difference.

Mickey's PhilharMagic is a Walt Disney World original, having opened there in October 2003. The two Asia resorts have imported the show since then, but Magic Kingdom is still its only home in the United States. Ostensibly a performance by Mickey Mouse's PhilharMagic Orchestra, the show takes place inside an opulent opera house. As stage manager, Goofy vocally ushers guests to their seats, after which Minnie greets them from backstage, where guests also learn that something has gone wrong (as is so often the case in Disney World story set-ups). Naturally, Donald Duck is to blame. Guests don their three-dimensional "opera glasses" just in time to see Mickey absent-mindedly leaving his famous, mystically empowered sorcerer's hat behind while he tends to backstage matters. Ever the instigator, Donald decides to try the cap on for size, and before long, he's emptied out a muddled mess of magic from inside it. That's when the *real* show begins.

Cast into the darkness by his own shenanigans, Donald suddenly finds himself in a bittersweet kind of nightmare. He tries to regain control of the rogue headpiece while being flung from one

Disney story world to the next. He wakes up to find himself in eighteenth century France, where *Beauty and the Beast*'s familiar cast of enchanted dinnerware invites him to "be their guest." He battles the broomsticks of *Fantasia*. He takes on Iago with Aladdin and Jasmine during a flight from Peter Pan's London. Somehow he even winds up in the African desert, where he feels the brunt of young Simba's ambition. Decades of Disney animation come together like memories flowing from Mickey's treasured brain trust, embodied in his iconic cap. The audience revisits their favorite characters and joins in their favorite songs, experiencing them in new dimensions — literally.

The seeing and singing don't fully explain PhilharMagic's heartwarming impact. A simple highlights reel from Disney movies certainly wouldn't have the same effect. Instead, what enables the show to hit the nostalgic sweet spot is the way the various Disney properties are woven together in a cohesive whole. That's Disney's legendary synergy at work, and it works in at least three specific ways inside the PhilharMagic Concert Hall.

First, the show looks back at a fondly remembered part of Fantasyland's past. When entering Mickey's PhilharMagic, guests walk through a lobby decorated with posters for fictional productions that supposedly once played inside the opera house. Among them are "Genie Sings the Blues," "An Evening with Wheezy," and The Wolf Gang Trio in "Straw, Sticks and Bricks in B-Flat." Banners for these and many more performances that never actually happened adorn the queue, but what's missing is a poster for a very relevant production that really did perform inside this very theater, the Mickey Mouse Revue.

An opening day attraction, the Mickey Mouse Revue harkened back to Mickey's earliest short films, where audiences first came to know him as a concert performer. He'd taken on the role in a number of his black-and-white cartoons during the 1920s and '30s, including *The Opry House*, *The Jazz Fool*, *Just Mickey*, and *Blue Rhythm*.[14] More famous than any of those, however, were two landmark cartoon shorts that cemented Mickey's reputation as an

orchestra conductor, 1935's *The Band Concert* and 1932's *Mickey's Revue*.[15] The latter not only marked the screen debut of Goofy (he was called Dippy Dawg back then) but also served as the obvious namesake of Mickey Mouse Revue in the Magic Kingdom in 1971.

The Mickey Mouse Revue featured a whole host of Audio-Animatronic Disney characters from the cartoons and feature films. The Three Little Pigs, Cinderella and her Fairy Godmother, Snow White and the Seven Dwarfs, and even the gang from *Song of the South* (sans Uncle Remus, of course) joined a cavalcade of other Disney stars in a medley of popular songs that included "Who's Afraid of the Big Bad Wolf," "I'm Wishing," "The Silly Song," "Bibbidi-Bobbidi-Boo," "Mickey Mouse March," and "Zip-a-Dee-Doo-Dah." Baton in hand, the tuxedo-clad Mickey again took to the podium to perform one of his most treasured roles, the maestro mouse, while his animated brethren looked on for direction.

Even with technology that would be considered modest by today's standards, the attraction is among the best in Disney's past. After enjoying a successful run in the Magic Kingdom, the whole show was boxed up in 1980 and shipped off to Tokyo, where it reopened in 1983 and ran until 2009. The space left behind was renamed Fantasyland Theater and operated only occasionally, screening various Disney cartoons.

Eventually, Michael Jackson took Epcot by storm with his enormously popular *Captain EO* film, displacing an attraction in that park called Magic Journeys, which moved over to the Fantasyland Theater in 1987. That's when Donald Duck had his first major performance in this building, his 3-D cartoon short, *Working for Peanuts*, providing an opening act for Magic Journeys (that same cartoon was re-released in 3-D to theaters across the nation in 2006, playing with *Meet the Robinsons*). Significantly, Magic Journeys marked the first time that Disney's Imagineering team had created a 3-D movie for the theme parks. That show closed in 1993, replaced the next year by an all-new stage production

called Legend of the Lion King, a retelling of the just-released movie using live puppets and performers. That, too, eventually closed, in 2002, at which time preparation for Mickey's Philhar-Magic got underway. When it opened, PhilharMagic was the fourth major show to occupy the theater space. Yet, in many ways, it was a return to the first show there, as well as a simultaneous nod to the others.

PhilharMagic is essentially an updated version of the Mickey Mouse Revue. Mickey returns to the theater as the esteemed concert conductor and his setlist again consists of popular Disney tunes. But this time, things are a little different, and the variations reflect the changes the theater has seen in the decades since the original Revue moved to Tokyo. For starters, PhilharMagic isn't an Audio-Animatronics show. Like Magic Journeys, it's a 3-D movie instead. The featured songs don't come from *Snow White* or *Cinderella*, either. Now they flow from more recent popular films, *The Lion King* among them. When Simba sings "I Just Can't Wait to Be King," he's reprising a number he performed in this same theater for eight years before PhilharMagic came around. In fact, that song is more closely connected to the theater than any other, having played there now for many years.

The new show also looks back to the short films that used to play in the Fantasyland Theater, especially *Working for Peanuts*. There's a distinctly cartoony feel to the attraction's opening scenes and Donald's starring role reflects that. Moreover, while the attraction is called Mickey's PhilharMagic, there's actually very little of Mickey Mouse in it. Donald upstages Mickey as the cartoon star in the show, just as he did in real (and reel) life during the 1930s. When Donald got his own line of cartoon shorts back then, his popularity quickly eclipsed Mickey's, relegating the mouse to the status of corporate icon that he commands today. In PhilharMagic, Donald is again stealing the show and making it his own.

But there are a few clever touches in PhilharMagic to subtly remind us who's boss. A flute tauntingly plays the "Mickey Mouse

March" in Donald's face, for instance, and Mickey is ultimately the one who saves the day. The main mouse takes on his *Fantasia* role with authority, reinforcing for the audience a relationship they've come to know and love through so many Disney productions over the years: Donald may be the real star but, much to his dismay, Mickey is still the undisputed leader of the club. For the viewers, this means that PhilharMagic ties in quite nicely with not only the annals of the Fantasyland Theater but also the whole legacy of Disney entertainment.

PhilharMagic's relationship to Disney's work in the cinema brings us to the second kind of synergy at work in the attraction — the partnership between diverging branches of The Walt Disney Company. As the largest multimedia conglomerate in the world, Disney is a corporate jack of many trades. Probably its two best-known subsidiaries are Walt Disney Pictures (the primary movie-making arm of The Walt Disney Studios) and Walt Disney Imagineering (the creative development and design arm of the Parks and Resorts division). The correlation between the two is self-evident: the movies made by Walt Disney Pictures directly inspire a great many of the Imagineering team's projects. Despite that important association, however, these two subsidiaries seldom work directly together. In fact, Mickey's PhilharMagic represents one of the few collaborations between them, and arguably the most extensive.

That's because PhilharMagic is comprised entirely of computer-generated, three-dimensional re-creations of characters originally created with traditional animation.[16] CGI was still relatively young when production began on PhilharMagic and the attraction would be the first attempt to wholly digitize these primarily hand-drawn characters whose first appearances ranged from 1928 to 1994. That's dicey territory for computer animators, especially with characters as fiercely protected as Disney's are. Naturally, the Imagineering team wanted guidance from the Studios to ensure that each character was faithfully rendered in the new CGI environment. Meanwhile, Disney fans and animation

enthusiasts waited with bated breath. How would Ariel or Aladdin look in 3-D? Well, pretty darn good as it turns out.

The background and character design in PhilharMagic don't dazzle with the polish and finesse of a Pixar film, but the results are better than most had hoped for given the challenges inherent in making over a hand-drawn character for the 3-D CGI world. For the audience, the new designs complement the attraction's transformative nature. Presenting the movie scenes in 3-D offers a new perspective in itself, but when the attraction goes on to revamp traditionally drawn characters for the prevailing CGI format, it becomes doubly transfiguring. On top of that, an array of other sensory effects[17] — wind, water, scents, lighting, and an Animatronic — is added to the mix to make the classic movie scenes featured in the show all the more immersive. We truly experience them as never before and that is one of PhilharMagic's most appealing qualities — it makes old ground feel new again.

Another enchanting element in PhilharMagic is its use of a third kind of synergy, perhaps the type that most defines the Disney brand — the gathering of characters from different movies under one very large umbrella. Disney is unique from other movie studios in that it markets its characters as a family. Sure, Warner Brothers' Looney Tunes have that kind of kinship, for example, but you don't readily associate them with *Gremlins*, the *Harry Potter* characters, *National Lampoon's* Griswold family, or other popular Warner properties. Disney is different in that almost every film bearing its label immediately claims a branch on the studio's sprawling family tree.

Peter Pan and *Aladdin* are two very different movies. They're set in different countries and time periods, and their stories aren't even remotely related. Nevertheless, when we see their characters together in the same universe, it makes perfect sense. That's because Disney is pervasive enough in pop culture for most of us to understand that they're part of the same entertainment universe. That's not just true for Disney's animated musicals, either. Live-action films like *Mary Poppins* and non-musicals such as *Honey, I*

Shrunk the Kids are very important parts of the Disney fold. Those characters get invited to the Disney family reunion too, a celebration invariably held inside the Disney parks.

Walt envisioned Disneyland as the place where his characters actually lived — all his characters, including the ones from television and live-action cinema. With movies, there was no going back. Once in the can, a film is what it is forever and to an innovator and perfectionist like Walt Disney that was a source of creative frustration. Disneyland provided an outlet. There, the characters could live on in new adventures, telling new stories. Accordingly, trips to the park were like visits to the Disney characters' home. Walt always treated them that way and so we've grown up thinking of them in the same way.

That's why Tinker Bell can fly out of Cinderella Castle every night without raising an onlooker's eyebrow about 20th century London (*Peter Pan*) suddenly colliding with 17th century France (*Cinderella*). Likewise, characters from a dozen Disney properties can dance side-by-side around the castle in a nighttime parade without the slightest inkling of narrative confusion. Each Disney character, each movie, each grouping of heroes, princesses, or villains contributes not only to their respective story worlds but also to the broader family of Disney characters at the same time. The interweaving of these otherwise unrelated figures strengthens the Disney identity and our sense of belonging to it. The characters aren't the only members of the family, after all. When we're patrons in the theme parks, we feel like a part of the family, too. The theme song to Disneyland's famous Parade of Dreams laid that out in the chorus, which it borrowed from the Studio's 2003 animated feature, *Brother Bear* — "Welcome to our family!" That's what being a Disney guest is all about. It's one of the things that draw millions of people to each of the theme parks every year. That's where PhilharMagic makes such an emotional connection with its audience.

We can feel like part of the family because we know and love all these characters, we understand their relationship with one an-

other, and we value the connection we've had with them all our lives. That pretty much applies to family in general. Mickey's PhilharMagic brings many of those characters together — in many cases, the ones who mean the most to us — for a visually and aurally enveloping homecoming. Ariel is one of them, and she claims a real high point in the attraction, singing "Part of Your World." The lyrics mirror what we take away from the show. Through engrossing 3-D, interactive theater effects, and characters and songs we all love, we come away feeling more like a part of their world... Disney World. The special bond we have with Disney entertainment allows us to have a unique escape while in it. You won't find that type of connection in any other recreational setting because no other studio has inspired anything remotely like the passionate loyalty that Disney has long enjoyed from millions of people. That's what sets the Magic Kingdom apart from everything else, and Mickey's PhilharMagic rhapsodizes on that Disney difference most alluringly.

WATCH THIS – Mickey's Christmas Carol (1983)

Mickey Mouse's version of Charles Dickens' incalculably famous Christmas novella is among the most beloved adaptations of the story and for good reason. With Mickey as Bob Cratchit, Goofy as Jacob Marley, and Jiminy Cricket, Willie the Giant, and Peg-Leg Pete as the Ghosts of Christmas Past, Present, and Future (respectively), the short film calls on something like 50 characters from Disney cartoons and feature films to act out the indelible story of charity and change.

In the pivotal role of Ebenezer Scrooge is none other than Scrooge McDuck, Donald Duck's uncle, which means that Donald plays Ebenezer's nephew, Fred. Some of the characters included are quite rare. Personalities turn up from *The Aristocats*, *The Adventures of Ichabod and Mr. Toad*, *Bedknobs and Broomsticks*, *The Three Little Pigs*, *The Band Concert*, *Robin Hood*, and the list goes

on. There are few nods to the characters' existence outside of the Dickens tale, but the audience is plenty aware of them on their own. And therein lies the magic of this truly great and rather faithful retelling — everybody loves a Disney family gathering, and it's even more special when it happens at Christmas.

The Many Adventures of Winnie the Pooh

Type: Dark ride

Duration: 4 to 5 minutes

Popularity/Crowds: High

FASTPASS: Yes

Fear Factor: None

Wet Factor: None

Preshow: None

Boarding Speed: Slow to Moderate

Best Time to Visit without FASTPASS: Morning or night

Winnie the Pooh first ran for President in 1968. If you don't remember his name on your ballot, you probably didn't vote in Disneyland. In a brilliant effort to promote their newly acquired character, the Disney Company tapped into the country's electoral tension that year and launched the first of several Pooh for President campaigns. While the United States shifted from blue states to red, the theme park went all yellow.

Unfortunately, even with support from Mickey Mouse and an expected endorsement by the Seven Dwarfs, the pudgy bear failed to win a single state. He's been a perennial candidate since then, but the country still hasn't put its first fluff-stuffed President in office. Well, I suppose that's up for debate. But while some blame his simple-minded reputation and few can forget his frequent "Oh, bother" reply when questioned on the issues, one might pin his more recent defeats on his surprisingly divisive presence in the Disney theme parks. That began with the opening of his signature attraction, The Many Adventures of Winnie the Pooh.

Author A. A. Milne first published *Winnie-the-Pooh* in 1926. The collection of short stories was inspired by his real-life son, Christopher Robin, and the stuffed animals in his nursery. A second anthology soon followed, *The House at Pooh Corner*, published in 1928. The stories delve into young Christopher's imagination, where animals come to life and talk him through life's simple lessons. All the while, he moves closer to adulthood, the point at which he knows he'll have to leave his imagination behind.

Among the toys in Christopher Robin's room were a bear, a tiny pig, a donkey, a tiger, and a kangaroo. As you might have guessed, that's how Pooh, Piglet, Eeyore, Tigger, Kanga, and Roo were born (Milne thought up Rabbit and Owl on his own). The characters' roots in reality were manifested in Milne's stories, which always presented them as material objects — toys. One needn't look any further than Eeyore, his tail forever falling off, for evidence of the animals' artifice. The original illustrations are consistent with that idea, too. Only Rabbit and Owl look like actual creatures in the drawings.

The characters' existence as anthropomorphic toys contributes to a marked self-awareness in Milne's prose, in which the author addresses the reader directly as he frequently acknowledges that he's telling fictive stories about the imaginary lives of inanimate toys. That idea would later become important at the cinema and in the Magic Kingdom, but the author's unique writing style also found him an early English audience.

The *Pooh* tales were an instant success in Europe, much to the chagrin of real-life Christopher Robin, who grew up harboring deep resentment for his father, believing that he had exploited his childhood and doomed him to certain hardships as an adult. Notably, Milne wasn't thrilled with the success either, feeling stifled by a public that now expected him to concentrate on children's literature despite his desire to move on.

The characters never caught on in the same way for Americans — at least not until Disney came along. Walt licensed Milne's characters in 1961 but waited a few years to begin adapting the

stories, realizing that audiences would need to acquire a taste for Pooh before they'd be ready for a whole load of it — er, him.[18] *Winnie the Pooh and the Honey Tree* introduced Pooh Bear to the American cinema in 1966, the first of three short films that would together comprise the seminal Pooh film oeuvre. Disney's *Pooh* was similar in many ways to Milne's, but initially put less emphasis on some of the major themes, such as Christopher Robin's approaching manhood and readers' awareness of the characters being mere toys. Walt also reached out to stateside moviegoers by introducing a new, decidedly American personality in the Hundred Acre Wood — Gopher, a hardworking and wisecracking miner. Walt's efforts were a success. At long last, Pooh had a lot of fans in the United States, too.

Walt died just when the characters were getting off the ground. Creatively frozen in the wake of his sudden passing, the company did very little with the franchise for years. That changed in 1977, when the ailing studio desperately needed to make a quick buck. To do that, they blew the dust off the Pooh projects and revisited the three aforementioned short films, combining them into one full-length feature and releasing it to theaters as its own movie: *The Many Adventures of Winnie the Pooh*. Far from merely slapping three disconnected cartoons together, the studio went an extra mile or two in producing entirely new animation and live-action bookends to interweave the stories beautifully and situate them in their original literary context. Christopher Robin, for example, now ends the film by engaging Pooh in a poignant conversation about growing up. Through meaningful touches like that, the movie not only realizes Walt's original dream of creating a full-length *Pooh* adaptation but also brings Disney's *Pooh* much closer to its literary source. The film has arguably become the most recognizable *Pooh* work in the world and has helped create tremendous worldwide affection for the characters.

Very much in keeping with Milne's use of the stories, Disney aggressively marketed them, particularly in the 1980s, when a new fervor for the lovably aloof bear swept the United States. Pooh

quickly became one of the company's most reliably profitable franchises. Milne had been a relentless marketer himself, licensing the characters to so many people that Disney has wound up in a number of legal battles with competing rights holders in the years since.

Pooh's popularity waned slightly during the early 1990s, a new golden age of animation having claimed his spotlight. By the late '90s, however, the bear's star was again on the rise, thanks in part to the success of a new direct-to-video movie, *Pooh's Grand Adventure: The Search for Christopher Robin*, in 1997. Following that release, Disney unleashed a tidal wave of new Pooh products that would continue over the course of the next decade.[19] The time was right at last for Walt Disney World to develop a theme park attraction around the Hundred Acre Wood, something Disneyland had considered but abandoned several times before.

The Many Adventures of Winnie the Pooh opened in Magic Kingdom in June of 1999, based on the film of the same name. Given that the Bear of Very Little Brain was enjoying a resurgence in popularity at the time, Disney fans would be thrilled about a large-scale dark ride built in his honor, right? Actually, they protested instead. The objection was nothing personal, mind you, but as much as Disney fans like a silly mammal, they love amphibious aristocrats even more. You see, the trees in the Hundred Acre Wood were planted atop the ruins of Toad Hall, once home to the highly acclaimed Mr. Toad's Wild Ride. When Disney announced plans to demolish that beloved attraction in preparation for The Many Adventures of Winnie the Pooh, fans mounted rallies and petitions with such zeal that even major media outlets picked up on the fuss. Nevertheless, without an invite, Christopher Robin's imaginary gang crashed the party.

Four years later, the same thing happened in Disneyland. The Many Adventures of Winnie the Pooh steamrolled The Country Bear Jamboree. Unlike Magic Kingdom crowds, Disneyland loyalists love the Country Bears and always will. The dust settled with time in Florida, but in California, it never really has. Disney-

land fans insist the ride's a big "pile of Pooh" and they're still waiting for someone to clean it up. Hell hath no fury like a Disney dork scorned.

Back in Magic Kingdom, the attraction is actually pretty popular today, in spite of its divisive beginnings. There's good reason for that. The ride begins in the thick of the woods on a particularly blustery day. Those just happen to be the same atmospheric conditions found in the middle and most iconic segment of the film, so the gusty breeze instantly puts us in a familiar place. The wind blows us right past Owl's disheveled home (look for a Mr. Toad cameo there) and into one of the coolest scenes in any dark ride ever made. When Tigger springs into view, the ride vehicle starts hopping around with him for some bouncy, trouncy, flouncy, pouncy fun, fun, fun, fun, fun! That's just one of several remarkable ways that the attraction brings us into Winnie's world.

The most interesting thing about the ride comes before it even begins. The queue is decorated with giant paper pages that appear to have been freshly ripped from a book. Written on them is text adapted from Milne's stories. These increase in number until at last we arrive at the loading platform, which appears to be a giant-sized bookshelf. Gargantuan tomes are stacked in the corner and *Pooh* pages are scattered everywhere.

Once aboard our honey-smothered car, we pass by an enormous book, open to Chapter II, "In Which We Join Pooh and His Friends in a Very Blustery Day," which sounds quite a bit like a Milne chapter but actually isn't one. Like the movie, the ride borrows from several of the short stories in creating the blustery day. Our car heads for a giant hole in the middle of the right-hand page and although the transition probably goes unnoticed by many, we have passed through a portal into the book. At once, the characters spring to colorful life, just like they do in Christopher Robin's imagination.

The many pages and the giant books all serve as important reminders of the story's literary origins. More to the point, they serve as reminders of the fictitious nature of these characters. Re-

member, one of the defining attributes of Milne's original work is its self-awareness, its consciousness of the fact that Pooh and his friends are all just pretend. In the Magic Kingdom ride, the pages pave the way toward the entrance and away from the exit, but they also continue during the ride itself, framing each show scene inside. In this way, the attraction is every bit as self-aware as Milne's books are.

It's one thing for guests to know that Eeyore isn't a living donkey, but it's another altogether for the storyteller (in this case, Disney) to subtly point that out for them. The torn-out pages do that. Most fiction, after all, asks its audience to suspend disbelief and buy into the fantasy until the final page turns. When authors choose to "break the fourth wall" and address their readers directly, they're opting to make a point by *sustaining* disbelief instead. The Many Adventures of Winnie the Pooh wants us to sustain disbelief.

Pooh is nothing if not an interrogation of the imagination. The ride reflects that by underscoring its imaginary setting. While even an attentive passenger is unlikely to walk away with any firm conclusions about the inner workings of a child's mind, there's enough in the ride to at least inspire reflection about the ways our imagination can help us work through dilemmas. That's really all a first-time reader takes away from Milne's books too, which don't exactly lend themselves to easy interpretation or definitive conclusions about a deeper meaning. What is clear in those texts is that Christopher's imaginary playmates are helping him come of age. His interactions with them all play out inside his mind, and the ride takes guests inside those dreamed-up adventures for a firsthand look at his imagination in motion. To even begin to appreciate that, though, guests must first know that they're inside an imagined world and that's where all of those torn-out book pages come in.

The way characters look in the ride also echoes the original self-awareness. In the Magic Kingdom at least, the characters are largely inanimate constructions that budge only when moved by a

lever or some other device controlling them from afar. In other words, these aren't the same kind of full-fledged, elaborately animated Audio-Animatronics one finds in The Hall of Presidents or Pirates of the Caribbean. While the three-dimensional cutouts certainly do look just like the cartoon characters everyone knows and loves, they also look fairly fake — as they should. Remember that Milne always emphasized the materiality of Christopher Robin's toys. In both description and illustration, they never looked lifelike and were never meant to. Not until Disney came along did the characters take on a more organic design, and even then they didn't entirely lose their doll-like configurations. Now, in Magic Kingdom, the Disney characters are more toy-like than ever. By putting guests face-to-face with physical, tangible recreations of these characters, The Many Adventures of Winnie the Pooh asserts their materiality in a way that the film adaptations never have. The moving figures have the same effect as all of those book pages — they remind the audience that the characters are only make-believe.

Pooh and his pals take the next step into the material world when the ride ends and we exit directly into a gift shop that only sells merchandise themed around the Hundred Acre Wood. While a Disney ride exiting into a gift shop is anything but uncommon, the transition is exceptionally fitting here. For many years, the store was called Pooh's Thotful Spot, a right proper name given all the thinking there is to be done in The Many Adventures of Winnie the Pooh. In November 2010, it became Hundred Acre Goods and it's still an important part of our post-ride thought process. We find abundant honey there, for example, and as Winnie will tell you himself, honey makes very good food for thought, indeed. He didn't become a savant on an empty stomach, you know.

The store also carries an ample selection of *Pooh* dolls, all the characters available in a variety of costumes, colors, and sizes. On those innumerable, plush-stocked store shelves, Winnie the Pooh comes full circle at last. The toy-turned-playmate-turned-cartoon star becomes a toy again, ready to be taken home to en-

joy new exploits inside another child's imagination — or maybe even in an adult's. That's what the Hundred Acre Wood is all about and in bringing it home that way, the Magic Kingdom's Pooh experience is every bit as full and well rounded as the tubby bear's little tummy.

WATCH THIS – Pooh's Grand Adventure: The Search for Christopher Robin (1997)

Pooh's first direct-to-video feature breathed new life into the franchise. Without it, there might never have been a Winnie the Pooh ride in Fantasyland. A direct sequel to the 1977 theatrical film, this venture into the Hundred Acre Woods doesn't quite measure up to the original, but nicely carries on with its tone and overarching themes. When Christopher Robin leaves for his first day of school, Pooh and his pals misunderstand a note he left behind, concluding that he's trapped inside a giant skull and must be rescued.

Pooh's Grand Adventure does away with the meta-story elements that define both the first film and the theme park ride, but that's because it isn't based on any of Milne's works. The original screenplay does, however, retain the author's interest in Christopher Robin's imagination. Despite its slow pace, the movie is a charming exploration of how a child might reckon with the major change that the first day of school represents.

Dumbo the Flying Elephant

Type: Flying, steerable elephants
Duration: One and a half minutes
Popularity/Crowds: High
FASTPASS: Yes
Fear Factor: 0.5 out of 5 (moderate heights)
Wet Factor: None
Preshow: None

Boarding Speed: Slow

Best Time to Visit: Morning, early evening, or late night, but see Special Comments below

Special Comments: At press time, Dumbo had just reopened as a two-unit attraction in a new location. Crowd patterns may fluctuate over time. Guests not using FASTPASS will enter the "Standby" line and receive a pager while they wait inside an air-conditioned children's playground area (as opposed to standing in a traditional queue).

Fantasyland is home to some of Disney's simpler rides, like carousels and spinning teacups. Perhaps the simplest of all is Dumbo the Flying Elephant. However charming it may be, the ride is no Splash Mountain. One might naturally expect, then, that it would be easy to get on with little wait. Not so. On the contrary, Dumbo can generate some of the longest lines of any theme park offering in the country. Given the ride's low-key nature, perhaps the old adage, "Good things come to those who wait," has reached a point of diminishing returns in the Magic Kingdom. Maybe, but the crowds gather around the elephant for a reason, and it's not because they're all Republicans.

Dumbo truly requires little explanation. Guests select one of 32 gray elephants, each one bearing the likeness of the lovable hero from Disney's 1941 feature film. Adults ride alone or with a small child or two. Technically, two adults can ride together, but that's best avoided, lest they draw depressing comparisons between their collective size and that of the elephant (he's a young elephant — don't be so hard on yourself). Following a warm welcome from ringmaster Timothy Q. Mouse, who stands atop the entrance sign, the elephants revolve slowly around the axis while guests use a joystick to raise themselves approximately 17 feet into the air. Ninety seconds later, they're back on the ground. On even a moderately crowded day, that can make for a ratio of nearly a minute in line for every second spent in the air. That's a lot of waiting for such a routine ride, and yet it is as popular as any other, and always has been.

Dumbo first opened at Disneyland on August 16, 1955, about a month after the park itself. Since then, the ride has been an opening day attraction at each of the Disney resorts around the world, including Magic Kingdom. Reportedly, plans initially called for pink elephants rather than gray, with the intention of theming them to the movie's famous "Pink Elephants on Parade" sequence. The only thing is that in the movie, Dumbo and Timothy Mouse are thoroughly inebriated and hallucinating when they envision the petrifying pachyderms. That's not the kind of experience Walt wanted to simulate in his park, so he supposedly mandated the use of gray Dumbo replicas instead. That was probably for the best, as all the bright pink might have distracted from the Fantasyland aesthetics that are so important to the attraction in its final form.

For more than 40 years, Dumbo the Flying Elephant was located directly behind Cinderella Castle, with only the carousel standing between them. It offered breathtaking views. Sailing through the sky, a gentle breeze brushing the face, the beauty of Fantasyland became newly apparent from Dumbo's heightened vantage point. The ride's aerial perspective laid out the full majesty of Fantasyland like a hand-drawn map. After the Skyway to Tomorrowland was retired,[20] this was the only ride to give an elephant's-eye view of the lush and splendid scenery in this part of the park. Taking it all in, even for a short time, allowed us to forge an emotional bond with Fantasyland that couldn't quite be achieved anywhere else. The castle, after all, looks all the more beautiful when seen from up in the air and The Flying Elephant gave us the chance to savor its extravagant architecture.

But Dumbo's meaning changed when it closed on January 9, 2012, and moved to a different part of Fantasyland — a new part, in fact — an area of the park that once wasn't considered to be Fantasyland at all. The flying elephants now take off from Storybook Circus, a neighborhood of sorts that used to be its own land in the Magic Kingdom — Mickey's Toontown Fair. Toontown opened as Magic Kingdom's seventh land in 1988 and closed in

early 2011 for conversion to Storybook Circus, a whimsical carnival town in a back corner of Fantasyland.[21]

Dumbo is Storybook Circus's principal inspiration. Ironically, this new neighborhood's theme is epitomized by a sideline attraction called Casey Jr. Splash 'N' Soak Station. There's very little to it — a train filled with mechanical animals squirts copious amounts of water at any guest who walks by it, showing neither mercy nor restraint. Should you choose to approach Casey Jr., you will be drenched. Should you choose not to, Florida's afternoon rainstorms will drench you anyway, so you really might as well. The deluge of water isn't what's important with Casey Jr., though. Rather, it's this simple splash zone's contribution to the Storybook Circus narrative — and Dumbo the Flying Elephant's new identity — that matters.

Turn a careful eye toward the ground in Storybook Circus. A single train track runs from Casey Jr. all the way back to the Walt Disney World Railroad, which encircles the whole perimeter of Magic Kingdom. The suggestion is that Casey Jr. himself veered off the WDW Railroad track and took a detour into Fantasyland. Being the circus train that he is, his many animal friends must have followed him in. Sure enough, the ground there is stamped with elephant footprints, horseshoe indentions, and peanut shells — clear signs of a circus invasion. At some point, Casey must have negotiated relocation terms with Mickey Mouse, who moved his meet-and-greet to Main Street and allowed his Toontown Fair to become Storybook Circus instead. Unquestionably, it was an improvement. Storybook Circus is as inviting and intricately detailed as any corner in Magic Kingdom, bigger and more impressive by far than Toontown ever was.

The Casey Jr. train comes to us from the *Dumbo* film. In fact, he was the very train that Dumbo's circus traveled on in the movie, so it only makes sense that if Casey has set up shop in the back of Fantasyland, Dumbo should join him there. And so it came to pass that in March 2012, Dumbo the Flying Elephant reopened in Sto-

rybook Circus, quite a distance from where it used to fly behind the castle.

But even from afar, the strikingly red-and-gold hubs and their 16 brilliant blue spokes are a sight to behold. That's part of the problem. The ride immediately catches the eye and inspires guests — especially children — to hop in the queue right away. Because the whole run of the ride is visible from the outside, everyone wants to be a part of what they've just seen.

To accommodate the crowds, Disney doubled Dumbo's capacity with the move to Storybook Circus. Now there are two hubs with a total of 32 elephants. The two units spin in opposite directions for a sort of "Dueling Dumbos" illusion. While waiting their turn, guests can rest inside an air-conditioned circus tent, where Dumbo flies around the ceiling. Why there's one Dumbo flying inside the tent and 32 more of him flying outside isn't quite clear. For that matter, how anyone is supposed to rest in a tent designed for children to run around and scream while adults sit on tiny wooden benches isn't apparent either. Nevertheless, it may still beat the heat of those lengthy lines, because even with double the Dumbos, the waits are long.

So why are the crowds so desperate for Dumbo? After all, the nakedness of the mechanics, beautifully designed as they are, means that Dumbo doesn't create the same illusion of flight found in the *Peter Pan* ride over yonder. With an unmasked apparatus lifting other guests into the air right in front of us, there's no mystery to Dumbo's takeoff. Without dark lighting, show scenes, or the use of forced perspective,[22] the thrill and fantasy of flying experienced in Neverland is less captivating here. That's okay, though, because the Dumbo ride's real power is found in its unmatched view of Fantasyland, even when the castle is as far away as it is now.

Fantasyland is the park's apex, the area that really puts the "magic" in Magic Kingdom. The Flying Elephant is surprisingly effective in connecting us with that magic, especially with the new charms found in Storybook Circus and the thick woods of the

Enchanted Forest. We can still see the castle on the horizon — three of them, in fact, now that *Beast* and *Mermaid* have palaces too. From this distant spot on its perimeter, all of the now-enormous Fantasyland sprawls out before us. Horses canter and teacups twirl while we gaze across treetops that span from Snow White's cottage to the Hundred Acre Wood. In the foreground, we can delight in Storybook Circus's atmosphere of understated frivolity, while perhaps waving a hand or trying to snag a photo of friends spinning in their own elephants just ahead.

There's beauty below us as well. Magic Kingdom's new Dumbo took its cue from Disneyland's and added a waterscape around the ride. Now, beautiful fountains add immeasurably to the ambience, especially at night when the water changes colors. At the base of each Dumbo hub is a series of story scenes. As the ride turns, the scenes recount the *Dumbo* tale in chronological order. That's fitting, because the ride is something of a continuation of the film.

Like the *Dumbo* movie itself, the ride is very short and simple but also extremely sentimental and sweet. And like the Dumbo character, his ride is kind of a pipsqueak but not to be underestimated. Despite its apparent simplicity and minimalist theming, the attraction brings us into the story that inspired it in a surprisingly meaningful way. We ride with Dumbo in his moment of triumph, following all of the sorrowful darkness that preceded his ultimate flight in the film.[23] In that sense, the ride is actually an extension of the movie's ending, which is all the more valuable given that *Dumbo's* finale always feels so abrupt.

In the movie, Dumbo is the conquering underdog. In the Magic Kingdom, his victory lives on in perpetuity, forever inviting us to share in it with him. When we do that, the ride makes an indelible impression on us, its vistas lingering in our memories long after our short jaunt on the ride comes to an end. Nostalgia for that experience must be what lures the crowds, even in its new locale, and how appropriate is that? The elephant ride is one that people never forget.

WATCH THIS – Soarin' Over California (2001)

This Disney short film is no ordinary movie and, alas, it's not one you'll find on DVD. You can only watch it in two theaters, one of them found in Disney California Adventure and the other in Walt Disney World's Epcot (where it's billed simply as *Soarin'*). The movie is part of an incredible attraction that lifts its audience high into the air for a hang-gliding simulator ride, synchronized to the sweeping in-air footage shot specially for the film. Each scene surveys a kaleidoscopic Californian landscape, from rivers and oceans to golf courses and nighttime traffic in L.A., from the Golden Gate Bridge to the Napa Valley, and yes, even to Disneyland — during Christmas season, no less! Wind and aroma effects enhance the experience to make the sensation of flight utterly convincing.

No other movie can so closely replicate the sensory encounter we find in flight on Dumbo. Doesn't it figure that Disney would be the company to make such a film? As is Dumbo, *Soarin' Over California* is a rare concert of sight and sound, matched in perfect harmony.

The Barnstormer

Type: Junior roller coaster

Duration: Under 1 minute

Height Restriction: 35 inches or taller

Popularity/Crowds: Moderate to High

FASTPASS: Yes

Fear Factor: 1.5 out of 5 (zippy speed, modest drops and turns)

Wet Factor: None

Preshow: None

Boarding Speed: Slow

Best Time to Visit: Anytime, but see the Special Comments below

Special Comments: At press time, The Barnstormer has just reopened with a new theme in a different land. So far, wait times are fairly manageable throughout day and night, but crowd patterns will likely fluctuate over time.

Magic Kingdom has always been a place for the young and the young at heart. Now, Storybook Circus is a place for the small and the we-can-pretend-we're-small. That's thanks to The Barnstormer featuring Goofy as the Great Goofini,[24] a new attraction that stretches the Fantasyland theme and makes us question whether we're really the grown-ups we thought we were. Actually, the Great Goofini isn't that new at all.

Back in 1988, a petting zoo called Grandma Duck's Barn, sometimes referred to as Grandma Duck's Petting Farm, opened in Mickey's Birthdayland, a temporary "land" that eventually evolved into Storybook Circus. Children could interact with live animals, including Minnie Moo, a real Holstein cow with a naturally occurring Mickey Mouse silhouette on her side.

Grandma Duck's closed when Mickey's Toontown Fair opened in 1996. The barn structure remained, though, and was converted into The Barnstormer at Goofy's Wiseacre Farm.[25] An apparent "kiddie coaster," The Barnstormer lasted all of 60 seconds and consisted of eight junior-sized cars assembled into a train mocked up like an airplane. The idea was that Goofy maintained a country farm at his Toontown vacation home, and he managed his abundant cornfields by way of crop dusting. In his obviously handmade airplane, he'd give his guests flying lessons.

Junior roller coasters like The Barnstormer are supposed to be gentle and mild. Now, I don't know about you, but I've seen some of Goofy's work over the years, and the idea of flying with him in an airplane that he built himself sounds like anything but tame to me. Sure enough, The Barnstormer packed a surprising punch for a ride of such tiny size. Not that great a pilot after all, Goofy took us through quick dips and zips and, ultimately, right through the wall of his barn.

Adults like myself ended up having at least as much fun as the younger target audience — more than we'd ever care to admit — and that made The Barnstormer the undisputed star of Toontown. Perhaps surprisingly, 9/11 did little to quell the ride's popularity, despite its airplane-through-building storyline and the interna-

tional concern about crop dusters in the weeks and months following the terrorist attacks.

Eventually, though, Goofy's Wiseacre Farm did close. But when it came time to bulldoze Mickey's Toontown Fair so that the Storybook Circus could roll into town, Disney announced to the relief of all children (and, secretly, many adults) that The Barnstormer would return with a brand-new title, backstory, and theme.

The Barnstormer featuring Goofy as the Great Goofini opened on March 12, 2012. Not one inch of the steel track changed, but nearly everything around it did. That means it's the same ride that's been delighting children and surprising adults for nearly two decades. Only the scenery is different. One small barn remains, and that's where guests squeeze into the tiny stunt planes (no longer crop dusters). After that, the ride offers a beautiful, heightened vantage point for surveying the immersive circus environment that makes up this back corner of Fantasyland. It may be a junior coaster of simple frills and modest thrills, but the Barnstormer is a fully realized and completely satisfying experience.

The new storyline posits that Goofy has set up shop as Storybook Circus' resident daredevil. As we approach his plane, we see posters advertising his recent performances — blasting from cannon balls, juggling tigers, dodging swords, and riding a rocket, among others. The Barnstormer is his latest feat and the circus' newest signature attraction, in which Goofy takes to the sky for a stunt show of aerial acrobatics. And we get to tag along for the ride. To quote the press announcement, it's "plane crazy."

"Barnstorming" once referred to pilots who would travel around the country, selling short airplane rides. They usually took off from — or flew over — farmland, essentially what Goofy was doing in Toontown. (The fact that his plane also "stormed," i.e. crashed through, an actual barn added a fun layer of wordplay to the name.) The 1920s saw the advent of "barnstorming shows," aerial performances at county fairs and the like in which stunt pilots would show off flying tricks and daring maneuvers in small

aircraft. That, of course, is the type of barnstorming Goofy's engaged in now. That the Imagineers were able to keep the title despite completely reworking the ride's theme is pretty serendipitous. (Fun fact: when multiple planes barnstormed together, it was colloquially referred to as a "flying circus," and since there are two planes on The Barnstormer track at any given time, this ride becomes a circus act in more ways than one!)

It should also be noted that the Great Goofini is a beautiful sight to behold. With bright colors, abundant sight gags in the queue, and an entrance that looks like it's handcrafted from wood, this new version represents a substantial aesthetic enhancement over Wiseacre Farm. In fact, it's a big part of why Storybook Circus is so much more dazzling than Toontown ever tried to be. Adding to its appeal are the costumes worn by Storybook Circus' cast members — perhaps the most enchanting, comfortable-looking, and form-fitting outfits Disney has created to date.

But in talking about the many factors in The Barnstormer's appeal — the colors, the zippy fun, the credible story it tells — one thing we are not talking about is magic. Goofy is not a wizard. He can't fly on his own, he doesn't cast spells, and he is not the ruler of a kingdom. Sure, he's a dog who walks and talks, but the Disney universe has never really treated "the fab five" (Mickey, Minnie, Pluto, Donald, and Goofy) as enchanted animals. Instead, they've typically been presented as Hollywood stars in their own right, bona fide celebrities who just happen to be anthropomorphic animals.[26]

At Goofy's Wiseacre Farm, Barnstormer contributed to the Mickey's Toontown Fair theme in a way that made sense. If the land was a country vacation home for the characters, why shouldn't Goofy maintain a farm there? And how better to explain a short flight over farm crops than with a crop dusting storyline? Even in a ride primarily intended to give youngsters their first taste of rollercoastering, Disney again demonstrated its commitment to a legitimate narrative.

But how does Goofy fit in Fantasyland? That's the question

many were asking when The Barnstormer featuring Goofy as the Great Goofini opened in Storybook Circus. Remember that unlike Mickey's Toontown Fair, Storybook Circus is not its own land inside Magic Kingdom. Rather, it is a subset of Fantasyland. Dumbo qualifies as fantasy because he's an elephant who flies and hangs out with a mouse who talks. No one questioned Dumbo the Flying Elephant as part of Fantasyland back when it was located right behind the castle, and no one questions it now. Goofy's different, though.

The Great Goofini might sound like a magician's name, but that's not the story here. He's actually a professional daredevil, Fantasyland's answer to Evel Knievel — in the Great Goofini meet-and-greet, Goofy stands beside a motorcycle in a steel cage. Those are the kinds of wonders he performs. You need any number of things to stage those types of shows, but a spell book isn't one of them.

Clearly, there is more cartoon than fantasy in this attraction. Whereas Dumbo's flight and Casey Jr.'s self-animated railway journey require a bit of imagination to embrace, The Barnstormer's story about a hijinksy plane could easily unfold in real life. Indeed, in the 1920s, it often did. The extent to which Goofy's flight goes awry (crashing through a billboard and whatnot) *is* a bit outlandish, borrowing from the spirit of Walt Disney's short-subject cartoon films, but that's what we'd expect to find in the old Toontown, not necessarily New Fantasyland.

The fact that The Barnstormer can't be adequately defended as a work of "fantasy" might give us pause if we consider the attraction by itself. I prefer to look at it in the context of its next-door neighbor — Dumbo the Flying Elephant.

Dumbo hit theaters in October 1941, a time when feature-length films were frequently accompanied in theaters by one or more short-subject cartoons. The 1930s through the 1960s marked the golden age of the cartoon short, though it's made something of a comeback in recent years.[27] The cartoons would usually play

before the feature film as appetizers to warm up the audience and give them added value for the price of admission.

We might think of the Great Goofini in the same way. It's the rollercoaster equivalent of a cartoon short, playing for Storybook Circus audiences as an adjunct to Dumbo next door. Given that nearly everything else in Storybook Circus is *Dumbo*-themed, it stands to reason that Goofy is there as a sort of opening act, a role that he and his "fab five" brethren have filled well for nearly a century.

Cartoons bring out the kid in all of us and The Barnstormer does that too. It's probably the ride's best quality. Kids love it because the thrills are tailor-made for them, and we adults love it precisely because the thrills *aren't* made for us. Disney lets us experience them anyways, and there's something about how our adult bodies fling around those tiny, sharp curves that exhilarates us.

Perhaps there is a little bit of fantasy in the Great Goofini, after all, then. It lets grown-ups pretend that they're young again, with body sizes and recreational sensibilities to match. If we're to be entirely honest with ourselves, it's a teeny bit ridiculous that we're riding it (and I'm sure there are some readers who wouldn't go near it and think I'm crazy for doing so), but the ridiculousness is half the fun, isn't it? That's what being goofy is all about, and in Storybook Circus we learn how to get goofy from the best.

WATCH THIS - The Big Wash (1948)

Goofy plays a circus worker in this animated short film, which ran in theaters during 1948, just seven years after *Dumbo*. He tries his best to bathe a circus elephant named Dolores, but she's having none of it. This was the second of Dolores the Elephant's appearances in Disney's cartoon canon. She's also seen in *Tiger Trouble* (1945) and *Working for Peanuts* (1953).

At just over seven minutes, *The Big Wash* provides plenty of the

character humor and sight gags that made Disney cartoons reliable box office diversions. We experience the same kind of fun in our short jaunt aboard The Barnstormer. Seeing Goofy in circus garb makes this one feel like a natural lead-in to Storybook Circus.

In fact, the cartoon just might have inspired The Barnstormer itself. As guests walk through the queue, they pass by a crashed rocket with the name Dolores painted on its side. The same can be seen in one of the posters on display there. While no explanation is given for the name, one might easily conclude that it's the Imagineers' subtle nod to Dolores the Elephant's circus role in *The Big Wash*.

Mad Tea Party

Type: Spinning teacups
Duration: 2 minutes
Popularity/Crowds: Moderate
FASTPASS: No
Fear Factor: 2.5 out of 5 (fast spinning; some guests experience motion sickness)
Wet Factor: None
Preshow: None
Boarding Speed: Slow
Best Time to Visit: Morning, early afternoon

Walt Disney was a man ahead of his time. He filmed his TV shows in color when there were no color TVs. He made a major investment in a theme park when the market for one didn't really exist. He produced the first animated feature film when conventional wisdom had it that audiences would never sit still for a long cartoon. In nearly all of his endeavors, he was ahead of the curve. He even got a jump on the 1960s drug culture with the release of *Alice in Wonderland* in 1951, though something tells me that wasn't his intention. Illegal drug use is nevertheless an important part of the movie's cultural history and the same might be said of its most notorious theme-park offshoot, the Mad Tea Party.

Alice was a relative flop when it hit theaters in 1951. Critics tore the movie apart for taking substantial liberties with author Lewis Carroll's source texts and audiences didn't connect with it either. The tepid reception and underwhelming box office led even Walt Disney himself to later lament that the film had no heart. That's not really how audiences view the movie today. While *Alice* doesn't enjoy the popularity of, say, *Lady and the Tramp*, it's now widely revered as a classic and continues to perform well on home video. So what changed? The times.

With the rise of the counterculture movement in the 1960s and its affinity for recreational drug use came a phenomenon casually referred to as "head films," movies that hippies liked to watch while high. By the late 1960s, Disney's *Alice* had become one, as had *Fantasia*. Strange, isn't it, that *Alice* would emerge as a head film when so much of its dialogue concerns the removal of heads? Then again, stoned college kids probably weren't using their heads at all. They were too mesmerized by the movie's mushroom eating and flower singing, all of which seemed to resonate so profoundly with their favorite extracurricular activities. Also enchanting the psychedelic set were all the film's bright colors, Alice's constantly altering body size, the Mad Hatter's tea-induced inebriation, the hookah-smoking caterpillar. . . okay, maybe they were onto something. But even if the flower children missed the whole point of the movie, they did serve a very important function — they brought *Alice* and *Fantasia* back from the dead. The psychedelic era largely faded away but those movies' renewed renown never did. Both unsuccessful in their initial runs, they're widely embraced and celebrated as family standards today.

Fortunately, when Disneyland opened in 1955 there weren't that many Disney movies to choose from. That meant that even the less successful ones were on the table as possible inspirations for new attractions, *Alice* included. The most famous *Alice in Wonderland* attraction is Mad Tea Party, which was running on opening day at both Disneyland and the Magic Kingdom. The spinning teacups ride requires little description — climb into an oversized

teacup and spin yourself around until the music stops. While you twirl in one direction, the giant platform below you moves in the other. The surrounding cups whirl both ways at the same time. Basically, there's a lot of spinning going on, like a hip hop DJ with a giant turntable — and everybody in the cup's gettin' dizzy.

Indeed, nausea is the ride's signature sensation. Mad Heave Party might be a better name, as a small percentage of riders do in fact end up heaving like mad when they get off, while many more are just mad to be queasy. Taking their first steps out of the tea-cups, off-balance guests stagger toward the exit with all the grace and precision of a zombie stumbling back from the dead. (Incidentally, this is one of the Magic Kingdom's top spots for people watching.) Like a sudden bout of vertigo, a ride on the teacups can make the whole park spin before your eyes. Fortunately, the effects are temporary and their incidence varying. In my many whirls 'round the teapot, I've been plenty dizzy, but I've never been sick. I'm too busy thinking about the intriguing ways the ride takes all of us down the rabbit hole and into *Wonderland*.

The dizzying sensation in Mad Tea Party relates back not only to the "dazed and confused" experience responsible for the film's renaissance but also to one of the major themes in both Carroll's books and Disney's film — Alice's profound sense of bewilderment. The very idea of Wonderland is inherently horrifying — a realm where nothing is as it seems, no one can be trusted, and nonsense pervades. In the first *Wonderland* book, the Cheshire Cat confesses to Alice, "We're all mad here." How utterly nightmarish! The Mad Tea Party echoes that madness while in motion. As the Fantasyland vista becomes a streaking blur, what once was clear becomes cloudy and indecipherable. Before long, we struggle to stay sure of the direction we're moving in. The temporary discombobulation is uncomfortable, just as Wonderland is for Alice.

In the moments after the ride ends, the theme of confusion sets in with even greater depth. Producing in us actual, momentary malaise, the teacups make real for us the sickening sense of being

lost and muddled that moves Alice to tears in Disney's film. Few attractions can so physically unite us with a character's feelings.

Rare, too, is the Disney ride that focuses squarely on a single movie scene instead of the story as a whole. The Mad Tea Party unfolds entirely inside the Mad Hatter's ridiculous Unbirthday party. The especially vibrant and bizarre sequence was a favorite among hippies and its Fantasyland counterpart is every bit as far out, demonstrating again that a Walt Disney World vacation can be a trip in more ways than one.

WATCH THIS – Alice in Wonderland (2010)

Disney's big budget, Tim Burton-directed sequel to Lewis Carroll's *Alice in Wonderland* novels made major bucks at the box office but didn't quite get its due with critics.[28] The philosophically robust premise finds Alice all grown up and barely able to recall her first visit to Wonderland. So distant is the memory that when she sees a rabbit running through the garden in a waistcoat, she doesn't think twice about chasing after it. We viewers know where she's heading, of course, or so we think. She falls down the rabbit hole again, but when she gets to the other side, it isn't Wonderland. This time, she's in a place called Underland.

Tim Burton masterfully takes us through the original *Alice* story all over again, seen not through the eyes of an easily befuddled and overwhelmed child, but from a young woman's perspective. Wonderland is not what Alice thought it was the first time she went there. As we realize that so much of what she misconstrued as nonsense is in actuality sinister and real, we're challenged to reconsider the observations we've taken for granted from our own childhoods. With screenwriter Linda Woolverton, Burton delivers a brilliant thought experiment that is nearly as pensive and profound as Carroll's original texts. Alice's bewilderment, which is engaged so uniquely in the Mad Tea Party, is reexamined and clarified in what might be Tim Burton's smartest movie.

Cinderella Castle

Type: Walk-through environment

Duration: Unlimited

Popularity/Crowds: Moderate to High

FASTPASS: No

Fear Factor: The "Dream Along with Mickey" stage show features Disney villains, which might frighten some children

Wet Factor: None

Preshow: None

Best Time to Visit: Anytime

Special Comments: There is very little to tour in the castle itself, unless you're visiting Bibbidi Bobbidi Boutique (for a princess or knight makeover for the kids) or Cinderella's Royal Table (for character dining). Reservations are imperative for both. But you should definitely walk through it if you have the chance. See daily Times Guide for scheduled performances of "Dream Along with Mickey."

For many people, the thing they're most anxious to do on their first trip to Walt Disney World isn't getting on a ride or meeting a character, but simply laying their eyes on the castle. Cinderella Castle is an icon not only for the Magic Kingdom but also for our culture, and visiting it in person is a rite of passage. The park's colossal centerpiece rises high above the rest of the Kingdom, visible from the other side of Seven Seas Lagoon, which guests must cross just to get there. Like a skyscraper or a star on the horizon, it beckons travelers from afar. It is the ultimate visual beguiler and also the thing that makes the rest of the park's narrative click. If the basic premise of the Magic Kingdom is an escape into fantasy, then the castle, just by being there — a full-sized storybook palace in the real world — makes that escape credible. It transforms fantasy into reality.

Even in Europe, where castles are common, they don't look quite like this. Cinderella's home is surreally opulent, sparkling and massive, sporting all the elegance of royal luxury but few of the practical features that would have been mandated by the

need for defense in times of war. This is the kind of estate that only a make-believe monarchy could call home, and yet the castle *is* part of a kingdom. That's the story anyway, and when we venture inside its mysterious corridors and along its perimeter walls, we discover the extent to which the building really does reinforce that idea.

Walt's first castle was built in Sleeping Beauty's honor and it still stands in Disneyland today. Years later, when he and his team started plans for Magic Kingdom, they decided to give Cinderella dominion there instead. The blueprints, borrowed from a long list of famous castles,[29] most of them in France, also referenced both Disneyland's castle and the palace drawings in the animated *Cinderella* (1950). The end result is that Magic Kingdom's castle is substantially larger (and much less pink) than Disneyland's, but each boasts its own, unique charm.

That most of the source castles are French is significant. The "Cinderella" fairy tale that inspired Walt's movie is French too, or at least the most famous version of it is, written by Charles Perrault[30] in 1697. The main floor of the castle interior is open to the public and inside it, the walls are intricately decorated with colorful glass mosaics that illustrate the "Cinderella" story as told by Perrault, with just a few touches of Disney's version. Had the mosaic relied exclusively on the cartoon feature, it wouldn't have been as effective in introducing us to Fantasyland as the realm of olden fairy tales.

Once upon a time, we found one of the resort's most intriguing gift shops inside the castle itself. The King's Gallery dealt not in plush dolls and collectible pins, but shields and swords, and was also well stocked with impressive porcelain and glass. This knightly retailer recognized both the obligations of battle and the spoils of war that were all part of royal life.

In 2007, The King's Gallery shipped some of its merchandise over to Main Street and closed for conversion to Bibbidi Bobbidi Boutique, a fanciful salon in which little girls can be given a makeover as a princess of their choosing and boys can be dubbed

knights. Whereas Prince Charming Regal Carrousel shifted attention away from Cinderella and toward the oft-overlooked men of the kingdom, the opening of Bibbidi Bobbidi Boutique erased a rare nod to *Cinderella's* king[31] (who, let's face it, is pretty out of shape and not much of a swordsman). But while the loss of The King's Gallery was sad, the new boutique is just as good at engaging with the fairy tale.

The story goes that the Fairy Godmother, who we all know to be proficient in rags-to-riches makeovers, is teaching her apprentices the art of transformation and the little girls in the Magic Kingdom get to be their guinea pigs — for a price. Fortunately, the godmothers in training do a pretty good job. With a curtsy, they bid beaming girls adieu with fancy new face paint and hairdos. Boys aren't completely ignored. If they haven't already been transformed into a buccaneer at The Pirates League station in Adventureland, they can sign up for Bibbidi Bobbidi's "Knight Package" (a much better name than the "Cool Dudes" option it replaced).

Across the hall from Bibbidi Bobbidi Boutique is the entrance to Cinderella's Royal Table, easily the most coveted dining experience in Walt Disney World. The restaurant, located on an upper level within the castle, serves three meals a day and all of them require reservations, usually months in advance.[32] Inside, we can see why there's such a fuss. As gorgeous and grand as the castle corridors are, Cinderella's Royal Table is even more exquisitely detailed. While the royal chef warms up the kitchen, the castle staff seats us at our table, which might be beneath a canopy of imperial flags or in front of beautiful windows overlooking Fantasyland. Cinderella is on hand to greet all the diners, and so are her friends. Yes, that means all those mice are on the loose, but they're giant-sized, which I guess is supposed to make us feel better about it. Maybe Pixar's *Ratatouille* destroyed the taboo surrounding French rodents serving dinner. The *Cinderella* story continues with a greeting from the Fairy Godmother, who leads the room in a chorus of "Bibbidi-Bobbidi-Boo" and teaches everyone how to cast the spell.

Cinderella's Royal Table was known as King Stefan's Banquet Hall until 1997. Before you get worked up about yet another instance of Cinderella throwing her weight around inside the castle, allow me to point out that King Stefan is actually Sleeping Beauty's father. Cinderella was very gracious to allow another king to host his banquets in her castle for all those years, but we can see why the name needed to change — the real mystery is why it took until 1997 for that to happen. Today, the restaurant is one of the most special things about the Magic Kingdom, a unique storybook experience hidden inside one of the world's most famous castles — even if the consensus is that there's better food elsewhere at Walt Disney World. Knowing that the giant building is more than just a hallway and a façade makes it more credible as an actual castle. The competition for reservations also lets the fortunate few who get their names on the list feel like royalty.

If the Royal Table is exceptional because it's on the second floor of the palace and hard to get into, the Cinderella Castle Suite is once-in-a-lifetime extraordinary. Originally intended as an apartment for Walt and his family, this room perched high up in one of the castle towers was just an office for years, until Disney converted it into the single most luxurious hotel room in all of Walt Disney World. During the "Year of a Million Dreams," which ran from the fall of 2006 through early 2009 (more than a year, I know), one lucky family visiting the park each day was selected at random by Disney's elusive Dream Team to stay in the suite overnight for free. When the promotion ended, so did the chance to sleep in the castle, and until something new is announced, there's no way to reserve it for even one night.[33] Still, as with the Royal Table, just knowing the suite is there makes the whole castle that much more exciting.

From the glass mosaics to the restaurant and boutique, the castle interior is mostly devoted to the *Cinderella* story, as it should be. They call it Cinderella Castle for a reason. On the outside, the building is used to tell a broader story about the entire park, supporting the idea that the Magic Kingdom is an actual *kingdom*

with detail that extends well into Fantasyland. In fact, the barrier that separates the park's most admired land from its neighbors is a fortress wall extending out from the palace itself in two directions, as if the castle walls are protecting the medieval village[34] of Fantasyland from outsiders. Behind every attraction façade in Fantasyland's castle courtyard, we can see the familiar blue-gray brick and stately turrets of the castle. When you are in the great open plaza that greets you after you have walked through Cinderella Castle, take just a moment to stop in the middle and turn around in a circle. You'll see that you're actually standing in a castle courtyard, protected by the impenetrable walls of the royal estate.[35]

The Imagineers' imposing castle hides Fantasyland from view until the visitor has passed through its gates. It is an architectural reminder not only that this is intended to be the Magic Kingdom's signature "land" but also that Disney is absolutely dead set on convincing us that it is real. Ancient kingdoms had barrier walls; so does this one. Here again, we see the attention to detail that is hard to come by elsewhere in the theme park industry, and I submit that Disney's brand of full-fledged storytelling is precisely the thing that holds its audience spellbound.

I mentioned earlier that Cinderella Castle isn't bogged down with the defensive mechanisms that real castles used to fend off attack, but the barrier walls are an exception to that. They suggest that Fantasyland does need protection, and that begs the question — from what? We find the answer in a stage show that's mounted in the castle forecourt several times every day, "Dream Along with Mickey."

The production begins as a happy gathering for the main mouse and his gang, complete with surprise guests like the princesses and Peter Pan. Some of the park's newest technology is on display, allowing the "masked characters"[36] to blink and move their mouths in synch with the pre-recorded dialogue, creating the very believable illusion that these anthropomorphic personalities are actually speaking for themselves. There's singing and dancing and some admittedly trite banter about believing in

dreams, but before long, *Sleeping Beauty*'s Maleficent crashes the party, as she's prone to do. Along with her villain friends, she's intent on returning to power by overthrowing the Magic Kingdom and seeking revenge for her downfall. Fantasyland isn't under threat from foreign combatants, you see (though I do suspect Universal Orlando might take a battering ram to the castle if given the chance). It's those evil villains they've got to worry about. "Dream Along with Mickey" doesn't go so far as to link the war against the bad guys with those imposing castle walls, but the connection is there for the audience to appreciate if they give it some thought.

And why shouldn't they? We travel from afar to visit national monuments like the Statue of Liberty or the Eiffel Tower, contemplating their symbolism and admiring their every detail. Just as those masterpieces are landmarks of our history and technology, Cinderella Castle and its fellow park icons are landmarks of our popular culture. They have as much importance to the generations who've grown up with them as many of the most notable historical sites have. In Europe and other parts of the world, castles have long been important national monuments. In the same way, Cinderella Castle is a monument for the United States, pop culture, and the imagination.

WATCH THIS - Enchanted (2007)

Princess Giselle (Amy Adams) spends most of her days whistling and playing dress-up with the woodland animals living in her entirely hand-drawn, hyper-cartoony world. That changes when the nefarious Queen Narissa (Susan Sarandon) banishes her to the live-action real world of New York City, circa 2007. There, she meets a disillusioned attorney (Patrick Dempsey) and spruces up his life with the kind of cheery housecleaning and random musical outbursts that only a true Disney princess can provide.

Part tribute, part parody, *Enchanted* is a hilarious, brilliant, and loving satire of Disney feature filmmaking. It is a delicious (and rare)

example of Disney spoofing Disney. The confusion Princess Giselle feels when she's maliciously expelled from her animated kingdom and hurled into New York is not unlike Alice's experience when she falls into Wonderland. Be that as it may, in this winning musical, the perplexity is played for laughs. Amy Adams was showered with Best Actress nominations for her pitch-perfect performance as a thoroughly clueless damsel, inspired by the Disney heroines of the past. As with Cinderella Castle and everywhere else in Fantasyland, the intersection of the fairy tale with modern day reality creates irresistible fascination.

Chapter 5

Tomorrowland

"A vista into a world of wondrous ideas, signifying man's achievements... a step into the future, with predictions of constructive things to come. Tomorrow offers new frontiers in science, adventure, and ideals: the Atomic Age, the challenge of outer space, and the hope for a peaceful and unified world."[1]

Walt Disney, "Dateline: Disneyland," July 17, 1955

It's interesting that Walt mentioned a "challenge" in this dedication. I'm not sure he realized then just how challenging Tomorrowland would be, not just in the Magic Kingdom but in all the Disney resorts around the world, though each has its unique issues. Tomorrow is always just two days away from being yesterday, and theme parks sadly don't change as quickly as the times. That inherent difficulty makes Tomorrowland the most difficult land to read, but also perhaps the most thought provoking.

Our walk through the eight primary attractions that make up Tomorrowland — the Tomorrowland Transit Authority People-Mover; Buzz Lightyear's Space Ranger Spin; Tomorrowland Speedway; Astro Orbiter; Monsters, Inc. Laugh Floor; Stitch's Great Escape!; Walt Disney's Carousel of Progress; and Space Mountain — will be our most intertwined and layered yet, as we delve into the annals of Disney history to unlock the narrative

curiosities of this most stimulating land. As is often the case, much of the future is in the past, and any good exercise in time travel takes us to that crossroads. That's especially true in Tomorrowland, an area that is positively brimming with activity, optimism, other-worldliness, and the kind of wrinkles in space-time that make for a bona fide sci-fi classic.

Tomorrowland Transit Authority PeopleMover

Type: Tram ride

Duration: 10 to 12 minutes

Popularity/Crowds: Moderate

FASTPASS: No

Fear Factor: None

Wet Factor: None

Preshow: None

Boarding Speed: Very fast

Best Time to Visit: Anytime

I can't urge you enough to make the Tomorrowland Transit Authority PeopleMover the first thing you do in Tomorrowland. Not just because the line is never long or because there's a cream cheese pretzel stand next door; and not because you can annoy your friends by insisting that they use the full Tomorrowland Transit Authority PeopleMover name at all times. Those are all excellent benefits of the PeopleMover experience but there's a more important reason to make a beeline for it. This oft-forgotten ride provides important context to an area of the Magic Kingdom that might not otherwise make sense.

To fully appreciate the attraction, it helps to have an understanding of how it has evolved over time and acquired its rather unwieldy name, one of the longest in any Disney park. Like so many other Disney classics, the Tomorrowland Transportation Authority PeopleMover can trace its roots back to the 1964 New York World's Fair, where Disney first created the Ford Magic Skyway. Sponsored by the car company of the same name, the slow-

moving ride took guests sitting in the latest Ford convertibles on a tour of prehistoric dioramas.[2]

After the World's Fair closed, the Magic Skyway concept moved to Disneyland where, on July 2, 1967, it opened with a new sponsor (Goodyear) and a new name — the PeopleMover.[3] The ride served as a sort of mobile preview center for the recently re-designed Tomorrowland. The sleek new train cars, which replaced the convertibles, moved along an elevated track to give guests an up-in-the-air view as on-board narration gave guests a rundown of the attractions below.

The name remained unchanged until 1982, when part of the ride (an enclosed sequence called the SuperSpeed Tunnel) was given a *Tron* overlay in support of that cutting-edge sci-fi flick's theatrical premiere. The name was changed to PeopleMover Thru the World of Tron and it stayed that way until Disneyland shut-tered the ride for good in 1995, reusing the track for a mild new thrill ride called Rocket Rods, which ran from 1998 to 2001. The track still stands in Disneyland, entirely unused despite persistent demands from the nostalgic to bring the PeopleMover back.

Fortunately for fans of the ride, a technologically advanced version of Disneyland's PeopleMover had opened in Walt Disney World's Magic Kingdom on July 1, 1975. Initially, Florida's adap-tation of the ride was simply called the WEDWay PeopleMover. WEDWay was the name for the track itself, inspired by Walter Elias Disney's initials. The narration was similar in tone but, visu-ally, the WDW version was a striking departure from the covered cars and bare track found in California. The Magic Kingdom's PeopleMover consisted of a roofless train gliding along a highly stylized and partially enclosed, tunnel-like highway in the sky. Ten years later, in 1985, the narration changed styles, with a "Commuter Computer" taking over the spiel.

Little else changed until 1994. In that year the Magic King-dom unveiled a massive overhaul for Tomorrowland with two chief goals in mind. First, work around the problem inherent in a land themed around the future — the fact that society's vision

for tomorrow is forever changing. Second, enhance the land's urban vibe.

The Imagineers dreamed up a new approach to Tomorrowland that could kill both birds with the same stone. Billed as "the future that never was," the new Tomorrowland created a fictional city of the distant future based on the futuristic imaginings of early 1900s urban visionaries. In the new narrative, the city of Tomorrowland is Earth's ambassadorial center for the intergalactic League of Planets. The new metropolis has all the makings of a living, breathing city, including a major metro system — the WEDway PeopleMover . . . only it wasn't called that anymore.

With the new theme came yet another new name, the Tomorrowland Transit Authority, more commonly referred to as "the TTA." The renovated TTA, now outfitted in a showy metallic finish, reflected Tomorrowland's evolution more than any other attraction. Riding it became the best way to understand the new future-city concept. The new narrator's spiel fully reflected the updated storyline, welcoming guests aboard the Tomorrowland Metroliners, part of a mass-transit system that would take them from the city's central spaceport to a variety of stops along the route (none of which actually existed). The booming, almost otherworldly voice lent new personality to the ride and referred to the TTA with a number of nicknames — Blue Line, Super-Skyway, and Grand Circle Tour, among others, all of which became part of Disney fans' vernacular.

The 1994 version of the ride lasted longer than any other to date, making itself an indelible part of Tomorrowland memories for many millions of visitors. By 2009, however, the script was again showing its age, failing to include several of the more recent attractions in its Tomorrowland tour. Rather than merely updating the existing spiel, Disney unveiled yet another incarnation of the TTA in September 2009, alongside a modestly re-themed Space Mountain. The all-new narration marked something of a return to the personality of Disneyland's original PeopleMover

ride, with a more friendly-sounding narrator acting as a sightsee-ing guide.

The next year, in August 2010, Disney went and renamed the ride yet again with its current title — the Tomorrowland Transit Authority PeopleMover, which gives a nod to the pre-1994 no-menclature and better reflects the tone of the new narration. I like to call it the T-TAP. Lots of other people like to call it lots of other things, too, so you practically need a PeopleMover lexicon to com-municate coherently about the thing.

The newest iteration of the ride is less effective than the one that ran from 1994 through 2009. Before, the spiel served as a dramatized municipal orientation of sorts. Welcoming guests who'd traveled through time to a fictional city of tomorrow, it told them how the Metroliner worked and where it could take them. Now, the narrator is positioned more as an instructional guide for visitors in the present age. His spiel advertises attractions as attractions, rather than as important hubs for galactic travel. Guests still get an overview of the land below, but the storytelling element is seriously diminished. Without it, the inviting premise of Tomorrowland-as-metropolis is harder to discern. Unaware that they're visiting a futuristic fantasy rooted in an earlier era and not a contemporary designer's prophecy for tomorrow, fans and casual guests alike might wonder why so much of Tomorrowland feels decidedly passé. Even when state-of-the-art isn't their goal, the attractions can't help but feel dated with the rapid passage of time.

In fact, one of the most fascinating things about the T-TAP is the way it shines a light on Tomorrowland's fundamental chal-lenge of keeping up with our ever-changing idea of what tomor-row looks like. As the land's lifeblood, the T-TAP is always changing in an attempt to adapt at minimal expense. Of course, accommodating transformation on a budget is something real cit-ies grapple with all the time, so maybe Tomorrowland is a more realistic municipality than it seems.

In its present form, the ride still works to suggest city life. For starters, the idea of a metro isn't dropped altogether. Even without the city talk, there are a few references to this being a mass-transit system. The new script encourages people-watching too, always a favorite cosmopolitan pastime. The Imagineers have also preserved a loudspeaker page for a "Mr. Tom Morrow," a creative touch that lends credibility to the cityscape. The page was so popular during the 1990s and 2000s that when it briefly disappeared in 2009, outraged fans successfully demanded its return the next year (well, almost successfully — the current recording is slightly different than before[4]). Ultimately, though, what you *hear* on the ride is now less valuable than what you see and feel.

With its mere presence, the T-TAP instantly defines Tomorrowland in a snapshot. Encasing the perimeter, wrapping around the curvature of each attraction, winding across the walkways, and curling up around the Astro Orbiter centerpiece, the People-Mover makes quite the visual impression with just one glance. The ride never stops running, and its perpetual motion makes Tomorrowland look positively kinetic. The constant locomotion on the T-TAP is juxtaposed with the visible movement of the Astro Orbiter's jets, the Indy Speedway's racecars, the Carousel of Progress's rotating show building, and the Walt Disney World Railroad's train. Everything's moving, a veritable Tomorrowland motionscape, and the T-TAP pulls it all together.

The sights seen from the tram are pretty out of this world too — quite literally, if we buy into the story. The T-TAP actually travels inside two Tomorrowland attractions, passing by a scale model of Walt's original dream for EPCOT along the way. One of those is Buzz Lightyear's Space Ranger Spin, which ostensibly takes us out of Tomorrowland and into the evil Zurg's outer space empire (more of that a bit later). The other is Space Mountain, the Magic Kingdom's star attraction (no pun intended). As the name implies, Space Mountain is set in the cosmos and looks the part. As the T-TAP travels into those rides, the Tomorrowland story-

line takes guests from a thriving city center to outer space in the blink of an eye — a very futuristic idea, indeed. That bold vision of transportation is one of the most exciting and intrepid ideas in Tomorrowland.[5]

From a storytelling perspective, the journey into Space Mountain is terrifically effective as a foreshadowing device. Though T-TAP's thrills are modest, Space Mountain's looming galaxy of the unknown is a real source of apprehension for many guests. The suspense starts to build with the first step into Tomorrowland, when the mountain's intimidating spires first appear on the city skyline. The T-TAP knows that and is a total tease about it, showing just enough scream-filled blackness inside the ride to psych out the fearful completely. That's another principal reason for riding T-TAP before anything else in the land — it really nudges the nerves.

Among the many phrases Walt Disney is famous for are these three words — "Keep moving forward."[6] The Tomorrowland Transit Authority PeopleMover does just that. For one thing, the ride contemplates the future, looking forward to a day when the subways will be sky-borne. It also *literally* never stops. The tram keeps moving, but eventually, you have to get off. When you do, you'll be ready to fully appreciate the rest of the Tomorrowland experience awaiting you.

WATCH THIS – Meet the Robinsons (2007)

"Keep Moving Forward" is a key phrase in Disney's 47th official Animated Classic.[7] The CGI movie follows a genius orphan boy named Lewis as he's whisked off to the future by another young man, Wilbur Robinson, in a time machine. Together, they travel to the year 2037, where Lewis meets the large and idiosyncratic Robinson family, a clan so eclectic that he fits right in. Wilbur needs Lewis's help in fixing another time machine, but there's clearly more to his motivation. While Lewis tries to figure it out, he and Wilbur must always

keep one step ahead of the evil Bowler Hat Guy, one of the all-time great comedic villains.

Bob Iger became CEO of the Walt Disney Company just a month before *Chicken Little* was released to theaters in November 2005, so *Meet the Robinsons* was considered to be the first Disney Animated Classic of the new Iger era. Following years of a nasty and very public battle[8] between the previous CEO, Michael Eisner, and Roy E. Disney (Walt's nephew and a big player in the company at the time), Iger was intent on sending a message — things will be different now. Accordingly, *Meet the Robinsons* is dedicated to Walt and his legacy, and the movie's primary themes are closely aligned with those that are often associated with the founder. One such theme is innovation. The movie demonstrates a very vivid and original imagination for what the future might look like, right down to transportation via floating bubble. In one memorable scene, Lewis and Wilbur pass over Tomorrowland itself, only 30 years from now, where it's winkingly presented as "Todayland."

This underrated movie has tremendous spirit, a great sense of humor, and an appreciation for the filmmaking values that have historically set Disney apart. First and foremost among those values is the need for a solid story, and *Meet the Robinsons* certainly has one. The playful nods to Disney history are a nice touch, too.

Buzz Lightyear's Space Ranger Spin

Type: Dark ride with interactive laser guns

Duration: 5 minutes

Popularity/Crowds: Moderate to High

FASTPASS: Yes

Fear Factor: None

Wet Factor: None

Preshow: None

Boarding Speed: Fast

Best Time to Visit without FASTPASS: Early morning or later in the evening

Buzz Lightyear's Space Ranger Spin is a world within a world within a world. Two of those worlds are set in the future, one is not, and it's the middle layer that creates a big problem for Tomorrowland's premise. And yet somehow, the video game-inspired ride gets away with playing fast and loose with the whole future theme. Video games are *virtual* experiences, after all, and "virtual" is just another way of saying "close enough." That's Buzz Lightyear's Space Ranger Spin for you — close enough... and a lot of fun.

The ride opened in the Magic Kingdom on November 3, 1998, in a building that had been occupied by an airplane-themed ride (in various incarnations) since the park's opening day. While it kept the same basic layout, Space Ranger Spin did away with the airways idea altogether and introduced a considerably more ambitious kind of ride. Through the magic of optical illusions, guests walk out of Tomorrowland and into Space Command, where they instantly shrink to the size of a toy.[9] A towering and life-like Buzz Lightyear awaits them inside, ready to induct all newcomers as immediate space cadets. The new recruits are ordered into the cosmos where they'll do battle with the galaxy's most notorious buzzkill, the evil Emperor Zurg. Space vessels arrive in no time, and cadets are then paired off and given one laser gun each. The ride vehicles follow a typical dark ride track, steadily inclining to simulate entry into outer space, where the cadets come under attack right away. It's never spelled out explicitly, but they've entered what is supposed to be — and indeed very much looks like — a Buzz Lightyear video game.

Zurg's army of toy aliens and accessories are outfitted with infrared targets bearing a giant "Z." Some are easy to tag; many of them are not. Each successful shot earns the responsible marksman a given number of points. The values are determined in large part by the difficulty of the target, many of which are in motion and far away. Fortunately, the cadets have an advantage over some of their alien adversaries because the space vessels are equipped with a joystick that can rotate the vehicle a full 360 degrees for

optimal aim. Immensely interactive, the ride keeps its gamers on their toes and ensures their attentiveness to the rich detail in each of the show scenes.

Of course, that means that riders will spend most of their time thinking about the innermost level of the ride — the Buzz Lightyear video game in which the ride's primary narrative unfolds. Walking into Buzz's virtual world from Tomorrowland outside, one might easily overlook the storyline that gets us from the Magic Kingdom to Buzz' Space Command — the world of *Toy Story*.

Tomorrowland takes place in the future and Buzz Lightyear's video game seems to as well. *Toy Story*, on the other hand, is set in the late 20th century. Conceptually, then, we must first travel back in time before continuing on in the future. The theme park asks its guests to leave the imaginary land of Tomorrow and return to a present-day mindset, where a contemporary video game provides the characters and future-oriented storyline used in Space Ranger Spin. I doubt many guests pause to reflect on the narrative time warp but I do think many come away thinking that the ride doesn't *feel* particularly futuristic. That's because the whole thing is about playing a video game, which isn't at all on the cutting edge of recreation. In fact, video games are nearly as old as the Magic Kingdom itself, and the point-and-shoot style of Space Ranger Spin would be more relevant in Todayland than Tomorrowland.

Consider also Disney's current concept for Tomorrowland. As established during its major 1994 reboot, the land is intended to be a future fantasy inspired by early twentieth century visionaries. Space Ranger Spin's galactic battle is certainly a future fantasy, but it was created by late, not early, twentieth century imaginations. The attraction breaks away from Tomorrowland's founding narrative and requires a momentary departure from the otherwise-immersive illusion that guests have traveled into the future.

But perhaps the ride is due some leeway, given that video games are all about approximation. Space Ranger Spin is ultimately a

life-sized video game and a very unusual one at that. How many electronic games actually transport guests inside their world and make them part of the action? Okay, there was Nickelodeon's 1992 game show "Nick Arcade," but unless you were a lucky young teen at the time, you never got to take part in that. For most of us, laser tag dark rides like Buzz,[10] Duel: The Haunted House Strikes Back! at England's Alton Towers, and Men in Black: Alien Attack at Universal Orlando are the closest we can get to total immersion inside the video game universe, and Tomorrowland's Space Ranger Spin is the most fully realized of its generation.[11]

Feature-length animation hasn't been the same since *Toy Story*'s release in 1995. Pixar revolutionized the movie industry by delivering the first major CGI success at the box office. More importantly, they also told a very good story with a cast of endearing characters. That's true of both *Toy Story* sequels, too (not to mention most other Pixar films). *Toy Story* captivated audiences with a supremely intriguing premise — when the child's away, the toys will play. The Pooh stories had charted similar territory decades prior, but Pixar brought a delicious air of mystery to the idea. Whereas Christopher Robin knows that his toys are alive (albeit only in his imagination), Andy doesn't have a clue what's going on when he's not home. And *his* toys are adventuring into the real world, to boot.

To some extent, Buzz Lightyear's Space Ranger Spin does for the video game what its inspiration, *Toy Story*, does for the toy. In the ride, a video game is brought to life and made immensely appealing, just as toys are in the films. The parallel isn't perfect, mind you. I doubt you'll feel the same compassion for a game cartridge that you'd have for a pull-string cowboy. No one supposes that a video game — a thing of bits and bytes — would have a personality of its own or get up and roam the entertainment center at night, so Space Ranger Spin wisely doesn't pursue that line of conjecture. What the ride does do, however, is three-dimensionalize the video game experience, making it exciting in a whole new way. Like a multi-player game, riders ward off at-

tackers and compete for points against the person beside them. Only here, the environment isn't generated on a screen by a computer — it's real!

That experiential relationship with the video game format might not matter much in another ride, but Space Ranger Spin's *Toy Story* lineage shouldn't be ignored. Guests already saw Buzz Lightyear come to life in the movies. Now they get to see his video game world come to life, too.[12]

The ride also provides the perfect case study for an ongoing debate among those who study video games as a cultural medium. Are the games first and foremost about storytelling, the way that books and movies are? Or are they primarily about gaming, where objectives and instructions and rules are the underlying purpose and draw? Buzz Lightyear's Space Ranger Spin offers plenty of both. As to the former, the queue and boarding area set forth a straightforward but nonetheless solid narrative, and the ride also ties into the *Toy Story* saga, including the "Buzz Lightyear of Star Command" TV series, which itself spawned an actual video game release. At the same time, the game is defined by an objective (defeat Zurg) and numerous opportunities to make progress toward that objective (hit as many targets as possible in each level), in accordance with the game's physical layout and rules (cars can spin in a full circle except during set times when the rotation device is automatically locked, for example).

Would the game be played any differently if the backstory was completely changed but everything else stayed the same? Would the story be worth telling without the element of gameplay? Clearly, both narrative and gaming are at work in the attraction, a result of its having fused two different theme park genres, the dark ride and the shooting gallery.[13] And yet the marriage of gameplay and storytelling isn't unique to theme parks. Space Ranger Spin mirrors many narrative-heavy video games in that way, and because the level of player interaction is so high in the ride, video game theorists might do well to spend some time away from their TV sets and in the Magic Kingdom instead!

Perhaps the most game-like of Space Ranger Spin's qualities is its repeatability. Even on the fiftieth ride, the attraction is as engaging as ever, if only because you have the chance to come away with a better score. Even with only one of Buzz's giant plastic feet planted in the future, then, the ride is still more forward-looking than most (and certainly more than Tomorrowland's original airplane rides ever were). Even if the present technology fades into irrelevancy as so often happens, the ride's appeal to guests' competitive instincts should give it a longer shelf life. While much might change in the near future, our desire to best a friend in a game of laser tag likely never will. Buzz may not quite be a light year ahead of his time, but he gives us good reason to keep him out of the toy box for at least a few more years.

WATCH THIS – Tron: Legacy (2010)

Tron isn't exactly a video game, but the action surrounding it plays out a lot like one. In point of fact, Tron is a *program*, one of many that interact inside The Grid, a labyrinthine virtual world that exists inside a computer. The mechanics actually get kind of complicated, despite the fact that the core idea of an electronic universe is a pretty simple (and arguably flimsy) one. Suffice it to say that humans can enter The Grid too, but some of the programs lurking there are hostile and getting back out isn't easy.

Legacy is the unexpected sequel to a movie that came nearly 30 years before it, 1982's *Tron*. Both movies have their fair share of problems, but each contains flashes of brilliance. Following them to a T isn't the easiest task, nor the most appealing to the technologically disinclined. There's a lot of story to chew on, however, and the audience is invited to take up some intellectual exercise. All blockbusters should be this substantive.

Legacy is more mainstream, more traditionally action-oriented, and more human than its predecessor. It imagines what it might be like for mortals to travel inside a computer system or video game (the

portal to The Grid is found inside an abandoned 1980s arcade), and it has that curiosity in common with Buzz Lightyear's Space Ranger Spin. While the movie isn't set in the future, The Grid is as sleek and bold in design as anything I've seen presented for the days ahead. As both a Buzz Lightyear counterpart and a companion piece to Tomorrowland, *Tron: Legacy* works. In fact, with *Toy Story* now covered in a similar ride at Disney's Hollywood Studios and Disney California Adventure, and with public interest in the 1980s sci-fi franchise finally piqued, maybe the time has come to reimagine Space Ranger Spin as a major *Tron* attraction.

Tomorrowland Speedway

Type: Slot car ride

Duration: 4 to 5 minutes

Height Restriction: 54 inches or taller to ride alone

Popularity/Crowds: Moderate

FASTPASS: No

Fear Factor: None

Wet Factor: None

Preshow: None

Boarding Speed: Slow to Moderate

Best Time to Visit: Morning or evening

The Tomorrowland Speedway might be a decent ride if it were at least remotely related to either tomorrow or speed. On the contrary, however, this enormous attraction is decidedly antiquated and tortoise-like. Far from the car race of the future it purports to be, the ride forbids lane changing, bumping, and all but the most meager acceleration. A more appropriate title would be something like The Slow and the Spurious. Still, even as dull as the "Speed"-way may be, there is some peripheral justification for its continued existence.

After what is usually a lengthy boarding process, the Tomorrowland Speedway kicks off with a... I would say "bang," but if you

hear one, it's either a noisy racecar backfiring or the guy behind you pulling into the exit stall and hitting his head in disbelief at the sheer timidity of the ride. When given the green light, drivers put the pedal to the metal and zoom from zero to seven in under a minute. Along the way, they're thrilled by the sights passing them by — understated shrubbery, cautionary signage, and heavyset tourists handily outpacing them on foot.

The yellow warning signs urge drivers to keep at least one car's length in between each vehicle, but at seven miles per hour, the only way anyone can catch up with anyone else is if the first car comes to a sudden halt. As it so happens, cars do frequently halt on the Tomorrowland Speedway because they're hard to drive. Petrified by the prospect of low-speed collision, Disney has shackled each vehicle to an ill-fitting rail that takes the driving out of an attraction that's supposed to be all about driving.

In its present form, the Tomorrowland Speedway offers very little reason to ride, despite occupying more real estate than most other attractions in Walt Disney World. That hasn't always been the case, though, especially in Disneyland, where the ride first opened on Opening Day in July of 1955. Called Autopia, the Disneyland version was actually quite modern in its time. Believe it or not, there were no U.S. Interstates in 1955,[14] but the prospect of limited-access expressways running across the country had spawned a lot of excitement and chatter in the early 1950s. Wisely foreseeing the future potential of these new roadways — President Dwight D. Eisenhower commissioned the first interstate highway a year later, in 1956 — Walt wanted an attraction built in their honor for his theme park.

When Autopia debuted, it was utterly chic — adults got a taste of this new mode of transportation and unlicensed children got an early start on their driver's ed. That was important to Walt, who very much wanted Disneyland to promote learning and responsible citizenship among both children and adults. Like most things in Disneyland, Autopia was in high demand and stayed that way for many years. So popular was the ride, in fact, that a number of

Autopia spin-offs opened over the years, though only the original survives today.[15]

When the Magic Kingdom was in development, Autopia was still a big attraction in Disneyland; so naturally, the company wanted to bring a similar experience to Florida. The only problem was that while Eisenhower's Interstate project was still far from finished, it was hardly the source of excitement it had been 15 years prior. Therefore, the Magic Kingdom version was themed as an international raceway instead — not a very futuristic idea, mind you, but there's at least something optimistic about international cooperation. Called the Grand Prix Raceway, the ride was one of Tomorrowland's opening day attractions on October 1, 1971.

The first big change came in 1988, when the original track was slightly shifted and abridged to make way for what was then Mickey's Birthdayland[16] (hard to believe, given that the current track runs for an astounding 2,260 feet as it is). In 1996, on the heels of the "New Tomorrowland," the ride's name was changed to Tomorrowland Speedway. It kept that name until December of 1999, when the Indianapolis Motor Speedway stepped in as a new sponsor. The roads and queue were modestly re-themed then to match the famous track's look and feel, and in January 2000, the name was officially changed to the Tomorrowland Indy Speedway. That partnership lasted just eight years. In the spring of 2008, Disney formally dropped "Indy" from the title, reverting to the former name. Otherwise, not much has changed.

As it now stands, the Tomorrowland Speedway doesn't have any of the appeal justifying many of its previous incarnations. Neither driving nor Interstates are in any way revolutionary to our present state of mind. There's no real discernible international theme either. There's not even a good view of Tomorrowland from the track, unlike in Disneyland, where the raceway's integration with Tomorrowland is Autopia's saving grace. Children are more likely to learn about driving from a local go-kart park than from this restrictive plod-along. For the very young who are seeing a motor track for the first time, there might be an enticing newness

in the experience, but I can't imagine that anyone else would even consider it much fun. You've probably driven faster in parking lots, over speed bumps, and through thick layers of mud and snow than you ever will on the Tomorrowland Speedway.

So why ride? Well, on a tight time budget, perhaps you shouldn't. On a more relaxed schedule, however, the racetrack can actually inspire some fortuitous meditation. By taking us back to the past, the ride unwittingly leads us to think about the future. The Speedway is the product of a time when cars and national roadways could stir tremendous excitement. The fact that they're a basic part of travel just 50 years later can inspire optimism about how much transportation might progress over the next half-century. Most of the people visiting the Magic Kingdom on a given day probably got there on an Interstate. The Speedway's marginal value isn't in the replication of that experience, but in the way it implicitly challenges it. Perhaps some of the more cutting-edge transportation in Tomorrowland, like rocket ships or highways in the sky, will be equally commonplace in another 50 years. That's an idea worth pondering on a lethargic putter through the park.

WATCH THIS – Freewayphobia (1965)

The educational short film starring Goofy is a Driver's Ed classroom classic, sometimes called *Freewayphobia No. 1* or by its official subtitle, *The Art of Driving the Super Highway*. In it, Goofy plays several different kinds of dangerous drivers, each of them inevitably causing a multi-car pileup on the freeway. The cartoon is prepared as an introductory video for Interstate driving, beginning with an animated map that charts the growing Eisenhower system. The film is still relevant as an instructional tool today, but its focus on the newness of Interstate driving reflects Walt Disney's desire to excite and prepare the public as he did with Autopia.

For more great moments with Goofy behind the wheel, check out the sequel to this cartoon, *Goofy's Freeway Troubles* (1965, sometimes called *Freewayphobia No. 2*), and 1950's *Motor Mania*, in which road rage triggers a Jekyll-and-Hyde transformation in the dippy driver. All three are available on one *Driver Safety* DVD from Disney Educational Productions. (Barnes & Noble has been known to carry such titles in their retail stores, and you can purchase directly from Disney at www.dep-store.com.) Oh, and while you're at it, don't forget the wonderful "On the Open Road" sequence in 1995's *A Goofy Movie* either!

Astro Orbiter

Type: Flying, steerable rockets

Duration: Under 2 minutes

Popularity/Crowds: Moderate to High

FASTPASS: No

Fear Factor: 2.5 out of 5 (tall heights)

Wet Factor: None

Preshow: None

Boarding Speed: Very slow

Best Time to Visit: Morning or night

Astro Orbiter immediately calls to mind two other iconic Magic Kingdom attractions, Space Mountain and Dumbo the Flying Elephant. Space Mountain because they both involve a rocket ride through space, Dumbo because they're both simple hub-and-spoke rides. Nevertheless, Astro Orbiter offers something that neither of those can — and it gives crucial direction to Tomorrowland.

Unlike Space Mountain, Astro Orbiter towers in the open air. When guests take off inside Astro's rockets, they're gazing up toward the heavens, hefty clouds billowing across the beautifully blue, sun-stamped Florida sky. The ascent begins with an elevator

lift to a third-story platform atop the PeopleMover, where the rockets are ready for launch. Once the guests have boarded and strapped themselves in, the space jets lift off for the skies, swooshing in a steady revolution as giant orbs swivel and sway all around them. It's less thrilling than Space Mountain, but Astro Orbiter proffers its own visual complement to the illusion of ascent that underpins both rides.

Like The Magic Carpets of Aladdin, Astro Orbiter is a clever variation on Dumbo, the progenitor of all Disney hub-and-spoke rides. In Astro's case, the principal distinguishing factor is height. Both Dumbo and Aladdin load from the ground, but Astro Orbiter kicks off from a platform in the sky. To the extent that heights are thrilling, the Astro Orbiter holds its own as a thrill ride (albeit a mild one), whereas Dumbo is anything but. At the peak, guests find themselves much farther off the ground than they expected, and at what feels like a faster speed because enormous, planet-like spheres spin around them, creating an illusion of acceleration.[17] The altitude affords riders an incredible view of not only Tomorrowland but also much of the Magic Kingdom and beyond. Just as Dumbo immerses guests in the Fantasyland aesthetic, Astro Orbiter offers its riders a spectacular view of the park from above, like a look at Earth from outer space.

A towering monument to intergalactic voyages, Astro Orbiter underscores the centrality of space travel in Tomorrowland's twentieth century-inspired vision of the future. The ride is quite literally in the center of the land. Its beautiful planetary plumage is salient, an eye-catching "weenie" for Tomorrowland, drawing crowds closer to Space Mountain and the PeopleMover. The ride has been playing that role for a very long time, but it hasn't always looked like it does now or carried the same name.

Astro Orbiter can trace its roots back to Disneyland's Astro Jets, which opened in 1956 and was renamed Tomorrowland Jets in 1964. That ride was basically the same as today's Astro Orbiter, only it loaded from the ground, like Dumbo. When Disneyland premiered its brand-new Tomorrowland in 1967, the ride reopened as Rocket

Jets, newly perched high atop the original PeopleMover. That's the version that was recreated in the Magic Kingdom as Star Jets in 1974. Back then, the ride was built around a giant white NASA rocket instead of planets, but the concept was essentially the same.

When Walt Disney World unveiled a new Tomorrowland of its own in 1994, Star Jets was retitled Astro Orbiter and given its current planetary design. In the years since, the Disneyland version was also renamed Astro Orbitor (note that in California, it's spelled with an "o" instead of an "e") and eventually moved back down to the ground level. The Magic Kingdom's Orbiter, on the other hand, has pretty much remained unchanged.

Tomorrowland wouldn't feel quite right if it didn't afford its visitors some air time. Astro Orbiter makes sure that happens, aptly fashioned as a blast-off to the cosmos. That said, the ride's presentation of the galaxy is a little curious. Who knew Cinderella Castle was visible from outer space? Or that it's still so darn humid up there? Or that it takes only two minutes to go in and out of orbit? Well, remember that Tomorrowland's a future fantasy. And with the Astro Orbiter that fantasy takes flight.

WATCH THIS - Moon Pilot (1962)

This little-known sci-fi comedy is both a spy movie and a romcom, the story of Captain Richmond Talbot's (Tom Tryon) reluctant voyage to the moon. Various forces in the U.S. government pressure him into becoming the first man to go there, but he has to keep the whole mission a top secret. Talbot grudgingly agrees, but on one condition: he gets to go home and visit his family first. Against their better judgment, the officials acquiesce. When Talbot gets home, though, no one shows much interest in him, except a pretty lady with a foreign accent that eludes identification. Talbot has no idea who she is, but she clearly knows entirely too much about him. Afraid that she's a Soviet spy, he plans to escape back to NASA and shake her from his trail on the way.

Opening with a cool rocket launch, *Moon Pilot* reflects Walt Disney's fascination with the national space program. Remember that this was released to theaters in 1962, seven years before Neil Armstrong landed on the moon (and five years before Don Knotts made another great movie along the same lines, *The Reluctant Astronaut*). Here, as in most things, Walt was way ahead of the curve. His early and eager attention to space travel manifested itself in Tomorrowland, Astro Jets, and Astro Orbiter in particular.

Disney's never given the movie a wide release on DVD, but subscribers to the Disney Movie Club can purchase it as a members-only exclusive. Fortunately for everyone else, those members often resell their purchases, so plenty of copies turn up on the online used market (as does the 1997 VHS release). Additionally, Amazon often makes the movie available as a cheap rental in its Video on Demand service, which is accessible to anyone with an Internet connection.

Monsters, Inc. Laugh Floor

Type: Theater show

Duration: 15 minutes

Popularity/Crowds: Moderate

FASTPASS: No

Fear Factor: None, but some guests are randomly put on the spot for interaction

Wet Factor: None

Preshow: Funny introductory video in a standing-room-only preshow

Best Time to Visit: Anytime

Special Comments: The front doors open at regular intervals. After watching the preshow video (which cannot be skipped) guests move into the main theater. Shows run continuously throughout the day.

As the old saying goes, laughter is the best medicine. For the monsters living in Monstropolis, it's the best fuel too. That's the lesson learned in the hit 2001 movie, *Monsters, Inc.*, a fantastic film

that too often gets lost in the Pixar shuffle. Picking up where the movie left off, Walt Disney World opened its highly interactive stand-up comedy show in April 2007, focusing on the memorable monsters' energy needs. Noting that comedy clubs are alive and well today, Disney fans on the net widely lambasted the attraction as a Tomorrowland misfit. They've got a point. There is, however, more to this incredibly well-themed show than meets Mike Wazowski's one giant eye.

The attraction's pre-show prepares guests for their entrance into Monstropolis through a special portal that has been erected in Tomorrowland. While waiting, the humans can actually text jokes of their own making to a special phone number provided in the queue. If they're good enough, the monsters just might use them in that very show. When that's taken care of, the doors to the laugh floor open and guests are ushered into a dimly lit comedy club, complete with tables and lamps. At the front of the room are several giant screens and a big, empty, yellow canister. Roz, the movie's hilariously annoying administrative type, appears on one of the screens to set up the premise — the monsters need to harvest human laughter to energize their world. And if the humans want the exit doors to eventually open, they better laugh up enough energy to power them.

Then the real fun begins. Roz introduces Mike Wazowski, the diminutive, Billy Crystal-voiced green monster who serves as the movie's star and the attraction's "Monster of Ceremonies." He brings onto the stage a cavalcade of monster comedians who, through the impressive technology of digital puppetry, actually interact with the human guests in real time. Theater attendants bring a microphone over to randomly selected audience members, who have the chance to converse with on-screen monsters, voiced by backstage actors. The effect is quite remarkable, creating the illusion that the characters are real, living, thinking beings. They're pretty darn funny too, routinely delivering fresh jokes that vary from one show to the next. Naturally, the laugh tank fills up in no time at all.

Right off the bat, the Monsters, Inc. Laugh Floor suffers from the same temporal dilemma as its next-door neighbor, Buzz Lightyear's Space Ranger Spin. *Monsters, Inc.* is set in either the very late 1990s or very early 2000s. The transition to Monstropolis therefore spoils the retro "city of tomorrow" illusion that Tomorrowland supposedly strives for. I doubt that the early twentieth century visionaries saw wisecracking monsters as part of the future. They might have been impressed with the show's digital puppetry, though. To its credit, while the production may not take place in anyone's version of the future, it is at least a showcase of cutting-edge technology . . . for now, anyway. Remember that the whole point of Tomorrowland's 1994 relaunch was to adopt a vintage vision of the future instead of trying to keep technological pace with the one we're actually creating today. The Laugh Floor is nevertheless more in keeping with the latter. The show probably won't feel fresh for long, but for the time being, it does.

The attraction keeps in touch with tomorrow in another, more rhetorical way, too. The monsters on the laugh floor are harvesting laughter to power their world, a goal not unlike humanity's quest for alternative energy in planning its own future. The monsters found a way to become less fear-dependent in the movie and now they're tapping into a new kind of energy (Mike's very green, you see). Perhaps our own future will include alternative power sources. We probably won't find ours in canned laughter, but the Laugh Floor nevertheless resonates with one of the major forward-looking issues of our time.

But however tangentially futuristic the attraction may be, the truth is that it's ultimately less interested in preserving the Tomorrowland theme than in simply showing guests a good time (and maybe promoting Pixar a little bit along the way). To that end, admittedly, the show succeeds.

The monsters specialize in the same brand of tongue-in-cheek, pun-laced, occasionally (and knowingly) cheesy humor that imbues the whole Resort. Partly scripted but highly improvisational, the show ensures variety from one performance to the next and

gives the talented voice actors the freedom to work in their element. The material is nearly always funny, but while the laughs in the show are plentiful, the biggest joke of all is perhaps in the attraction's name — or at least its acronym.[18]

Having originally entitled it the Monsters, Inc. Laugh Floor Comedy Club, Disney quickly dropped "Comedy Club" from the name about a month after opening. Maybe they were concerned that the name was too long (but then how do you explain the Tomorrowland Transit Authority PeopleMover?) or that people would expect a live comedy show. It may be that the term "Comedy Club" reminded many guests of raunchy stand-up routines, something that has no place in the Magic Kingdom. Instead, Disney keeps the laughs coming with truly wholesome family entertainment, with enough humor to crack at least one smile from everyone in the room... and that's just what the monsters need.

Here in the human world, laughter isn't going to turn on our lights or cool down our houses anytime soon, but it does play a very important part in giving us the energy we need to get through a busy day. Most of our days in the Magic Kingdom are, of course, quite busy. In the midst of thrill rides, sit-down shows, and a lot of potentially stressful time spent standing on foot, the Monsters, Inc. Laugh Floor is one of a few Magic Kingdom attractions chiefly designed to provide some much-needed comic relief. The show may not be a perfect fit for tomorrow, but it gives us the good-humored sustenance we'll need to make it there.

WATCH THIS - The Emperor's New Groove (2000)

Another underappreciated Animated Classic, *The Emperor's New Groove* is Disney's 40th in the official canon. The movie had originally been developed as a serious musical drama entitled *Kingdom of the Sun*. Sting was hired to pen a number of original songs and Roger Allers, a longtime Disney story man and co-director of *The Lion King*, was brought on board to direct. For the better part

of a decade, the project underwent numerous revisions and corporate turmoil began to brew. The movie was way behind schedule, the filmmakers couldn't agree on a stylistic approach, and a firm release date had already been set. By the time it saw the light of day, the project had a different director, a new title, and a lot less Sting. The pop/rock star's wife, Trudie Styler, produced a documentary about the whole ordeal, *The Sweatbox*, which was screened at the Toronto Film Festival in 2002 but has never been released to home video (perhaps because Disney owns those distribution rights).

While the final product is less epic and grand than Disney had planned, it's still an abundantly entertaining comedy. With a voice cast that includes David Spade, John Goodman, and Patrick Warburton, this hilarious movie is the closest to an outright comedy the studio has ever come in the Animated Classics department. The movie's tongue-in-cheek, self-aware silliness strikes a similar tone to the humor in Monsters, Inc. Laugh Floor, another Disney project that steps away from more serious pursuits just to have a little fun.

Stitch's Great Escape!

Type: Theater show

Duration: 12 minutes

Height Restriction: 40 inches or taller

Popularity/Crowds: Moderate

FASTPASS: No

Fear Factor: 3 out of 5 (total darkness for much of the show; deliberate suspense; moments of mild surprise in the dark; may scare kids but not adults)

Wet Factor: 0.5 out of 5 (Stitch squirts a small amount of water at the audience)

Preshow: Guests watch a video in one room, then move to another for a brief Audio-Animatronics performance; both are standing room only and can't be skipped

Best Time to Visit: Anytime

Special Comments: The front doors open at regular intervals, inviting guests into the first preshow area. After the second preshow room, guests move into the main theater. The show runs continuously.

Stitch's Great Escape! is easily the least popular, most widely despised attraction in Walt Disney World. Sure, it has its supporters, but so do tax hikes, Ed Hardy shirts, and "Jersey Shore." For most people, it seems, Stitch's Great Escape! is Disney World's great big joke. Why? Well, for starters, the attraction simply suffers from a paucity of entertainment appeal. But to really grasp the fervent disdain for this lights-out theater show, you've got to have a firm appreciation for the similar-yet-incredibly-different attraction it replaced: The ExtraTERRORestrial Alien Encounter. Combing through decades of Tomorrowland history, we can see why Stitch never had a warm welcome, even if his show is, in some ways, more in touch with the Magic Kingdom than any other.

The building that Stitch currently resides in has always been home to an exciting, high-profile Tomorrowland headliner. Originally, it hosted Flight to the Moon, which opened in 1971 and then reopened three years later as an updated and newly titled attraction called Mission to Mars. Based on Disneyland's 1955 Rocket to the Moon, which was also relaunched (pun intended) as Mission to Mars in 1975, the innovative show put guests inside a supposed rocket chamber — actually a theater — for a simulated launch experience. Giant screens above and below them acted as windows to the atmosphere outside the vessel. The show ran in both parks until the early 1990s, with the Magic Kingdom's version closing in October 1993 to make way for the "new Tomorrowland."

The headline for 1994's revamp was the ExtraTERRORestrial Alien Encounter, arguably the most envelope-pushing attraction in Disney history. Dark, pensive, and downright scary, the grisly show clearly had no interest in placating parents concerned about their frightened children. In fact, Disney even warned that the show wasn't intended for kids under the age of 12. Opening mere months after Fantasyland had just toned down the intensity of an attraction called Snow White's Scary Adventures,[19] Alien Encounter signaled that Magic Kingdom wasn't closing the door on fear for good.

Alien Encounter's theater-in-the-round looked a lot like the rocket chamber of Mission to Mars, mostly because it was the same chamber, only now, there was a giant teleportation tube in the center. That was so that an extraterrestrial monster could be accidentally transported into the chamber to terrorize guests during a power outage. Confined to their seats with shoulder restraints, people watching Alien Encounter had to endure complete and total darkness while a terrifying alien prowled around the room, breathing on their necks and getting entirely too close for comfort. An impressive array of technology allowed each guest to have a unique and personal encounter with the alien from his or her seat. When the creature wasn't on their side of the room, the suspense only mounted as they heard the screams of guests in its vicinity. By the time the monster finally made his way around to them, the effect of darkened uncertainty had already taken its toll.

The show was immediately and intensely controversial. Many applauded Disney's daring, while others insisted that the Magic Kingdom was no place for such a fear fest. The debate endured until the attraction closed in October 2003, just over eight years after its official grand opening on June 20, 1995.[20] Whether Disney pulled the plug because of the controversy, excessive operational costs, or dwindling popularity was never entirely clear. Whatever the reason, the shutdown of Alien Encounter, which maintains a sizeable and passionate cult following, inspired boisterous fury from its fans. With the passage of time, they might have gotten over the closing, but what they really couldn't abide was the show's replacement.

Everything about Stitch's Great Escape! stands in stinging contrast to Alien Encounter — despite the fact that Great Escape uses essentially the same set and story concept — Experiment 626 (otherwise known as the lovable Stitch from Disney's *Lilo & Stitch*) is accidentally transported into the chamber and wreaks havoc in the darkness. Where the previous alien was menacing and dangerous, however, Stitch is silly and playful. Gone is the intelligent commentary on corporate overreach that ran as an undercurrent

in the previous show. Missing too is that sense of edginess that made Alien Encounter feel so daring and unique. With none of that going for it, the current show is left barren and utterly bland.

The idea was apparently for guests to revel in Stitch's adorableness, a quality that had proven to be a pretty respectable box office draw. Unfortunately, the powers that be may have miscalculated just how bankable the Stitch character would be without Lilo and in these new surroundings. While certainly a marketable force in merchandising, he's had more than one Magic Kingdom blunder during his short tenure in the park — an outdoor stage show called Stitch's SuperSonic Celebration lasted all of six weeks. The public may love Stitch, but not unconditionally. In his Great Escape, he strikes an uncomfortable balance between cutesiness and animality.

We meet Stitch as Lilo met him at the beginning of the film, an uncivilized problem child among his kind. Accordingly, he's wild and untamed, but at the same time, the show assigns him the personality traits that emerged later in the film under Lilo's care, so he's also clumsy and sweet. The theme park audience, then, has a hard time getting a read on the character. The show clearly hopes to hold onto the element of anxiety in Alien Encounter — just without the scariness of it all. But suspense doesn't work without peril. Stitch bumps around, giggles, and makes a mess in the dark, but there's no reason for anyone to care. His personality doesn't seem particularly dangerous, and there's no apparent harm in his being there, and thus no real sense of urgency for getting him under control. Instead, guests just sit and wait until the other aliens manage to catch him and put him back in the tube.

I'm not sure what the intended emotional response was supposed to be, but the show ends up neither funny nor scary. If anything, it's just gross, with Stitch burping up a chili dog and filling the chamber with its odious aftermath. Gross-out humor isn't becoming for a park of Disney's high standards and guests seem to get that.

Like several other attractions there, Stitch's Great Escape! puts a wrinkle in Disney's current concept of Tomorrowland. Aliens were common in early twentieth century visions of the future but Stitch himself emanates from the twenty-first century universe depicted in *Lilo & Stitch*. That was never a problem with the ExtraTERRORestrial Alien Encounter, which was originally inspired by the *Alien* film series but not in fact based on it. Alien Encounter had its own freestanding narrative and took place inside the Tomorrowland Interplanetary Convention Center, under the guise of presenting new importation technology from a company in the future. Stitch's Great Escape! isn't so interwoven with the "city of the future" theme. To be fair, the audience shouldn't have too much trouble forgetting about the *Lilo & Stitch* storyline and simply imagining that Stitch has been teleported into Tomorrowland's version of the future. To make any real sense of the show, they'll just need to make that leap on their own.

Like Stitch himself, his starring attraction is something of a nuisance, but it isn't all bad. In fact, the show ends with a moment of redemption, the presentation almost turning meta and connecting with Walt Disney's original vision for his theme parks. After running amuck in the chamber, Stitch teleports himself out of the room and onto the spires of Cinderella Castle (why he has to leave Tomorrowland and travel through space just to get to Fantasyland, I don't know). This is the great escape promised in the title. He knocks on the castle door to tell Cinderella that her prince has arrived. She doesn't buy it, but the scene, which unfolds on video monitors inside the chamber, is a mirthful nod to the idea that the Disney characters live in the Magic Kingdom and that Stitch is a part of that community.

Stitch was always marketed as a renegade member of the Disney dynasty. The early posters for *Lilo & Stitch* showed the rest of the Disney clan scowling toward him with the tagline, "There's one in every family." When Stitch's Great Escape! opened in the Magic Kingdom, Disney inaugurated it by rolling Cinderella Cas-

tle in toilet paper and storming its stage with Elvis impersonators, all ostensibly the handiwork of Stitch. I can't help but think that whatever Walt might have thought about the rest of the attraction, the spirit of its ending would make him proud. A script more narrowly tailored to Stitch's escape into the Magic Kingdom, and more cognizant of the chamber's Tomorrowland setting, might have enjoyed much greater success. But for all its flaws, the show isn't a complete failure. It's just in need of a few "stitches."

WATCH THIS – "Disney's House of Mouse" (2001)

Having spent a long time out of the limelight, Mickey got a new starring role with this animated TV series, which ran for 52 episodes from 2001 to 2003. Part of the ABC network's "One Saturday Morning" programming block, the show played with the idea that Mickey and the rest of the Disney gang ran a dine-in theater/club in Toontown. Cartoon shorts, some old and some new, were interwoven with original animation that featured dozens of Disney characters convening in the diner. The idea was a neat one for the same reason that Stitch's escape into the Magic Kingdom seems so fun. The show entertains the fantasy that Walt's creations and their progeny all live in the same neighborhood.

During its run and the repeats that followed, the series aired on "ABC Kids," The Disney Channel, and Toon Disney. These days, finding it on U.S. television is no easy task, but Disney released two feature-length home video spin-offs, which each operate from the same basic template: *Mickey's Magical Christmas: Snowed In at the House of Mouse* (2001) and *Mickey's House of Villains* (2002). Both are now out of print (for the time being) but sometimes turn up for rental online. Copies are easy enough to find from third-party sellers.

Walt Disney's Carousel of Progress

Type: Theater show

Duration: 18 minutes

Popularity/Crowds: Low to Moderate

FASTPASS: No

Fear Factor: None

Wet Factor: None

Preshow: None

Best Time to Visit: Anytime

Special Comments: The front doors open every few minutes; since the theater rotates, the wait is almost never very long

The Carousel of Progress is like no carousel you've ridden before. There are no horses, no chariots, and no calliope. In fact, the attraction isn't much of a ride at all; it's really a theater show. Granted, your typical stage production doesn't rotate the audience along a platform, but Walt Disney was never one to entertain in the conventional way — and that's what makes this attraction so very special. More than anything else in any Disney park in the world, the Carousel of Progress has Walt Disney written all over it — literally. Stamped with his personality, his values, his aspirations, and his signature style, the attraction is a love letter from Walt himself, and it just happens to reside in a theme park he never set foot in. As you might have guessed, though, that wasn't always the case.

To tell the story of the Carousel of Progress, we must once again travel back to the 1964 New York World's Fair, where the attraction first opened as General Electric's Progressland. Back when Walt was planning Disneyland, he'd envisioned an attraction in which guests would walk past a number of stages that presented a different decade and the technology that had revolutionized it. General Electric had long been on board as a sponsor, but the concept was shelved.

Years later, when the World's Fair rolled around, General Electric wanted an exhibit there and, like so many other companies, wanted Walt to design it. Dusting off those earlier plans, he moved forward with his theater of progress at long last. Technology had improved and with GE footing the bill, Walt could now cast Audio-Animatronics as the stars of his stage show, and rather than requiring his guests to walk between the decades, he could seat them in a rotating theater instead.

With its original Progressland title, the World's Fair show opened to huge crowds and tremendous acclaim. Those first guests experienced substantially the same performance that Magic Kingdom guests see today. Then, as now, the stage itself didn't rotate; the audience moved around it instead, passing through six scenes in all. The first and last were for entry and exit. In between, the audience got to spend a few minutes with the same American family during four different moments in time: the 1890s, 1920s, 1940s, and 1960s (the last representing, of course, the then-present).

An all-American father named John was the star of the show, voiced by the famous singing cowboy, Rex Allen. In each scene, he would marvel at how developments like the refrigerator, air conditioning, and the dishwasher had changed his family's day-to-day living. When the time for progress rolled around, guests moved forward to the sound of "There's a Great Big Beautiful Tomorrow," one of the most infectious and uplifting songs in the Disney canon, penned at Walt's request by the legendary Sherman Brothers.

After the Fair, Progressland was packed up and shipped to Disneyland, where it reopened in 1967 as the Carousel of Progress. General Electric stayed on as sponsor and the show remained largely the same, aside from a few minor modifications and a small update to the 1960s finale. It stayed in Disneyland for just over six years. Then GE started pining for Walt Disney World's newer, bigger, and more diversified tourist population. At GE's behest, Disney packed up the show once again and shipped it over to Florida, where it opened in Tomorrowland on January 15, 1975 (the same day as Space Mountain).

The Magic Kingdom's first version of the show introduced a number of substantial changes, including a new cast of voice actors, an updated 1970s finale, and a new song from the Sherman Brothers. "There's a Great Big Beautiful Tomorrow" was already a beloved classic, but GE wondered why guests should bother with a great big beautiful tomorrow when they could buy great big beautiful GE appliances today. Heeding the sponsor's appeal, Disney commissioned a new soundtrack focusing less on the future than the present day. And so "The Best Time of Your Life" replaced "There's a Great Big Beautiful Tomorrow." Indeed, the song's opening line, "Now is the time," spoke volumes about the attraction's altered tone. Though enjoyable in its own right, "Time of Your Life" lacked the original's catchy refrain and forward-looking optimism.

With the arrival of a new decade, the final scene was changed once again in 1981, to update it from the '70s to the '80s, while the rest of the show remained untouched. Then, just four years later, after a nearly 20-year partnership, GE chose not to renew its sponsorship deal, and most of the attraction's references to GE were swiftly removed. Still, the new Sherman song remained... but not forever. As discussed earlier, the new Tomorrowland of 1994 came in and radically changed everything. The Carousel of Progress was no exception.

Retitled Walt Disney's Carousel of Progress, the show reopened in 1994 with a brand-new recording of "There's a Great Big Beautiful Tomorrow" ousting "The Best Time of Your Life" once and for all. John was recast yet again, this time with Jean Shepherd as his voice. The finale scene was revised for a fourth time, but not to the current decade as had become tradition. The new scene was set in the year 2000 instead, looking six years into the future with an eye toward fast-approaching developments in home theater, gaming, and kitchen appliance technology. The script in the other scenes was tweaked too, and the entry scene dedicated the attraction to Walt Disney's enduring legacy. A few

tiny adjustments and a new HDTV aside, the attraction's 1994 version is still running today.

The Carousel of Progress has the distinction of being not only the longest-running theater show with the most performances in American history but also the oldest exhibit in all of Walt Disney World, one of only two Magic Kingdom attractions to bear Walt Disney's name in its official title,[21] and the only one in the whole Florida resort that he actually touched with his own hands. For a Disney destination that opened after its benefactor died, that's an important connection to a man who has meant so much to popular culture over the last century. And Walt's personal touch runs even deeper in the Carousel of Progress than just his name.

Continually moving forward, developing new technology, and improving the world were the motivations that defined Walt Disney's work ethic. He spoke often of his ambition for innovation and his deep sense of personal responsibility to make a difference in people's lives. His Carousel of Progress wholly embodies those values and aspirations, almost as if he designed a living monument to his personal worldview. He was intensely nostalgic, fascinated by America's development from the late nineteenth century into the mid-twentieth. Accordingly, the Carousel of Progress, though known primarily as a future-oriented show, is also overflowing with nostalgia for the past. Indeed, almost the entire show takes place in yesteryears, with only the script's occasional winking nods and a happily recurring theme song paying homage to the future.

"There's a Great Big Beautiful Tomorrow" resonates with Walt's sunny outlook, too. "Man has a dream," the lyrics say, "and that's the start." Walt was a fierce defender of the American dream, having fully lived it himself, and so while the lyrics aren't so specific as to narrowly pertain to it, we might easily read them as a meditation on the American dream in particular. Walt certainly spent a lot of time thinking and talking about that dream. In keeping with that same spirit, the song goes on to assert that if man follows his dream with both his mind and his heart, the dream can become a reality not only for him, but for the rest of us as well.

Here again, we see a reflection of Walt's philosophy. He saw his own dreams come true before his very eyes and was intent on seeing society benefit from them, believing that the ideas and technologies he developed would improve our way of life.

The Sherman Brothers have said they wrote the attraction's theme song as Walt's personal anthem. By all accounts from those who knew him, they did just that. The lyrics and the grand, uplifting orchestration accompanying them perfectly capture Walt's enthusiastic positivism. It's no wonder, then, that the Carousel of Progress is said to have been his single favorite attraction.

Despite living through more than a century in just over 15 minutes, the family in the Carousel of Progress barely ages from one scene to the next. The anachronistic effect unites the audience with the characters. After all, the audience isn't aging much during those 16 minutes either. It's one thing to live a long life and see technology slowly develop over time; it's quite another to stand still and witness a hundred-plus years' worth of progress transpiring all at once. By compressing the passage of time in this way, the attraction poetically underscores just how momentously the standards of comfort and communication can change in a lifetime. Having been born at the turn of the twentieth century, Walt had seen that kind of transformation in his own life.

Naturally, the passage of time creates problems for the Carousel of Progress, as it does for most things in Tomorrowland. When the attraction first opened, only 20 years separated the last two scenes. Then with the updates in each decade, the gap widened to 30, then 40, and now 60. The current setting of the show's finale in the year 2000 was a thing of the future when it was created in 1994. Today, it's more than a decade into the past, meaning that audiences are already separated from the preceding 1940s scene by more than 70 years — longer than the entire timeline of the original World's Fair attraction.

Speaking strictly from a Tomorrowland perspective, the finale isn't out of date. The living room gathering in the year 2000, with its self-automated kitchen and high-tech gadgetry, is probably

pretty consistent with what early twentieth century visionaries might have imagined for the year 2000. So even a hundred years from now, the scene will always be in keeping with what the Imagineers set forth in 1994 as Tomorrowland's mission — presenting the past's future that never was. That said, the jump from 1940 in one scene to 2000 in the next is quite a jolt for audiences, and the selection of the year 2000 increasingly feels as random as any other year drawn out of a hat would. Every other scene in the show depicts a time that actually came to pass in the United States, but the 1994 version of 2000 never did. The current finale therefore feels lost in time — neither vintage, nor contemporary, nor futuristic.

This uncomfortable time warp was inevitable. There's a reason the Carousel of Progress used to update its finale every ten years or so. Today, the last scene has gone unrevised longer than ever before, likely because waning attendance in the spinning theater has discouraged Disney from investing in an overhaul. Rumors of closure have dogged the attraction for years now, but Walt Disney World insists that the Carousel isn't going anywhere. Let's hope that's true. With unforgettable music, a rich story, a likeable cast of characters, and an inspiring message, the attraction has all the workings of the classic it has become, an awkward ending notwithstanding. Perhaps more importantly, the attraction stands as the one vestige of Walt's personal presence in the park. As long as Carousel of Progress continues to operate in the land of tomorrow, Walt Disney will always be a part of the future.

WATCH THIS - Pollyanna (1960)

Despite disappointing box office returns, *Pollyanna* was one of Disney's most critically acclaimed films up until that time. In the movie that made her a household name, young Hayley Mills plays an orphan girl whose unbounded optimism genuinely changes the town she lives in. The heartwarming story is set in 1910, which falls halfway between the second and third scenes in Carousel of Prog-

ress. Not only does the movie look the part as an ideal accompaniment for this ride, it feels it too. *Pollyanna* isn't just about the virtue of optimism; it's about the *power* of optimism. That's a belief Walt Disney very much cherished and it compelled him to deliver some of his best work in both this movie and the Carousel of Progress.

Space Mountain

Type: Roller coaster

Duration: 3 minutes

Height Restriction: 44 inches or taller (adult riders can switch off)

Popularity/Crowds: E-ticket

FASTPASS: Yes

Fear Factor: 4.25 out of 5 (near-total darkness; sharp turns and drops at moderately high speed; heights)

Wet Factor: None

Preshow: None

Boarding Speed: Moderate to Fast

Best Time to Visit without FASTPASS: Very first thing in the morning or very end of the night. Thank goodness for FASTPASS.

Special Comments: An absolute must-see, despite the long waits

Space Mountain is Walt Disney World's pride and joy, the crown jewel of the whole Resort. No other attraction inspires anxiety, commands crowds, or brings people back for more like Space Mountain, the great big granddaddy of WDW rides. This roller coaster just happens to be a Magic Kingdom original, granting the park bragging rights for a ride that has become one of the most popular in the world. There's a lot to brag about too. Though a little scant on story, this psychologically intimidating behemoth of a ride is a mountain in more ways than one.

To Disney, a "mountain" is a member of an elite class of top-of-the-line Disney thrill rides. There are Splash and Big Thunder in Frontierland, Everest in Disney's Animal Kingdom, and Grizzly Peak over at Disney California Adventure, among others. The

first such mountain was the Matterhorn Bobsleds attraction in Disneyland, a project Walt thought up himself but also initially had doubts about. Were he to open the Matterhorn, which his team had designed as a zippy steel roller coaster through the mystical Swiss Alps, he'd be introducing Disneyland's first real thrill ride, something he wasn't sure it needed. He'd always envisioned his parks as a place where story mattered more than speed, and kids would and could ride the same things their parents did. But as design work on the attraction progressed, Walt began to see it as a ride with universal family appeal, its modest thrills notwithstanding. Ultimately, he warmed to the idea, and it opened to the public in the summer of 1959.

Following the Matterhorn's wildly popular reception, Walt and his team started thinking that another family-friendly thrill ride might be in order, so Walt dreamt one up — Space Voyage, a lights-out coaster through the stars. Disneyland's creative team was already at work on a major Tomorrowland revamp, set to debut in 1967, and Space Voyage seemed an ideal headliner for the project. Walt lived just long enough to see his idea put on paper and given its current name, Space Mountain, before he died in December 1966. After his passing, the company's attention turned almost entirely to Walt Disney World (still a few years away from opening), and Space Mountain was put on hold.

Disney kept its focus on Florida for several years after the Magic Kingdom's big premiere in the fall of 1971. The park opened its gates without any thrill rides behind them, but when the new resort became an even bigger success than anyone had imagined it could be, Disney scrambled to change that. Rather than replicating the Matterhorn, which Fantasyland really didn't have room for anyway, the Imagineers pulled out Walt's Space Mountain idea and went right to work. Space Mountain officially opened in Walt Disney World's Tomorrowland on January 15, 1975,[22] the second crest in the Disney mountain range and the first of its summits to rise in Florida. (A Disneyland version opened in 1977.)

Now if we're being honest, we can't go any further without acknowledging that, unlike Splash, Big Thunder, Everest, Grizzly Peak, and the Matterhorn, Space Mountain is not a mountain, at least not in the usual sense of the word. Mountains are geological formations. Space Mountain is just a building — a very cool building, mind you, but a building nonetheless. Granted, Splash and those other mountains are technically just buildings too, but they at least look like mountains. The Space Mountain structure, meanwhile, is something altogether unique, resembling a futuristic space station of some sort, and it's incontrovertibly manmade. So what's with the name?

We've already said that the word "mountain" has a different meaning in the Disney dictionary than it has in Webster's. By bestowing the "mountain" banner upon a ride, Disney signifies that the attraction is one of its premium offerings, the Kingdom's crème de la crème. But whether the word had the same import in the mid-1960s, when Space Mountain got its name, is questionable. Only one Disney mountain existed then and the word wasn't even part of the Matterhorn Bobsleds' proper title, so the Imagineers likely had something else in mind when they came up with the name Space Mountain.

The early designs for the ride's exterior reveal an earthier appearance than the smooth concrete and sleek steel we see today. Regardless of its final countenance, though, the whole concept for the ride makes it a mountain in the figurative sense of the word. Mountains don't refer merely to geological features; they can be personal challenges too. For a newcomer to thrill rides, Space Mountain is a fiercely intimidating prospect. Even for the roller coaster aficionado, the totally enclosed, pitch-black nature of the experience makes it a harrowing experience. The ride's sheer unpredictability arouses uneasy apprehension in all who approach its colossal edifice for the first time. It's proven itself capable of psyching out guests more than any other attraction in the Magic Kingdom, so those who summon the nerve to "climb the mountain," so to speak, emerge as conquerors.

Despite the fact that much of it is cloaked in darkness, Space Mountain is as attentive to detail as any other E-ticket Disney attraction. Here, each of the details is aimed at making the space setting both realistic and nerve-racking. The effect begins in the queue, which is entirely enclosed within the ominous building. Walkways that tilt ever upward and seem to grow increasingly narrow quickly begin to imply a sense of claustrophobia. Low lighting and eerily soothing, rippling music create a mood of intrigue. Faux windows are placed throughout the skinny corridors. Through them, strangely warped panoramas of the cosmos are just barely visible. Whether you're actually in space at this point or not isn't clear. In fact, nothing about this strange and mysterious experience is clear at all. Space Mountain is extraordinarily skimpy on narrative and always has been, especially in the Magic Kingdom. Almost paradoxically, the non-specificity of the story contributes brilliantly to the experience Disney wants to create. Disorientation is one of Space Mountain's key ingredients and everything about the ride is tailored to that aim.

Most of the attraction's story elements are triggered before and after the ride itself. Space Mountain is not about being *in* space; it is about traveling *to* space from Earth — more specifically, from the thriving future metropolis that is Tomorrowland. In 2009, Disney substantially revised the queue to make that important point clearer than ever. This updated edition of the ride welcomes guests to "Starport Seven-Five," a new name that appears in a beautiful, recurring logo that incorporates the mountain's exterior design. The boarding guests are greeted as "space travelers" and a number of maps charting the galaxies and various travel routes adorn the narrow hallways. These enhancements tell guests that they've entered a spaceport. In that concept we find the visionary premise and promise of Space Mountain, an idea that Walt and the Imagineers had all along but that often eluded guests.

The ride imagines a future in which a quick ride through space is as commonplace and easy as a flight across the country is today. Even easier, in fact, given the total absence of the TSA in Starport

Seven-Five. If you get groped on Space Mountain, you're probably just standing too close to somebody in line.

Imagining that kind of progress is one thing. To believably create such a wholly enveloping experience around it is another. Yet that's exactly what Disney does with Space Mountain.

The ride itself is almost incidental to the experience as a whole, and yet the steel coaster shooting through the dark is supremely and unforgettably fun. Two tracks run parallel inside the building, occasionally coming close for a near-miss with the other. The 2009 upgrades label the two tracks Alpha and Omega and each has its small distinguishing idiosyncrasies. Though their close encounters are minimal and the other track can barely be seen, the divergent nature of the paths ensures that one ride can differ from the next and even adds something of a dueling component to the ride, giving a whole new meaning to the term "space race."

Careening through the blackness, sharp turns and surprisingly steep drops come without warning. In terms of speed, the ride is relatively tame by today's standards, but the wind blowing in the darkness and the giant projections on the ceiling make it a kind of hyper-speed planetarium. As stars and asteroids whiz by, passengers feel that they're flying much faster than they actually are. In 2010, Disney added new music and sound effects to further enhance the intensity of the sensation. The world's fastest outdoor roller coaster couldn't pull off the kind of sensory illusions that make Space Mountain so mesmerizingly unique.

As the pinnacle of the Tomorrowland experience, Space Mountain brings us to the end of the Magic Kingdom's most conceptually challenging region. Fittingly, it is the one attraction that is a pitch-perfect match for everything the land has ever strived to be. The ride's spaceport story could only unfold inside a city of the future, where citizens could embark on travels that simply aren't within our reach today and likely won't be anytime soon. Remarkably, the ride even works under both the original concept of Tomorrowland as a future city seen through contemporary eyes and the current premise of a future imagined by those who lived more

than a hundred years ago. Recreational space travel has long been an enduring dream for tomorrow, and the ride is every bit as timeless as that aspiration. Standing back and surveying the whole breadth of Tomorrowland, with Space Mountain towering majestically over its horizon, we can see that the ride really is in many ways a mountain, and everything else in Tomorrowland should look up to it.

WATCH THIS – The Black Hole (1979)

The Black Hole was a highly experimental movie for Disney, their first foray into serious science fiction. The movie borrows elements from both "Star Trek" and *Star Wars* but ends up less memorable or epic than either of them. That's not to say it's all bad. On the contrary, *The Black Hole* is an engaging and suspenseful movie that tells an interesting story with great acting and incredibly impressive visuals for 1979. The big name cast includes Ernest Borgnine, Anthony Perkins, Maximilian Schell, and the voices of Roddy McDowall and Slim Pickens as friendly robots. They play members of two different space crews who meet in the vicinity of a black hole, where they encounter the mysterious Dr. Hans Reinhardt (Schell).

Unfolding entirely aboard stations and ships in outer space, the movie immediately bears the look and feel of Space Mountain. In fact, Disney could re-theme the ride as a *Black Hole* attraction and the story would fit right into place. That would be going entirely too far, but it's nice to know that Disney has been as sci-fi in the movies as it has in the parks.

Disney fans often talk about *The Black Hole* and *Tron,* the studio's two big sci-fi efforts in the pre-Eisner era, in the same breath. When *Tron: Legacy* hit theaters in 2010, one of its opening shots featured a *Black Hole* poster, a clever nod to the fact that Disney has announced plans to revisit this one, too. The *Legacy* team has already been assigned to a major *Black Hole* remake, and it's reportedly in pre-production at the time of this writing.

Chapter 6

Main Street, U.S.A.

*"Main Street, U.S.A. is America at the turn of the century —
the crossroads of an era. The gas lamps and the electric lamp —
the horse-drawn car and auto car. Main Street is everyone's hometown—
the heart line of America."*

Walt Disney

Our final dedication is one that was never really given. The words above weren't a part of Disneyland's grand opening, but were later attributed to Walt in describing his most cheerful district: Main Street, U.S.A. They ring just as true for the Magic Kingdom.

Because Main Street is a different sort of land from all the rest, we'll take a different approach. To be sure, we'll consider all the attractions that pass through here. Yes, "pass through." Only the Walt Disney World Railroad has a permanent presence on Main Street, U.S.A. — the station that sits atop the park's main entrance — but even when the train is there, it's always about to depart. The others — the Celebrate a Dream Come True Parade, SpectroMagic, and Wishes: A Magical Gathering of Disney Dreams — appear, work their magic, and then evaporate until it's showtime again. Likewise, a new role-playing game called Sorcerers of the Magic Kingdom begins on Main Street but quickly sends

guests off to other parts of the park. But before we consider all of those, let's take a moment to contemplate Main Street itself and all the shops, sugar, and shindigs that imbue this razzle-dazzle boulevard with such merriment and mirth.

Main Street, U.S.A.

Type: Themed environment

Duration: Unlimited

Popularity/Crowds: High

Fear Factor: None

Wet Factor: None

Best Time to Visit: Anytime, but expect major congestion during fireworks, night-
time shows, and parades

Main Street is both the first and last of the Magic Kingdom's six themed lands. This turn-of-the-century promenade is a gilded gateway to the past and also happens to be the only route into or out of the park. It is an attraction itself and the only one that each guest is guaranteed to experience — twice. There aren't any real rides or shows to speak of, and yet there's a lot to do. This is the gathering place for parades and fireworks, home to ice cream and cookies and the premiere destination for serious shopping.

Main Street is a long avenue designed as a kind of orientation for guests to the "Disney bubble," the Resort's realm of unabashed fantasy that closes off the worries and distractions of the outside world. On one end is Town Square, a community center we'd expect to find in early twentieth century, Midwestern, small town America. On the other is Cinderella Castle, something we wouldn't expect to find in any part of America at any time. Clearly, there's something magical about this road and the destinations it can lead us to. But before we reach the castle's "hub," a flower-filled departure point for each of the park's other lands, Main Street lets us revel in an idealized re-creation of America's past.

Walt based Disneyland's original Main Street on his hometown of Marceline, Missouri, in the year he was born, 1901. The Magic

Kingdom's Main Street draws on the same inspiration, but incorporates a variety of other regional influences, most notably from turn-of-the-century New England, making the avenue a literal Memory Lane for America. There's the merchandise Emporium, the candy shop, the bakery, penny arcade games, Casey's Corner for hot dogs, and a lot of street traffic. A horse-drawn trolley crosses paths with a fire engine, a horseless carriage, and a double-decker omnibus. You can catch any of them for a quick ride to the castle or devote your morning to round-trip tours on all of the above if they strike your fancy.

Walt built the original Main Street as an homage to his childhood, his country, and its then-burgeoning entertainment medium, the movies. The Main Street Cinema, even if it is now just a façade in Magic Kingdom, captures the excitement of motion pictures at the dawn of the twentieth century. Many commentators have observed that the Magic Kingdom is itself like a movie, and Main Street provides the opening credits. The windows at the top of each little building bear the name of someone instrumental in the Resort's development, just like the credits sequence in a film. We might also think of the park as a giant theater, with Main Street the red carpet leading to the five genre "films" now showing — adventure, western, historical, fantasy, and sci-fi. There are even vendors selling popcorn and snacks to round out the movie theater metaphor.

In all likelihood, this is the Main Street that never was. I doubt that small towns were ever quite this idyllic — or clean! — but the idea is refreshing nonetheless. Antique vehicles putter past prancing horses while a brass band marches and a barbershop quartet sings. Original but archetypal characters, like the town's mayor and a woman campaigning for suffrage, not only give the place life but also contribute to a fervent busyness on the street. Main Street is so immersive largely because there's so much activity there. Surely it must be one of the world's busiest thoroughfares! All of that action, more than the authenticity of the buildings or the tastiness of the desserts, makes Main Street the blissful dreamland that it is.

We walk into the Magic Kingdom expecting to find The Happiest Place on Earth,[1] and Main Street is dedicated to giving us that the very moment we step inside. That's why it's so important that the entire place teem with hustle and bustle. The beaming faces of the storybook cast, the buoyant greeting from the mayor, the toe-tapping ragtime ditties, and the foot traffic from tens of thousands of park guests exuding their contagious excitement all foster a pervasive sense of joy. Each morning kicks off with Mickey Mouse's arrival by train and then a full-blown production of "The Trolley Song," performed on an actual trolley. Then the cast of extravagantly outfitted singers breaks into a rousing chorus of "Walking Right Down the Middle of Main Street." All of this unfolds on the walkway, right beside the guests in their street clothes, like a movie musical brought to life.

The excitement doesn't end with the morning ceremonies. There are performers, loud and merry music, character greetings, and parades all day long. There's always something happening on Main Street. At night, each building glows with a bright white trim. It's simply beautiful, making nighttime probably the best time to be there.

Main Street is every bit as important on your way out as on your way in. By the end of the night, you're on such a high from junk food and good times that you're dangerously susceptible to giddy delirium. The urge to buy a lollipop the size of your face and dance the Charleston is nearly irresistible. It isn't uncommon to see teenagers skipping or grown men dancing a jig with their kids. Everyone is whistling or laughing or marching to the relentlessly up-tempo beat of the world's cheeriest music. There is literally a song in the air. If this isn't The Happiest Place on Earth, I don't know what is.

WATCH THIS – Meet Me in St. Louis (1944)

Everything about *Meet Me in St. Louis* feels like Main Street. The time's right, for one thing. Set in 1904, the movie takes place just

three years after Walt Disney's birth and unfolds in St. Louis, Missouri, just a few hours' drive from the small town of Marceline, where he grew up. This is the film that gave us "Have Yourself a Merry Little Christmas," as well as "The Trolley Song," which kicks off Main Street each and every morning.

The movie, starring Judy Garland, follows one family over the course of a year. Special attention is paid to Halloween and Christmas, which also happen to be cause for major fanfare on Main Street each year. The importance of family and home are among the movie's prevailing themes, and those sentiments are obviously integral to the Main Street atmosphere, too.

Despite its connections with Main Street, U.S.A., *Meet Me in St. Louis* was an MGM movie upon its release and is currently distributed on Blu-ray and DVD by Warner Home Video.

Walt Disney World Railroad

Type: Train ride

Duration: 20 minutes for a full circuit of the park

Popularity/Crowds: Low to Moderate

FASTPASS: No

Fear Factor: None

Wet Factor: None

Preshow: None

Boarding Speed: Moderate to Fast. Trains depart on a regular basis.

Best Time to Visit: Anytime, but the attraction typically closes for the night one hour prior to the evening's first fireworks show

The Walt Disney World Railroad (WDWRR) is a ride without a home. Unlike all the other rides in the Magic Kingdom, this scenic train trip around the outer berm doesn't belong to any one of the park's six lands. Yet, by the time it's made its single loop around the park's perimeter, the train has chugged through all but one of them. Much is said about the railroad's elaborate train stations and the destinations they serve, but too often, the ride itself

is tragically overlooked. That's unfortunate because the train is an enchanting stand-alone attraction in its own right. More than a monument to Walt's love of trains, it's a truly magical vehicle that transports us through space and time.

Now it's no secret that Walt Disney had an affinity for trains. He loved them so much that he built a scaled-down but otherwise fully functional steam engine railway, the Carolwood Pacific, in his own backyard. It inspired the numerous trains that keep the Disney resorts in motion today, including the Santa Fe & Disneyland Railroad, which was running when Disneyland opened. Walt's inaugural train ride into the park even kicked off the opening ceremony that day. (Televised for all to see, Disneyland's grand opening ranks as one of history's most-watched live broadcasts.) That train, now known simply as the Disneyland Railroad, still operates today and its progeny can be found in every Disney resort on the planet, including Walt Disney World.

The Magic Kingdom's railroad was running at its opening, too, and is more or less the same today. The WDWRR runs four trains, each named after someone important to the company's legacy — Walt, his wife Lillian, his brother Roy, and Roger E. Broggie, one of the chief Imagineers to work on the Carolwood Pacific and both U.S. Disney Railroads. *Lily Belle*, the train named after Walt's beloved wife, was built in 1928, the same year Mickey Mouse was born; its runs today are usually limited to each morning's opening ceremony.

The other trains take guests around the park, making three stops along the way. The first and easiest to find is at Main Street, U.S.A., where a turn-of-the-century depot doubles as the Magic Kingdom's official entryway. When the park first opened, it was the *only* train station, meaning that if you got on, you were committing to the 20-minute "grand circle tour" of the park. That quickly changed, however, when Disney opened a second train station in Frontierland the very next year. Tucked away on a second-story platform just behind Splash Mountain's entryway, the Frontierland station is charmingly rustic and filled with visual de-

tails, such as a ticket booth and several "wanted" posters for frontier bandits.

The third and final station is found in Fantasyland. It opened in 1988 inside Mickey's Birthdayland, which was counted as the park's seventh land at the time but has since been annexed by Fantasyland and converted to Storybook Circus (see *Chapter Four* for a more detailed history). Because Birthdayland was never intended as a permanent exhibit, the train station there was rather barren, especially when compared to the intricately detailed stops we find on Main Street and in Frontierland.

When Storybook Circus opened in 2012, it boasted a totally new train station for Fantasyland. Gone was the sparse Birthdayland structure. In its place now stands a beautiful, barn-like building with a covered walkway and a train-shaped weather vane rising from the roof. The face on the depot clock reads "Carolwood Park," a fitting tribute to Walt's backyard railroad.[2]

Since it is the first thing you see on your way in and the last thing on your way out, the Main Street station has become the most popular starting point for a train tour around the kingdom. You are free to get on or off at the Frontierland or Fantasyland stations, but it's best to ride the full circuit. That's because there is much more to the Walt Disney World Railroad than stops and stations.

Assuming you board at Main Street, the ride begins in early nineteenth century small town America. From there, it embarks on a most unusual journey through different eras and realms. Within moments, the train is suddenly chugging through the jungles of Africa and Asia. Steel drums and the sounds of wild animals wash over the tracks. A minute later, the train has returned to America, but it's half a century earlier than where it started. The train pulls up alongside the cars of Big Thunder Mountain Railroad as they careen through the enormous buttes of the Wild West. Then the WDWRR crosses over an antique bridge and onto Tom Sawyer Island, where a hidden part of Frontierland is visible only to railroad riders. Pocahontas is there, singing in the

distance, and there's a teepee outpost around the corner. No sooner has it passed them than the train rolls out of reality altogether and into the world of cartoons and fantasy, where the Storybook Circus itself is said to have rolled off the tracks and into Fantasyland (see *Chapter Four*). Then it's off to the future! Before the audio track changed in 2012, the train's narrator became audibly confused as he saw spaceships and the like, but now he's busy plugging attractions like Stitch's Great Escape! instead. Still, there's reason for guests to take note of the transition. After all, one wouldn't expect a steam engine in a city of tomorrow, and yet here it is... but not for long. As quickly as it came in, the train travels back in time to the familiar environs of Main Street, U.S.A. You've just taken a voyage across continents, through centuries, and into the imagination — all in under 20 minutes.

Like the Liberty Square Riverboat, the Walt Disney World Railroad opens itself up to a postmodern narrative hodgepodge, in which a single journey borrows from myriad settings and stories to piece together an adventure all its own. That's the Magic Kingdom in a nutshell, so the Railroad is an exquisitely effective pastiche of the whole park experience. In the tradition of The Polar Express, The Hogwarts Express, and Mr. Rogers' Neighborhood Trolley, the Walt Disney World Railroad train is a magical and mysterious one. Disney doesn't advertise it that way, but that makes its surrealistic movement through the park all the more alluring, like a great and wondrous surprise. There isn't the slightest hint for those first boarding at Main Street of the time warps and hidden scenery that lie ahead. More than a simple transit system or a sightseeing tour, the ride turns out to be an enchanted expedition that defies the constraints of place and time.

Such a magical train trip is only fitting for the *Magic* Kingdom, where an ordinary perimeter tour just wouldn't do. But to really appreciate the illusion, you'll need to pay attention to your surroundings. If life's about the journey and not the destination, then so is the Walt Disney World Railroad. Those who just want a lift to Splash Mountain might miss out on the fantasy underpinning

the train that gets them there. The best way to ride these ra
ride them full circle, from Main Street to Main Street. If you d
that, you'll find yourself on a train of thought, bound for an en-
lightening exploration of the interwoven story worlds that make
the Magic Kingdom so stimulating.

WATCH THIS – Chitty Chitty Bang Bang (1968)

Many people assume, incorrectly, that *Chitty Chitty Bang Bang* is a
Disney movie. It isn't, but it's easy to see how it might be mistaken
for one. Released just four years after *Mary Poppins*, the movie re-
united much of the *Poppins* team. The Sherman Brothers, who
wrote all of the *Poppins* songs, and Irwin Kostal, who penned its
score, came together again to create the top-notch *Bang Bang*
soundtrack. Dick Van Dyke, who had played Bert for Disney, takes
the lead role here as the offbeat inventor, Caractacus Potts. (Julie
Andrews was reportedly asked to co-star as Truly Scrumptious but
declined, passing the role to Sally Ann Howes instead.) It's not sur-
prising then that the movie has a distinctly Disney charm about it.

In the movie, Caractacus and his two children grow very fond of
Truly, the daughter of a big-time candy manufacturer. They drive out
to the beach for a picnic one day, and when the tide comes in, their
motorcar suddenly becomes a floating vessel. The group begins to
realize that the car, which they've nicknamed Chitty Chitty Bang
Bang, has magical properties that can — and do — take them on a
magnificent adventure into a world of fantasy.

When riding the Walt Disney World Railroad, imagining that the train
is like Chitty Chitty Bang Bang can help us appreciate just how en-
chanting its trajectory really is. Like Chitty, the WDWRR is one of
fiction's classic creations of magical transportation.

Chitty Chitty Bang Bang was originally distributed to theaters by
United Artists. It is now an MGM film, distributed on Blu-ray and
DVD by Twentieth Century Fox Home Entertainment.

agic Kingdom

ng game

: Moderate

None

W. or: None

Preshow: Optional training session (recommended for first-timers)

Best Time to Visit: Anytime

Special Comments: Lines fluctuate from one portal to the next throughout the day; if you arrive at a portal and there's a long line, you may wish to visit another attraction and return a little later

Magic Kingdom introduced an altogether different type of entertainment in February 2012, one that finally addressed a demographic long overlooked inside the park: nerds. Happily, your author belongs to just such a group and can tell you all about it. Maybe I can even convince you that it's actually pretty cool, at least in a changes-how-you-think-about-Disney kind of way.

One does not ride or watch Sorcerers of the Magic Kingdom. Rather, one plays it. This distinguishes Sorcerers from most other attractions, especially within this particular park. Open to all guests at no additional charge, Sorcerers of the Magic Kingdom is an interactive card-trading and role-playing game with a storyline that incorporates four of the park's six lands. Playing requires a fair amount of foot travel and a willingness to be judged by others for looking decidedly dorky. If that's okay with you (and it is with me), then let's head together into Merlin's secret lair on Main Street, U.S.A.

That's where Sorcerers' gameplay begins. The Main Street Fire Station, previously home to an unremarkable gift shop, is now the headquarters for sorcerer enlistment. A banner at the entrance reads, "Help protect our community!" Inside, we meet an animated Merlin (the wizard from Disney's *The Sword in the Stone*,

appearing here in a rare nod to the oft-overlooked 1963 classic), who talks to us from a round video screen, which he calls a magic portal. He gives us a rundown on the war that's breaking out across the Magic Kingdom at that very moment.

We learn that Merlin is charged with guarding the Crystal of the Magic Kingdom, an almighty orb that protects the kingdom from evil forces and grants considerable power to whoever possesses it. When Hades (the arch-villain from Disney's 1997 film, *Hercules*) finds out about the Crystal, he sends his minions (Pain and Panic, also of *Hercules*) to steal it from Merlin's cottage in the woods. They're nearly successful, but Merlin catches them in the act. A scuffle ensues and the Crystal is accidentally broken into several pieces, four of which get scattered around the kingdom.

Now there's a race between Merlin and Hades, and whoever mends the Crystal first will determine the fate of the Magic Kingdom. Unfortunately, Hades has recruited a whole host of bad guys to aid in his quest. Being the lord of the underworld and all, he's even able to resurrect villains presumed dead. Merlin's no match for them alone, and that's where we come in. Armed with a little magic, we can help Merlin fend off the villains and recover each missing Crystal piece before it's too late.

Apparently, Merlin created a whole network of mystic portals, just like the one we find inside the Main Street Fire Station, and he spread them throughout Magic Kingdom. Whenever opened in the right place and at the right time, the portals will "show you the thing you seek." Of course, it's a safe bet that the villains and their henchmen will be hot on our heels, tracking down the portals for themselves.

So how can we, mere mortals, possibly hope to open mystic portals and fend off mighty evildoers? As it turns out, all we need is every dweeb's favorite weapon — trading cards.

After Merlin recites his spiel, we move to the rear of the Fire Station, where cast members equip us with a key card, a shrink-wrapped set of five spell cards, and a map. There are also practice portals in the firehouse so everyone can get into the groove before

going off to war. Just use the map to find the proper portal (always a video screen, often cleverly concealed within building façades), hold the key card up to the keyhole you'll find once you get there, and wait for on-screen instructions to appear. At any given portal, there's a very good chance you'll be confronted by an on-screen villain, and if you are, you can defend yourself by holding up a spell card, which cameras hidden in the portal will recognize as a specific spell. Once you've defeated them, you'll hear the next part of the story and you'll be directed to a different portal, where your adventure will progress.

If this is all sounding like it's a little too involved for your taste, I regret to inform you that we've just scratched the surface. But if it seems right up your alley, then put down your comics, tape up your glasses, and brace yourself, because I'm about to blow your nerdy little mind.

As mentioned earlier, the game begins with a shrink-wrapped pack of five cards. Those are five *random* cards, out of more than 70 that exist. Every card features a different Disney character and a different spell. Not only that, they each fall into different categories and are assigned unique numerical values that make particular cards stronger in certain battles than in others. Some cards are quite common while others are extremely rare. Collecting them is a challenge in and of itself, one that thousands of people have already accepted — and with surprising exuberance, I might add.

But wait, there's more. You can *combine* cards. And when you combine them, they produce *new* kinds of spells. Some combinations are more potent when used against particular enemies, and the spells increase in strength and pizzazz the more you use them. If you want to defeat the game — that is, conquer every portal and recapture the Crystal pieces for Merlin — you'll eventually need to think critically about how you're casting your spells or else they won't measure up to the villains.

Collecting all the spell cards is easiest when you trade your duplicates with other players who have spares. It's not unlike trading

baseball cards. Impromptu trading happens in the park all the time, usually near a game portal, outside the Main Street head-quarters, or at Sorcerers' alternate HQ in Liberty Square. You can also turn to various Internet fan forums to trade after you return home from vacation, or you can seek out rare spell cards for sale on sites like eBay.

There are three levels of gameplay — easy, medium, and hard. Everyone starts on easy and it's pretty difficult to lose at that level, but as you work your way up, additional challenges are introduced and the battles become more sophisticated. Strategy is essential for victory at the most advanced level. If you want to play from begin-ning to end, you'll need to devote a considerable chunk of your day to it, and if you want to claim victory on all three difficulty levels, plan on coming back to Magic Kingdom for at least another day.

Sorcerers' earliest and most ardent players had the look and de-meanor of veterans of *Dungeons & Dragons* and other role-playing games (think "Big Bang Theory"). But before long, something re-markable happened — Sorcerers started working its magic on the park's population at large. Today, the game has a healthy-sized following that includes hardcore fans and first-time park guests alike. From my observation, its appeal seems to be universal. Par-ents love playing it with their kids, while teens, singles, and young couples get into the spirit, too. It's not unusual to see soccer moms and grandfathers swapping cards with teenagers, all of them hav-ing a great time. Capitalizing on the success, the company is al-ready rolling out merchandise, including apparel that can interact with the portal screens and "booster packs," which allow easier access to those rare spell cards — for a price.

Disney clearly invested a great deal of imagination and re-sources in creating the game. The portals feature all-new anima-tion, which varies wildly in quality but is often quite good. Many of the original voice actors return to reprise their famous charac-ters, including big names like James Woods (Hades), Anika Noni Rose (Tiana), Jodi Benson (Ariel), and Patrick Warburton (Kronk), among others. When substitutions are used, they're usually pretty

close (a notable exception is the very talented Jenifer Lewis, who lends her voice to two Sorcerers characters, but sounds nothing like Whoopi Goldberg as *The Lion King*'s Shenzi).

The game also exhibits a clear respect for narrative. That's not to say that everything in the story makes sense. For instance, how exactly did the Crystal pieces get spread around the park? And if the Crystal's been keeping evil out of the kingdom, how do you explain villains turning up in meet-and-greets, parades, and stage shows? Maybe the Crystal lets them inside, but only on good behavior? (They never kill anyone in the parks, after all). Also, why is Londoner Cruella de Vil the only villain we find on Main Street, which is set in the United States?

The occasional plot hole aside, the narrative structure is impressive. No matter where an individual gamer's quest begins, the adventure progresses in a way that makes sense. The Fantasyland storylines, which feature Ursula (*The Little Mermaid*) and Maleficent (*Sleeping Beauty*), are especially good. Hades may have enlisted his cads to help him capture the Crystal, but they enter the mix with double-crossing motives of their own, and that makes the game rather fascinating... even for those who are just tagging along and watching as their friends play.

The very idea of a story unfolding as we explore a theme park is pretty intriguing in and of itself. Sorcerers is an extension of the premise we established inside Cinderella Castle, that this is a real kingdom, and it needs protection from outside threats. It turns the entire park into a game board, a stage on which we play a part in a story as it's being told. That gives us a sense of ownership in Magic Kingdom, which is a pretty nice feeling.

The game's map also reinforces an important idea we considered in Liberty Square. That's because Sorcerers of the Magic Kingdom doesn't acknowledge a distinction between Liberty Square and Frontierland at all. Geographically, both are there, and portals are found within each, but the game simply consolidates the two as a single setting for the same storyline. Why? Well, it could be that the game was designed for future implemen-

tation in Disneyland, which does not have a Liberty Square, or that dealing with one less land simply made Imagineers' lives a little easier. Whatever the reason, it certainly lends newfound credence to the notion that Liberty Square and Frontierland are really one in the same, with nothing more than an arbitrary border to divide them.

Interestingly, Tomorrowland is neglected entirely. It's not on the map, there are no portals inside it, and not a single element of gameplay even references its existence. An explanation for that is elusive. Tomorrowland sees pretty heavy crowds, so could Imagineers have feared excessive congestion? Perhaps, but it's not as if other lands don't get crowded themselves. Or maybe Tomorrowland portals are in store for some sort of Sorcerers 2.0 in the future. Without an official explanation, I like to think that the villains aren't able to access a "future that never was and never will be." We know that Merlin can time-travel (he returns from the twentieth century wearing Bermuda shorts in *The Sword in the Stone*), but it may be that Tomorrowland is not on his or anyone else's timeline.

Merlin isn't just the game's main character; he also appears on one of its spell cards. There are many other Disney icons who also feature in the game, which is far-reaching enough to include random characters like Colonel Hathi (*The Jungle Book*), Lythos the Titan (*Hercules*), and Doris (*Meet the Robinsons*), alongside scores of more popular personalities.[3] Like Mickey's PhilharMagic and Stitch's Great Escape!, Sorcerers brings a whole host of unrelated characters under one banner, and their interplay adds to the game's charm.

But I think there's quite a bit more to this game's appeal than the way it interfaces with the Magic Kingdom's cartography or its cast of characters. If gameplay is first and foremost an experiential activity, then there must be something about the action of this game that's speaking to its players. I suspect we can find the answer inside the castle. Not Cinderella's, though. Harry Potter's.

"You're a wizard, Harry." Those words in *Harry Potter and the*

Sorcerer's Stone sparked an international obsession with spell casting and wand wielding that is likely to persist for a long time to come. Harry Potter instilled in many millions of us a desire to run around enchanted castle grounds, casting spells and heroically facing off against diabolical wizards.

Sorcerers of the Magic Kingdom offers that same kind of thing, essentially allowing us to live out the *Harry Potter* fantasy inside Magic Kingdom.[4] While *Potter* is not a Disney property (in fact, it's Disney's rival, Universal Orlando, that offers a Wizarding World of Harry Potter attraction), I don't doubt that J.K. Rowling's fantasy is alive and well in the subconscious of many a Magic Kingdomgoer. You might be able to find me a few people who haven't been enchanted by the *Potter* saga, but I doubt that Sorcerers' many bespectacled, card-carrying gamers and enthusiastic youths are among them.

In Sorcerers of the Magic Kingdom, we learn about different spells and are then turned loose to cast them in the acreage surrounding an enchanted castle. We encounter bad guys and peril along the way, always advancing in a storyline and drawing nearer to an ultimate showdown against evil. The parallels between our quest in the park and Harry's seven-year adventures connect themselves in our imaginations, where we're Gryffindors at heart, even in an environment that doesn't expressly acknowledge Rowling's mythos. All we need is a wand.[5]

Enlisting as one of Merlin's recruits is not unlike joining Dumbledore's Army, *Potter*'s band of students who teach themselves self-defense spells in order to battle against "the Dark Arts" in the fifth novel. Indeed, the Dumbledore character bears considerable resemblance to Disney's Merlin. Together, they are perhaps our culture's two greatest examples of the tall-hatted, long-bearded wizard archetype. The *Potter* texts are replete with Merlinian allusions, as are (to a lesser extent) the films. Rowling's characters recognize Merlin as one of the greatest wizards to ever live, and she makes much of Dumbledore belonging to the Order of Merlin, a society of sorts founded by the Arthurian wizard.

It stands to reason then that Sorcerers players, nearly all of them likely versed to some extent in *Potter* lore, will draw a connection between the game and Rowling's pervasive and wonderfully absorbing fantasy. Granted, *Potter* might only enhance Sorcerers for nerds and nerds alone, but if you're playing the game enough to enjoy it, there's a pretty good chance that you are one.

WATCH THIS – "Once Upon a Time" (2011)

ABC's hit primetime TV series isn't the first to ponder whether all the old fairy tales really were true, but it's certainly the most clever and elaborate creation to do so. Bail bondswoman Emma Swan answers her door one day to find a young boy named Henry, who claims to be the son she gave up after his birth. He persuades her to take him home to Storybrooke, Maine, where she quickly crosses paths with the town's malevolent mayor, Regina.

Soon thereafter, Henry confides in Emma his belief that all the inhabitants in Storybrooke are actually real-deal fairy tale characters who are trapped under a curse that won't let them remember who they are. Emma is Snow White's long-lost daughter, he tells her, and Regina is the apple-poisoning Evil Queen. Emma doesn't believe Henry (nor does anyone else), but those of us watching from home know the truth — he's right.

Created by two of the writers from "LOST" and produced by Disney's ABC Studios, "Once Upon a Time" is a riveting, complex, and brilliantly constructed fantasy soap opera capable of delivering mind-blowing twists and revelations week after week. Fairy tales and legends from different times and locales come together in an epic narrative mashup that rarely fails to amaze, even if the show's mid-budget special effects often leave something to be desired.

Like the gamers in Sorcerers of the Magic Kingdom, Emma Swan is an ordinary mortal who must learn a thing or two about magic in order to track down mythical legends, unlock hidden portals, and face off against conspiring tag teams of villainy who are intent on manipulating her world for their own selfish ends. Harry Potter she is

not, but she comes to encounter considerable sorcery inside a magic kingdom of her own.

"Once Upon a Time" is still producing new episodes as this book goes to press, but its first season is available on Blu-ray and DVD, while recent episodes of the show can often be found streaming for free on Hulu.com and ABC's own website.

Celebrate a Dream Come True Parade

Type: Parade

Duration: 7 minutes

Popularity/Crowds: High

FASTPASS: No

Fear Factor: 0.5 (Disney villains appear in person and may frighten some children)

Wet Factor: None

Preshow: Promotional "pre-parade" floats will occasionally run in advance of the actual parade

Best Time to Visit: Arrive 20 to 30 minutes before the scheduled showtime (usually offered once daily, most often at 3 p.m.)

Special Comments: In the event of rain, Magic Kingdom may present the "Rainy Day Character Cavalcade" instead, using the same parade route and usually at the same time as the scheduled parade

There's an unwritten rule at Disney — daytime parades are short-lived, nighttime parades last forever. But rules are made to be broken and the current daytime parade in the Magic Kingdom is on its way to doing just that. The Celebrate a Dream Come True Parade has rolled out in some form nearly every afternoon for more than a decade, making it by far the longest-running daytime parade in Magic Kingdom history. It's also the one with the most complex evolution. The parade that runs today is but a distant memory of its former self, and the substantial alterations in recent years reflect a new approach to live theme park entertainment.

The current parade was originally called Share a Dream Come

True when it opened on the Magic Kingdom's 30th Anniversary, October 1, 2001. It was one of the key components of the resort-wide 100 Years of Magic celebration, honoring the centennial of Walt Disney's birth in 1901. Leading the show was an actor portraying Walt as a young man, stooped over an easel and drawing Mickey Mouse for the first time. Behind him was a float featuring Mickey himself atop a stack of film reels and a banner reading "It Was All Started by a Mouse." That float and the five that followed it put key Disney characters inside giant, life-sized snow globes, as if all those top-dollar decorative orbs in the gift shops had come to life on Main Street. Among those so encased were Aladdin, *Snow White*'s Evil Queen, and three pairs of Disney princes and princesses. A host of other characters, both on the floats and on the ground, marched alongside them. The parade was generally well received. Some fans were put off by the barrier that the globes created between characters and guests, but you have to admit, driving giant snow globes down the road is a great way to set a Disney parade apart from all the rest.

The 100 Years of Magic ended up lasting well beyond Walt's 100th birthday. Eventually it ran its course and wrapped up. Its signature parade, however, did not. Share A Dream Come True kept running in more or less the same form until an accident involving the "A Dream Is A Wish Your Heart Makes" float took the life of a cast member on February 11, 2004. The accident occurred backstage and no guest saw it happen. Why it occurred has never been determined, but the parade was never the same again.

The "A Dream is a Wish Your Heart Makes" float was temporarily retired and the famous "show stops," a feature in which the characters and floats would occasionally pause for a dance sequence and character greetings, came to an end. Disney's castle float, which has turned up in countless parades over the decades, was brought in as a replacement. With the new float installed and the show stops excised, the parade went on.

Eventually, a modified version of the "A Dream is a Wish Your Heart Makes" float returned (the castle float was allowed to stay

in, too). Then, in August 2006, Disney unveiled the first major change to the show since the fallout from the accident, marking by far the most substantial alteration in its five-year history. The snow globes came off, the top of each float was redesigned, the soundtrack changed, and the show was given a new name — the Disney Dreams Come True parade.

That lasted until January 23, 2009, when the Magic Kingdom revamped the show once again, dressing it up to match the new resort-wide "What Will You Celebrate?" campaign, which explains the parade's newest name — Celebrate a Dream Come True. The film reels on Mickey's float were disguised to look like party favors and some of the characters were given a festive costume change, but the new parade was nearly identical to the old one. Complete with re-instated show stops, the parade ran just over 15 minutes in length. Today, it runs just over seven.

Where'd the other eight minutes ago? Well, not long after Celebrate's debut, the very cool villains float that had been there since the beginning was unexpectedly removed and the show stops were cut out once and for all (although Disney continues to feature stops in some of its other productions). In August 2010, the modified "A Dream is a Wish Your Heart Makes" float was taken back out, too. With just five floats and no more pauses along the route, the once-lengthy parade is now over in a flash. So although it has basically offered the same presentation since it opened, the parade running today looks and sounds pretty different from the one that rolled out in 2001.

What's with the short show? Well, in parade years, Celebrate a Dream Come True is a little old lady. Magic Kingdom daytime parades used to change every couple of years. They started extending their stays in the late 1990s but not one has made itself an ongoing houseguest like the Dream Come True parade has. As any old person can tell you, a seven-minute walk is a lot less tiring than a 15-minute one, so maybe the parade just needs the extra rest. Or maybe, as is more likely the case, Disney has something else in mind.

Between staking out a good spot on the sidelines and fighting the crowds at the end, watching a Disney parade used to be an hour-long affair... at least. The new "here they come, there they go" length of the daytime parade makes the experience a lot breezier and perhaps that's more in keeping with the times. When you think about it, standing still in the sun to watch slow-moving floats crawl by is a lot to ask of the YouTube generation, accustomed to ten-minute limits on its entertainment. By whittling down the parade, Disney puts on a great show without pushing the limits of a shrinking attention span.

The extra time also frees Disney to stage a few bonus shows throughout the day. There's a street party in the castle hub every afternoon, for example; a lights-and-effects show projected onto the walls of Cinderella Castle each night; and a daytime country-western hoedown held in the middle of Frontierland. Shifting from one big parade to a series of smaller performances throughout the day allows Disney to keep its guests on the go, moving in and out of gift shops and rides (but mostly gift shops). When Disney can make more of your time and get more of your money too, everybody wins.

There's no doubt that while Celebrate a Dream Come True is the Magic Kingdom's longest-running daytime parade, it certainly isn't one of its best. With the snow globes gone, there's no semblance of a storyline and not much of a discernible theme. It is, basically, a random assortment of Disney characters walking or riding floats down the street for seven minutes. Admittedly, I'm not sure that there's anything in the long and celebrated tradition of parades that requires them to be anything other than that, but Disney parades have often gone above and beyond to create a cohesive narrative. Even if lacking in substance, Dream Come True is eminently likeable. The characters are diverse, fun, and sometimes unexpected. The floats are detailed and splendid. The soundtrack is lively and effervescent, successfully generating the celebratory atmosphere the title calls for and sending guests on their way with extra pep in their step. Unless you're a dedicated

Disney fan with a long memory and a hankering for the lengthier parades of the past, it's hard to dislike this one.

Knowing its epic history makes the production even easier to appreciate. Armed with an understanding of the show's past, you'll know, for example, why the castle replica on one of the floats has a shiny case around it — one last remnant of the show's snow globe roots. You'll understand why the princesses are packed like sardines on the new finale float, or, if the rumors are true and a re-tooled version of "A Dream is a Wish Your Heart Makes" is slated to return someday, you'll know why that particular float means so much to the park.

The parade has certainly proven itself enduring, but there's one thing that occasionally stands in its way — rain. If there's too much water on the ground for the floats to roll out safely, Disney stages the "Rainy Day Character Cavalcade" instead. "Cavalcade" uses streetcars instead of floats and has its own, very catchy soundtrack. It's so good that it's worth getting a little wet for! Disney could just as easily cancel the parade but their determination to go on with the show whenever possible calls to mind the banner song from *Funny Girl*, "Don't Rain on My Parade," which could just as easily be the unofficial mantra for Celebrate a Dream Come True, Walt Disney World's most durable daytime procession.

WATCH THIS - Hello, Dolly! (1969)

Speaking of Streisand songs… *Hello, Dolly!* took on a whole new meaning for Disney fans in 2008 when its soundtrack played an important role in Pixar's *WALL•E*. However, the 1969 movie musical (based on Jerry Herman's Broadway stage show) already had a big Disney connection long before that. Its signature song, "Put on Your Sunday Clothes," has played on Main Street for many years, part of a music loop that features several ragtime and vaudeville standards. Like Main Street itself, the movie is set at the turn of the twentieth century. "Put on Your Sunday Clothes" is a rousing, show-stopping

number that begins with two young men in a store, but soon grows into a full-blown parade down the middle of a period-set street. Both visually and lyrically, the song could be a soundtrack for Main Street and its daytime parade. It speaks of strutting down the road to take a picture and riding around in horse-drawn cars. By the time the sequence builds to a finale, an old-time steam-powered train has rolled into town and Barbra Streisand is belting out, "All aboard!" Later, an official parade becomes an integral part of the story, leading to another of the movie's famous songs, "Before the Parade Passes By." In all of these scenes, one can't help but think of Disney's Main Street.

The Twentieth Century Fox film also stars Walter Matthau, Michael Crawford, Louis Armstrong, and Disney legends J. Pat O'Malley and Fritz Feld. It's available on DVD from Twentieth Century Fox.

SpectroMagic

Type: Parade

Duration: 19 minutes

Popularity/Crowds: High

FASTPASS: No, though Magic Kingdom has been known to test FASTPASS implementation for evening entertainment in the past

Fear Factor: 0.5 (Disney villains appear in person and may frighten some children)

Wet Factor: None

Preshow: Marching bands or promotional "pre-parade" floats will occasionally run in advance of the usual parade

Best Time to Visit: Arrive 20 to 30 minutes before the scheduled showtime (usually offered between one and three times a night)

Special Comments: Disney's Main Street Electrical Parade occasionally runs in place of SpectroMagic for an extended stay, as is the case at press time

Note: From time to time during its history, SpectroMagic has stepped aside to allow its predecessor, the Main Street Electrical Parade, to take a vacation from California and run down Florida's Main Street. Most recently, that happened as part of Disney's "Summer Nightastic" promotion in 2010. When "Nightastic" ended, Disney

announced that the Electrical Parade would stay in the Magic Kingdom indefinitely while SpectroMagic is fine-tuned for its return at some undetermined point in the future. As this book goes to press, the Main Street Electrical Parade is still performing in Spectro's stead while the latter's floats undergo refurbishment backstage. Unless plans change, SpectroMagic will return in the likely near future — perhaps even by the time you're reading this. Because SpectroMagic is Magic Kingdom's official nighttime parade and is expected to make its return soon, we'll focus on it rather than its occasional replacement.

While Magic Kingdom has welcomed plenty of daytime parades over the years, it's had only one evening parade to call its very own — SpectroMagic. The über-illuminated extravaganza premiered on October 1, 1991, the night of the park's 20th anniversary. It has been passionately embraced ever since then. There's a warmth to the parade that worms its way into onlookers' hearts, stirring emotions that, together with the wafting scents of freshly baked cookies and waffle cones in the nighttime air, lift the whole crowd up to cloud nine. The effect is enigmatic at first, but with careful attention, we can find the magic in the music that makes this parade more powerful in its impact than most.

When the Magic Kingdom opened, it didn't have a nighttime parade at all. Instead, a light show called the Electrical Water Pageant ran each night on two bodies of water located just outside of the theme park. Giant sea creatures glided along the Resort's lake and lagoon, set aglow with innumerable lights. The Imagineers were inspired to design a similar pageant for Disneyland, only this one would be themed around Disney characters and would run on land instead. The result was the Main Street Electrical Parade, which opened the next year in the summer of 1972. Pitching itself as a "spectacular festival pageant of nighttime magic and imagination in thousands of sparkling lights and electro-synthe-magnetic musical sounds," the show became an instant classic. Disney's visually arresting cavalcade quickly took its place alongside Macy's Thanksgiving Day Parade as one of the most famous processions in the world. The theme song, "Baroque Hoedown," was a little-

known electronic recording that had previously been featured in the Electrical Water Pageant. Upon the parade's success at Disneyland, the song became a theme park standard and raised the bar for musical pageantry everywhere.

Five years later, on June 11, 1977, Florida's Magic Kingdom welcomed its own version of the Main Street Electrical Parade. The occasional hiatus aside, the show ran nightly in both resorts for many, many years. Eventually, Disney decided the Magic Kingdom should have its very own parade, and the park's 20th Anniversary seemed like the right time for that to happen. The Florida floats were all packed up and shipped over to Disneyland Paris, where they would enjoy an 11-year run. Meanwhile, preparations were underway in Orlando for a new generation of nighttime parades.

SpectroMagic's debut in 1991 was every bit as momentous as the Main Street Electrical Parade's had been in 1972. With an array of brand-new technology and a seemingly limitless collection of lights, the new parade was positively dazzling. This showstopper on wheels captured the magical essence of Walt Disney World in one glorious motorcade and delivered on its promise to create a memorable evening of entertainment.

As theme park parades go, SpectroMagic is a masterpiece. Each float is beautifully crafted to play a specific role in the story being told through beaming light and emotive song. Comprised of six distinct but related sequences, each chapter of the parade flows into the next with aesthetic and thematic finesse. It begins with a prelude of sorts, during which a clan of clowns rides out on revolving spheres. The bright lights in their costumes, the heralding clamor of their horns, and their ostentatious jittering immediately pique guests' interest. Who are these creepy clowns and what are they doing here? They don't look like any Disney character that audiences are familiar with, and that's because they aren't. Their purpose is made apparent soon enough — they're ushering in the main mouse himself.

Mickey rides into view atop a tall platform, glowing brighter

than anything that precedes him. Decked out in royal white and gold for the occasion, he lays his gloved hands on a gleaming crystal ball and summons visible bolts of electricity inside it, which seem to flow out of his cape and back toward the rest of the parade behind him. In this opening sequence, Mickey generates the power that will bring his nighttime marvel to life. Exactly what kind of power is it? Electricity? Magic? Maybe a little of both? We aren't entirely sure, and that's part of the wonderment. The musical preamble reveals that he's cast a special spell to light our way with "pure enchantment." If every story needs a beginning, middle, and end, this is the first of those, and it's a promising one. Mickey is casting some kind of electrical spell that will enable imagination to manifest itself in "a million points of musical light."

And while the lights might get all the attention, the musical component can't be ignored. The second sequence of the parade is dedicated entirely to music as a concept. Sure, there are Disney characters there, but they're almost incidental. The floats aren't themed to movie scenes or sets, but simply to music. *Aladdin's* Genie conducts while Goofy hammers the timpani and Chip and Dale duel on a grand piano. A giant metronome serves as a transition piece from Mickey's introduction and simultaneously sets the tempo for the musical suite.

The suite's lyrics ruminate on the magic and music now surrounding the audience. The parade is clearly aware of the importance of music in its procession, but nothing in the show reveals what makes SpectroMagic's soundtrack unique. That's where our thinking caps come in handy. Most parade scores are marches, but SpectroMagic's score is a waltz. That makes it really special, not only because it stands out from other parades but also because it allows our connection to the song to be more emotional, as opposed to merely kinetic. The waltz sinks in at a deeper level and allows us, as listeners, to sway with — and be swayed by — the music. That clever rhythmic choice gives the parade its staying power, which the lyrics tell us is its goal.

The parade's theme song is "On This Magic Night." Its lyrics

suggest that Mickey is casting a spell that will make sure we never forget such a special evening. The music delivers on that promise with its bold choice of a waltz as its theme. Infectious and melodic, the soundtrack is unquestionably hard to forget.

The parade's third sequence looks at nature in the same way that the second focuses on music. A giant peacock hides behind his feathers the first of the three *Sleeping Beauty* fairies, who remarkably get one giant float each. Rare indeed is the Disney parade that devotes abundant time and resources to multiple characters from a decades-old property, but it works for Spectro-Magic. Therein lies another quality making this parade unique — the attention it pays to storytelling even at the expense of lost promotional opportunities. *The Little Mermaid, Fantasia,* and *Sleeping Beauty* are the only movies with their own sequences in the parade, and even those feel decidedly non-commercial.

Rather than keeping space open for current Disney properties to make an appearance, the parade transitions to *Mermaid* organically. There's no rush to get to Ariel. The show moves away from the floral aspects of nature seen in the *Sleeping Beauty* floats and into marine life. Guests soon find themselves staring at a seemingly random procession of fish, who, like the clowns at the beginning of the parade, are the prelude to the next major act. Amazingly, the production takes the time it needs to build up to that act without any jarring jumps from one scene to the next. We eventually learn that the fish are paving the way for King Triton. Or maybe they're just running away from Ursula. Either way, they're seamlessly bridging the gap from the woods of *Sleeping Beauty* to the ocean depths of *The Little Mermaid*. That progression takes a while. A lot of other parades, including some of Disney's own, would be afraid to gamble guests' attentiveness on something so leisurely and abstract.

Fantasia surely isn't in the parade for its marketing potential. That movie is older than most people in the park! No, it's there because it's so fitting for the parade's theme. The lyrics call this pageant a "symphony in SpectroMagic," with narrator Jiminy

Cricket describing the fusion of music and light. *Fantasia* is a film devoted to the visualization of music, the marriage of eyes, ears, and imagination. At the most basic level, that movie's goals are closely aligned to the parade's. So even if it isn't likely to sell the most merchandise or DVDs, *Fantasia* is given a substantial chunk of the parade, one that includes an awesome Bald Mountain float that actually opens up to reveal Chernabog, the horrifying demon from the film's finale.

He isn't the only olden character who turns up. The final sequence begins with The Three Little Pigs, characters from Walt's *Silly Symphonies* series of short films. Incidentally, the *Silly Symphonies* were test projects for *Fantasia*, so the transition from Chernabog to the Big Bad Wolf is as clever as it is villainous. Cinderella's famous pumpkin coach then leads a cavalcade of classic Disney characters from the 1930s, 1940s, 1950s, and (in Mary Poppins' case) the 1960s. You won't find a more recent personality in the bunch. In fact, since the parade opened, the only franchise addition has been *Aladdin's* Genie, a widely loved character who sits comfortably beside his classic brethren.[6]

SpectroMagic is very much a product of its time, not only because of its fascination with all that is fiber-optic and neon but also its fixation on Disney's past. Up until *The Little Mermaid*, the 1980s hadn't been very kind to Walt Disney Animation, and the 1970s had been even worse. The parade therefore looks back with fondness on the first "Golden Ages"[7] of Disney animation, when Walt Disney was alive and well. The company could scarcely have know when the parade premiered in 1991 that it was on the verge of a new golden age, which we now see as having begun with *The Little Mermaid*. That film and *Aladdin* are Spectro's only nods to contemporary Disney and, more than 20 years after their release, even they don't feel so contemporary anymore. Their characters have become as beloved as Snow White and Peter Pan.

With nothing new or "now" in it, the parade feels astoundingly nonpromotional. Disney could have planted a Pixar character or a *High School Musical* cheerleader in the mix at any time, but the

powers that be have seen fit to leave it alone. Some might say that leaves the parade feeling dated, but it also leaves it feeling pure, which is surely preferable to productions that are constantly manipulated for promotion's sake. In that sense, SpectroMagic is a triumph of art over commercialism, a victory that cynics won't expect and will be reluctant to acknowledge in a Disney theme park. But there it is in the Magic Kingdom, each and every night.

WATCH THIS – Fantasia (1940)

Walt Disney's third feature film doesn't factor into the Main Street Electrical Parade, but it's a critical piece of SpectroMagic. Naturally, many watching the parade will have seen the movie, but I suspect there are also many who have not. With a recent viewing fresh in your memory, the show's several *Fantasia*-inspired floats will be much more meaningful.

The extent to which *Fantasia* pushed the envelope can't be overstated. Just three years earlier, the world was telling Walt that an animated movie was a fool's dream. After one big success and one relative flop, here he was engaging in experimental filmmaking in that still-new medium.

With almost no dialogue, a classical score, and a runtime that goes beyond two hours, nothing about *Fantasia* made sense on paper (and still doesn't). Audiences didn't embrace the movie for a very long time, but we consider it a remarkable artistic achievement today. Walt knew what he was doing and put his artistic integrity ahead of his potential commercial return at the box office. SpectroMagic does exactly the same thing, with the key caveat that the parade has been a success from the beginning.

Wishes: A Magical Gathering of Disney Dreams

Type: Fireworks show

Duration: Twelve and a half minutes

Popularity/Crowds: High

FASTPASS: No, though Magic Kingdom has been known to test FASTPASS implementation for evening entertainment in the past

Fear Factor: 1 out of 5 (fireworks scare some children)

Wet Factor: None

Preshow: Celebrate The Magic (light-and-effects show projected onto Cinderella Castle)

Best Time to Visit: Arrive 20 to 30 minutes prior to the scheduled showtime (usually offered between one and two times a night)

Special Comments: Celebrate The Magic is sometimes offered multiple times during the evening and thus does not always immediately precede a performance of Wishes, one show you absolutely do not want to miss

An adventure as rich and spellbinding as a day in the Magic Kingdom demands an epic conclusion and Disney delivers as only Disney can. Every night at the Magic Kingdom ends with fireworks and so, too, does our journey through the park together. In this book, as in the park itself, there could be no more fitting a finale. Wishes: A Magical Gathering of Disney Dreams is one of the best fireworks extravaganzas in the world. It is a culmination of the spectacle, optimism, faith, and nostalgia that make Walt Disney World so distinctly appealing. The imagery, music, and fundamental themes in this hyper-sensory experience resonate with millions of Magic Kingdom guests every year in a way that is both profound and lasting. True, all good things must come to an end, but in Walt Disney World, the end is one of the best things of all.

Fireworks displays have for centuries marked the dawn of a new year, a royal celebration, or the birth of a nation. The idea of staging a full-scale display every night of the year, however, is relatively new. The Disney theme parks are renowned more than any other for their nightly pyrotechnics, and Walt Disney World just happens to be the largest single consumer of fireworks in the world. That kind of nightly extravagance might seem curious to some. Surely any given evening in a theme park is less momentous than Independence Day or New Year's Eve. Perhaps, but the Magic Kingdom realizes that its guests aren't there by happen-

stance. The chance to stand in front of Cinderella Castle and see it with one's own eyes often represents years of working, saving, and planning for a family's once-in-a-lifetime vacation to The Happiest Place on Earth. Every night, there are guests in the massive crowd who have literally been waiting their entire lives to be there. Disney sends them off with a glorious celebration that recognizes and rewards everything it took to make that dream come true. Magic Kingdom fireworks, therefore, aren't just about making a crowd ooh and ahh. They're a celebration of a day that will often rank among the most memorable in its guests' lives. That's an occasion worth making a little noise for.

Fireworks are nothing without music, and Wishes features one of the all-time great pairings of the two. A raucous score would be the obvious choice for musical accompaniment to a fireworks show — high-energy music for high-energy explosions in the sky. But as we've already seen, Disney isn't big on the obvious. Instead, the theme song is a stirring serenade, performed by a children's choir and interwoven with a few of Disney's most inspirational songs, which tap the heart and warmth of the Disney classics to give the show resonance and weight. Dialogue from familiar characters is in the mix, too, using the park's crisp and omnipresent sound system to fortify the show with a message from none other than *Pinocchio*'s Jiminy Cricket, who serves as Disney World's venerable narrator.

At least half an hour before the scheduled show time, the crowds start to gather, their anticipation building by the moment. Suddenly, almost without warning, the park goes dark, the castle lights up in a blinding white blaze, and the enormous trumpeting of horns heralds the long-awaited arrival of the fireworks show.

Words alone can't convey the impact of that moment. There is no point during the Disney park experience when the magic hits harder than with the opening notes of this fireworks show. To quote Jiminy, "like a bolt out of the blue," a feeling of "Wow! I'm actually in Disney World" washes over the crowd in that split second.

Following an incantation from the Blue Fairy, Disney's pyro-technicians launch a breathtaking shooting star over the castle and across the sky. The show is called Wishes, after all, and what's a wish without a star to wish upon? After a few more of those stars and a gorgeous medley of "Star Light, Star Bright" and "When You Wish Upon a Star," the guests finally hear from Jiminy Cricket, who immediately turns his attention to the cynics in the crowd:

"Pretty, huh? I'll bet a lot of you folks don't believe that, about a wish coming true, do ya? Well, I didn't either. Course, I'm just a cricket, but let me tell you what made me change my mind. You see, the most fantastic, magical things can happen, and it all starts with a wish."

Here, Jiminy brings us full circle to the first attraction in our clockwise tour of the park: the Jungle Cruise. That ride challenged us to check our cynical hang-ups and disbelief at the door, to give in to our imaginations and heartily embrace the make-believe that propels the entire Resort. At the end of a long day, Jiminy speaks to us from on high to remind us that it's okay to indulge ourselves in a little fantasy. He gives us permission to let our defenses down and entertain a bit of sentimentality. He prepares us for the heartstrings-plucking symphony that will follow. And just as he says "wish," those trumpets return with an extraordinary key change and direct our attention to the castle spire, where none other than Tinker Bell herself instantly appears, as if out of nowhere, and literally flies out over the crowd and into the nighttime sky.

Then the real fireworks begin. A whole host of Disney characters chime in to tell the familiar tales of their own dreams come true as the skies fill with wonder. These are stories we all know, of course, so they don't have to work to convince us. As the show goes on, the music grows grander, the fireworks boom larger and louder, and Jiminy's message grows more and more pointed. He returns at the top of each new phase of the show to reiterate his faith in faith itself — to let us know belief is an act of courage.

Then comes the grand finale. The children's chorus returns and exchanges lines with the larger Disney choir. "Make a wish," they sing, "dream a dream!" They chant the word "Wishes" in a round. The music builds to a crescendo and as the climax approaches, the suspense grows. There's a drum roll. The music swells. Trumpets soar. The choir belts, "Your dreams. Will. Come." — wait for it — "TRUE!" With timpani rumbling and brass blaring, the sky erupts in a spreading landscape of color and fire.

Jiminy laughs and says, "see what a little wishing can do?" And there, in that overwhelming moment, amidst the cheering and applause, and the sniffling from a crowd moved to tears, with the whole sky lit up in front of us, we do see. Wishes-come-true aren't just things of fairy tales and make-believe. They are the manifestation of human ingenuity and divine inspiration, the very things that Walt Disney acted on when he pursued the dreams that led up to this very moment in the Magic Kingdom a few decades later. He was born into poverty but capitalized on the opportunities available to him, eventually overcoming his circumstances to build an entertainment empire that has been a source of joy and inspiration to the world. All of the multi-billion dollar spectacle and unforgettable euphoria of the theme park around us is there because of his vision, courage, and faith. His is one of the greatest American success stories and Wishes doesn't just celebrate that, it reminds us that it can happen for us, too.

WATCH THIS – Magic Kingdom (Date Unknown)

Walt Disney Pictures currently has a major live-action movie in the works, tentatively titled *Magic Kingdom*. The basic premise will explore what happens when one family is still in the park after closing and things start to come to life. Director Jon Favreau (*Iron Man*, *Elf*) has been tapped to helm and co-script the project, and he's made assurances that his movie will stay away from *Night at the Museum* territory and will avoid crossing too far into other Disney franchises,

like *Pirates of the Caribbean*. Little else has been announced, not even a year for release (the studio says it wants to give the project all the time it needs), nor has there been any official clarification as to whether it will be set in California or Florida.

An interview with Favreau on Geek Time radio, however, generated a lot of excitement. "I want to make it a little bit spookier, like the old Disney movies were," he said, "I really want to focus on the classic stuff like *Dumbo*, *Steamboat Willie*... all the Fantasyland stuff. I think there was something timeless about what Walt Disney did... There is such a weird, shared experience that any of us who's ever gone to Disneyland feels, that I don't think has really been mined yet. It's this collective subconscious that we have."

That collective subconscious is what allows something like Wishes to work so powerfully. If the movie is as mindful of that, and as respectful of Walt's creative ingenuity as Mr. Favreau is, then the project shows incredible promise.

Wishes is all about looking ahead, having faith, and moving forward. It's in that spirit that I close this book with a recommendation for a movie that hasn't been made yet. Walt famously said that his park would never really be done, that it would keep growing. This momentous addition to the Disney Parks legacy will open yet another new chapter in the perpetual progress to which he was so committed, and give us all a brand-new way to savor and cherish the magnificence of the Magic Kingdom.

Notes

Chapter 1: Adventureland

1. Western River Expedition is probably the most famous and influential Disney attraction never to be constructed. Original story and show elements from the ride are today found not just in Big Thunder Mountain Railroad, which is covered in *Chapter Two*, but in numerous other attractions in Walt Disney World and around the globe, including Splash Mountain, Tom Sawyer Island, The Great Movie Ride, Living with the Land, Phantom Manor, and Expedition Everest. It continues to inspire new ideas for future attraction development.

2. The building's name and design were inspired by the Castillo San Felipe del Morro, also known as Morro Castle, in San Juan, Puerto Rico. In Spanish, "Castillo del Morro" means "Castle of the Point" or "Castle of the Promontory." The name is not related to the so-called "Moors," a questionable and sometimes controversial term used to identify certain Northern African populations, despite that term's occasional correlation with piracy.

3. As this book goes to press, Captain Blackbeard has replaced Davy Jones in the ride. While this change is said to be temporary, it has already lasted longer than initially expected. Jones will presumably return to the attraction at some point in the future, but Disney has not yet announced a date for that to happen.

4. Marc Davis (1913 - 2000) began his Disney career as an animator on films like *Snow White and the Seven Dwarfs* and *Bambi*. He went on to become one of Walt's "Nine Old Men," the studio's core group of animators. In later years, he worked on attractions like Haunted Mansion, Walt Disney's Enchanted Tiki Room, and It's a Small World, among others. He was named a Disney Legend in 1989.

5. The term "tree house" is properly written as two words. Disney, however, uses the unconventional "Treehouse" spelling in the official title. Accordingly, I will use "Treehouse" when referring to the attraction name and "tree house" when speaking more generally.

6. Wyss' *The Swiss Family Robinson* (published in 1812) is a reworking of the original English novel, *Robinson Crusoe*, by Daniel Defoe, which was in turn inspired in part by the real-life adventures of Alexander Selkirk, who in 1704 was a castaway for four years on an uninhabited island off Chile. Today, that island is known as Robinson Crusoe Island.

7. *Variety* announced in late 2004 that a major live-action remake of 1960's *Swiss Family Robinson* was in production at the Disney Studios, and in June 2005 confirmed that Jonathan Mostow (*U-571*, *Terminator 3: Rise of the Machines*) had signed on as director. Production was repeatedly delayed as story and casting plans changed and other projects interrupted progress. At one point, Lindsay Lohan was reportedly in talks to star. In 2009, news broke that Will Smith, Jada Pinkett Smith, and their three children, Trey, Jaden, and Willow, would star in *The Robinsons*, presumably a new title for this same project. Since then, however, and as this book goes to press, there have been no further announcements or developments. I asked Mostow for an update on *The Robinsons*' status during a virtual press junket in January 2010, but he remained tight-lipped about his plans for the future, declining to comment on the project except to say that he hopes that his next film will be a thriller, a genre that may or may not apply to *The Robinsons*.

8. One of my favorites came from Mikey of the *Magic City Mayhem* video podcast. He drew a sketch of the likely perpetrator: the Dreamfinder, a long-lost and iconic Epcot character who, like the original Tiki birds, had been silenced when Disney updated his attraction. So why the Dreamfinder? Well, not only does he have the revenge motive, but there's his signature theme song, too: "One Little Spark."

9. Prior to February 6, 1986, The Walt Disney Company was known as Walt Disney Productions. Originally founded in 1923 as the Disney Brothers Cartoon Studio, the partnership became The Walt Disney Studio in 1926, and then Walt Disney Productions, Ltd. in 1929, before later merging with several other Walt-owned enterprises to form Walt Disney Productions in 1938.

10. Magic Kingdom's Sunshine Pavilion is not to be confused with The Land Pavilion's Sunshine Season Food Fair in Epcot.

11. The show's opening line, "Ohhh, buenos días, señorita, my siestas are getting shorter and shorter," is one of the Disney Parks' most famous quotations.

12. Between The Magic Carpets of Aladdin and the "Under New Management" incarnation of The Enchanted Tiki Room, *Aladdin* has not fared well in Adventureland, despite the film's popularity. A dining experience-turned-storytelling show called Aladdin's Oasis struggled in Disneyland's Adventureland too, and ultimately closed. The property has caught on in other lands and parks, however, most notably in Disney's Aladdin: A Musical Spectacular in Disney California Adventure.

13. *One Thousand and One Nights* is one of several accepted titles for a collection of short stories and folk and fairy tales that were probably first gathered and anthologized during what is known as the Islamic Golden Age, as far back as the ninth century or even earlier. The work's history is uncertain and complex, and numerous versions exist. Many scholars believe that its three best-known stories, "Aladdin and the Enchanted Lamp," "Ali Baba and the Forty Thieves," and "The Seven Voyages of Sinbad the Sailor," did not exist in the original Arabic texts but were added by French translator Antoine Galland (and possibly some of his contemporaries), though there is little doubt as to the stories' origins in authentic Arabic or Persian folklore. The other stories are believed to have originated in the ancient or medieval Middle East or South Asia. Galland's 1704 translation is considered extremely influential as a part of the collection's legacy, and it was followed two years later by the first English translation, entitled *The Arabian Nights' Entertainment*. The English-speaking world has commonly referred to the work as *The Arabian Nights* ever since. Disney's *Aladdin* and especially its progeny in the studio's *Aladdin* franchise draw inspiration from the "Enchanted Lamp" tale and others (particularly "Ali Baba"), though the film diverges from the original tale in a number of ways. In *The Arabian Nights*, for example, "Aladdin" unfolds in China.

14. Alan Menken (born 1949) is an eight-time Oscar-winning composer of songs and scores for film and the stage. His first big break came with the Off-Broadway productions, *God Bless You, Mr. Rosewater* in 1979 and *Little Shop of Horrors* in 1982, the latter of which was adapted for a major motion picture. He is best known, though, for his work in Disney animation, where he was instrumental in the renaissance of animated filmmaking during the late 1980s and 1990s, beginning with *The Little Mermaid* in 1989. He worked with lyricist Howard Ashman until the latter's death, and their partnership produced the acclaimed soundtracks for *Beauty and the Beast* and *Aladdin*. Menken's later films include *Pocahontas*, *Hercules*, *Enchanted*, and *Tangled*, among others, and his recent stage work includes the Broadway adaptations of the 1992 Disney-studio films, *Sister Act* and *Newsies*. In addition to his Oscars, Menken has seven Golden Globes and a Tony Award to his credit. He was named a Disney Legend in 2001.

15. Sabu Dastagir (1924 - 1963) was an Indian actor who enjoyed a vogue in British and American films of the 1930s and 1940s. He was typically billed by just his first name. Notably, Sabu's next two film credits were as Mowgli in a live-action version of *The Jungle Book* (1942) and as Ali Ben Ali in *Arabian Nights* (1942), also inspired by *One Thousand and One Nights*.

16. Conrad Veidt (1893 - 1943) was a German actor who specialized in playing villains. Although vehemently anti-Nazi, he is perhaps best remembered by American audiences as the Nazi Major Strasser in *Casablanca*.

Chapter 2: Frontierland

1. Then again, there *are* those out there who hate It's A Small World (for shame!). I suppose the title of "Most Divisive" might be up for grabs.

2. Disneyland's expectations for the Country Bear Jamboree were so high, based on its success in Florida, that they built *two* theaters for it right away. Inexplicably, whether due to its location or some other variable, the show was never as popular in Disneyland as it was in Walt Disney World and that extra capacity went largely unneeded. When Splash Mountain opened there, Bear Country became Critter Country instead, and the Bears' popularity declined even further. Disneyland shuttered the attraction in 2001 to make way for The Many Adventures of Winnie the Pooh. Ironically, many Disneyland fans now pine for the Jamboree, while Walt Disney World's guests generally express less passion for it. Perhaps absence makes the heart grow fonder.

3. Big Al is voiced by actor and country music star Tex Ritter (1905 - 1974), and it is he who performs "Blood on the Saddle" in the show. Ritter had performed the song earlier in his career, including in the 1937 Western film, *Hittin' the Trail*, and as the lead track on his 1960 album, *Blood on the Saddle*. While there is some dispute as to the song's origins, it was most likely written in the 1920s by Everett Cheetham and first recorded by Ritter. For more, see Herndon, Jerry A. "'Blood on the Saddle': An Anonymous Folk Ballad?" *The Journal of American Folklore* 88.349 (1975) : 300-04. Print.

4. The Golden Horseshoe is a lunch-and-dinner theater that has operated in Disneyland's Frontierland since 1955. Magic Kingdom initially opened with its own version, the Diamond Horseshoe Saloon, which sits on the border between Frontierland and Liberty Square and has been officially designated as belonging to one or the other at various times in its history. The stage show there ran under several names until it was replaced in 2003 by "Goofy's Country Dancin' Jamboree," a line-dancing character show that went unaccompanied by any dining menu and ended in 2004. The Diamond Horseshoe no longer appears on the attractions roster and has remained mostly closed since 2004, opening only for special events or for occasional counter-service dining (without live entertainment) during the busiest days of the year.

5. "The Country Bears (2002)." *RottenTomatoes.com*. Flixster, n.d. Web. 3 Jan. 2012.

6. Fess Parker (1924 - 2010) was an actor best known for playing the title hero in Walt Disney's "Davy Crockett" television series. He also starred in several Disney feature films, including *Old Yeller*, *The Great Locomotive Chase*, and *Westward Ho, the Wagons!* He was inducted as a Disney Legend in 1991.

7. The mine train is a common type of steel roller coaster in which the vehicles are shaped like mine cars and appear to be pulled by a steam locomotive at the front.

They typically feature steep banks and sharp turns but few drops. Mine train coasters outside of the Disney parks include The Runaway Mine Train at Six Flags Over Texas (built in 1966 and often credited as the very first mine train coaster); the Carolina Goldrusher at Carowinds Park in Charlotte, North Carolina; Thunder Run at Canada's Wonderland in Vaughan, Ontario; and Thunderation at Silver Dollar City in Branson, Missouri (note the thunder motif in this particular genre of coasters). While these other mine coasters may be charming in their own right, they feature a standard, exposed-steel design with only modest detail in comparison to Big Thunder Mountain Railroad.

8. Tony Baxter is the former Senior Vice President of Creative Development at Walt Disney Imagineering and is one of the most famous and celebrated living Imagineers. He began his career at Disney in 1965, working as an ice cream scooper on Main Street in Disneyland while also studying for a degree in theater design at California State University, Long Beach. He worked his way up the company ladder, where his ingenuity caught the attention of WED Enterprises, the precursor to Walt Disney Imagineering. Big Thunder Mountain Railroad was his big break in terms of creative control, and he has since been heavily involved in the design of Splash Mountain, Indiana Jones Adventure: Temple of the Forbidden Eye, the original Journey Into Imagination, and many other attractions, in addition to Disneyland's overhauls of Fantasyland in 1983 and Tomorrowland in 1998, and the overall design of Disneyland Paris.

9. Joel Chandler Harris (1845 - 1908) was an American writer born in Eatonton, Georgia. A white man, Harris spent his teenage years working as a printer's devil (a printing press apprentice) for Turnwold Plantation just outside of Eatonton, where he spent much of his time with slaves, befriending them and learning their speaking and storytelling styles. Later, he moved to Atlanta, where he developed two careers under two names. As Joe Harris, he was a journalist and an associate editor of the *Atlanta Constitution* newspaper, in which he became known as an outspoken voice in favor of racial reconciliation and certain minority rights during the Reconstruction era and the years following. As Joel Chandler Harris, meanwhile, he was the best-selling author of *Uncle Remus: His Songs and His Sayings* (1880). It is the latter for which he is most commonly remembered today. Despite what he professed to be his earnest disdain for racism, Harris' work as both a folklorist and a political advocate is the source of ongoing academic criticism and controversy. Some scholars defend his writings as important milestones in the history of black literature, while others accuse him of paternalism toward black citizens and theft of black storytelling. Still others have called into question the authenticity of his folklore.

10. Other objections have been lodged against the film, including what some have called the racial stereotyping of Aunt Tempy (McDaniel) and several of the

animated characters, not just Uncle Remus — but Remus' apparent satisfaction
with his lot in life has been at the core of most objections to its re-release.

11. Given the constraints and purpose of this book, I am content to raise these
 questions without endeavoring to fully answer them here. After all, it is often the
 purpose even of scholarship merely to interrogate and inquire. I believe that this
 is the first book to ask these specific questions, and I pose them in the hopes that
 others will see fit to pursue them, as I may some day as well. There is surely a
 world of academic intrigue to be found in their answers.

12. Michael Eisner and Frank Wells became the new CEO and President/COO,
 respectively, of The Walt Disney Company in 1984. Interestingly, it was Walt's
 nephew, Roy E. Disney, (along with fellow shareholder Stanley Gold) who
 recruited the two men for the jobs, which meant that Walt's son-in-law (and Roy
 E.'s cousin-in-law), Ron W. Miller, lost his position as company head.
 Under the leadership of Eisner and Wells, The Walt Disney Company radically
 changed, transforming from a movie-and-rides studio to a mighty multimedia
 conglomerate and introducing an unprecedented decade of success in numerous
 new ventures. Wells died in a helicopter crash in 1994 (he was posthumously
 inducted as a Disney Legend the same year), and Eisner's later years as the
 corporate head honcho were less successful, ultimately resulting in Roy E. and
 Gold's "Save Disney" campaign to oust their own handpicked CEO from his job.
 The campaign was successful and Eisner bowed out from the Mouse House in
 2005, handing the CEO reigns to his successor and the current head, Bob Iger.
 For more on this, one of the most fascinating sagas in media history, see Stewart,
 James B. *DisneyWar*. New York: Simon & Schuster, 2005. Print.

13. Walt Disney Pictures launched its Touchstone Pictures subsidiary in 1984,
 intended for material too edgy for Disney's family-friendly brand. Its first
 film was the PG-rated *Splash* (1984), a box office titan that paved the way for
 future Touchstone titles like *Pretty Woman*, *Sister Act*, *Who Framed Roger Rabbit*,
 Armageddon, and many more. As Touchstone is merely a distribution and
 marketing label, there is no real difference between a Touchstone film and a
 Disney film at the studio level. Often, movies are well into production before
 a final decision is made as to which brand will be applied. Touchstone is also
 designated for much of Disney's broadcast television programming. The number
 of Touchstone releases has slowed in recent years, as Disney has cut back on the
 overall number of films it produces each year. It has also moved into PG-13 fare in
 its native brand with films like *Pirates of the Caribbean: The Curse of the Black Pearl*.

Chapter 3: Liberty Square

1. Frontierland is the only land in the Magic Kingdom not directly accessible
 from the Castle hub and that is significant. To get there, guests must start at the

beginning of the story by entering through Liberty Square (or cheat and take a backdoor shortcut through Adventureland). The park map draws a seemingly arbitrary boundary between the two worlds; in the park, the transition is marked on the ground by a strip representing the Mississippi River and an out-of-the-way Frontierland entrance sign, both easy to miss.

2. President Obama is the 44th President, but there are only 43 in the Hall of Presidents because Grover Cleveland served two non-consecutive terms.

3. While administering the oath of office to President Obama, Chief Justice John Roberts misspoke part of the oath and the President repeated the garbled version. In an abundance of caution, Justice Roberts re-administered the oath in the White House the following day.

4. Paul Frees (1920 - 1986) was an actor best known for his versatile voice work. His many credits with Disney include the Ghost Host in Haunted Mansion, the Auctioneer in Pirates of the Caribbean, the narrator for Adventure Thru Inner Space, and the voice of cartoon character Professor Ludwig Von Drake. Frees is also a staple of the Christmas season, having voiced memorable holiday characters that include Burgermeister Meisterburger in *Santa Claus Is Comin' to Town* and a number of characters in *Frosty the Snowman*, *Mister Magoo's Christmas Carol*, *The Little Drummer Boy*, and many more (especially with the Rankin/Bass studio). He was named a Disney Legend in 2006.

5. Claude Coats (1913 - 1992) worked as a background artist on many Disney films, including *Snow White and the Seven Dwarfs*, *Pinocchio*, *Fantasia*, and *Cinderella* before joining WED Enterprises in 1955 to aid in the design of Disneyland. His tenure there lasted until his retirement in 1989, during which time he worked on attractions such as Mr. Toad's Wild Ride, Snow White's Scary Adventures, Haunted Mansion, It's a Small World, and many more. He was named a Disney Legend in 1991.

6. See *Chapter One*, Note 4.

7. Xavier Atencio (born 1919), more commonly known as simply X Atencio, came to Disney as an animator, most notably working on *Fantasia* and the Oscar-winning *Toot, Whistle, Plunk, and Boom*. But he made his biggest impact as part of WED Enterprises, where he wrote "Yo Ho, Yo Ho A Pirate's Life for Me" and co-wrote "Grim Grinning Ghosts." He also penned the scripts for Pirates of the Caribbean and Adventure Thru Inner Space, among other notable contributions to the parks. He retired in 1984 and was named a Disney Legend in 1996.

8. Haunted Mansion is found in New Orleans Square in Disneyland, Liberty Square in the Magic Kingdom, and Fantasyland in Tokyo Disneyland, while the Parisian counterpart, Phantom Manor, is located in Frontierland in Disneyland Paris. The Hong Kong Disneyland version will be called Mystic Manor and is under construction as this book goes to press. It is expected to open in Mystic Point (a new, supernatural-rainforest-themed land) in spring 2013.

9. Disney has been known to proffer various versions of a Mansion backstory, not only in the *Haunted Mansion* movie but also in various publications and as part of backstage tours. Mansion cast members are known to have theories of their own. The details of these narratives vary and they can all probably be best regarded as supplementary and non-canonical. What matters to guests during the ride is what is — and most importantly, what *isn't* — made clear to them as part of the attraction experience itself.

10. One possible reading for this scene is that when the Doom Buggies fly out of the window, they actually fall to the ground, suggesting that the guests have just died (either because they committed suicide or were pushed out of the window by the evil bride). There's nothing in the ride to establish that narrative as definitive, but it *would* explain why the ghosts suddenly seem so happy to see us (perhaps they're welcoming us to the afterlife) and why a mortal groundskeeper is shaking in his boots when he sets eyes on us (though he could just be frightened by the ghosts behind us).

11. Shakespeare's full verse reads:
 "Look, how the world's poor people are amaz'd
 At apparitions, signs, and prodigies,
 Whereon with fearful eyes they long have gaz'd,
 Infusing them with dreadful prophecies;
 So she at these sad sighs draws up her breath,
 And, sighing it again, exclaims on Death.
 'Hard-favour'd tyrant, ugly, meagre, lean,
 Hateful divorce of love,'— thus chides she Death, —
 'Grim-grinning ghost, earth's worm, what dost thou mean
 To stifle beauty and to steal his breath,
 Who when he liv'd, his breath and beauty set
 Gloss on the rose, smell to the violet?" (925-936).

12. Thurl Ravenscroft (1914 - 2005) was a successful singer and voice artist who first became associated with Disney as part of The Mellomen, a singing quartet he co-founded in 1948. In addition to singing backup for the likes of Elvis Presley, Rosemary Clooney, Bing Crosby, and Peggy Lee, The Mellomen also contributed songs to a slew of Disney productions, including "Zorro," *The Jungle Book*, and *Peter Pan*. For Disneyland, they recorded the now-classic "Meet Me Down on Main Street." Meanwhile, in his individual capacity, Ravenscroft lent his voice to dozens of Disney films and attractions, with Splash Mountain, Pirates of the Caribbean, and Walt Disney's Enchanted Tiki Room among them. Notably, his face is projected onto one of the singing busts inside Haunted Mansion. It was, however, his work outside the Disney studio that brought him his greatest fame. In 1966, he recorded the sneering anthem for Chuck Jones's classic *How the Grinch*

Stole Christmas!, and for more than 50 years, he provided the voice of the Frosted Flakes mascot, Tony the Tiger. His signature phrase, "They're Grrrrreeeat!" left an indelible mark on popular culture. He was inducted as a Disney Legend in 1995.

13. For many years, there was something very ring-like in the pavement just outside Haunted Mansion's exit, often said to have been the remnant of an old pole. Still, rumors persisted that this was the bride's wedding ring, either intentionally placed there by mischievous cast members/Imagineers or somehow supernaturally reappearing. It came and went at least a couple of times over the years but has now seemingly disappeared for good. However, when the Imagineers unveiled a brand-new, interactive, and amazingly detailed graveyard queue for the Mansion in 2011, they found a way to pay tribute to that legend… but I'll say no more.

14. For one such photograph, see "Truly Haunted Haunted Mansion Photo." *WDWMagic – Unofficial Walt Disney World discussion forums*, 4 Dec. 2004. Web. 17 Dec. 2012. <bit.ly/V3HyQJ>.

I'm not signing on as a believer in the ghost quite yet myself, but the attraction *does* feel just real enough to make one wonder…

Chapter 4: Fantasyland

1. The dark ride concept actually predates Walt Disney's birth, tracing all the way back to the late nineteenth century. A popular precursor was the "Old Mill" ride, typically an indoor, water-borne boat ride through a dark and spooky environment. Just such a ride was among the earliest offerings at Coney Island's Sea Lion Park, which opened in 1895 to become the world's first permanent, enclosed amusement park. Likewise, the "Tunnel of Love," originally a boat ride, has long been a staple of carnivals and fairs. In fact, one of Disney's first encounters with the dark ride came when a jealous Donald Duck followed Daisy into a Tunnel of Love in 1946's *Donald's Double Trouble*, nine years before Disneyland opened. What we might call the modern dark ride premiered in 1928 at the Tumbling Dam Park in New Jersey. The park's developers, Leon Cassidy and Marvin Rempfer, wanted to replicate the Old Mill experience in their park, but without the expense of water canals. As a result, Cassidy patented the first-ever electric dark ride, an Old Mill concept using a single floor-mounted rail as opposed to water boats. Though initially untitled, the ride became known as the Pretzel after one guest said he felt like the twisting track had bent him into one. Soon thereafter, the Pretzel Amusement Ride Company went into business and Cassidy's single-rail dark ride — complete with large, cast-iron pretzels on the vehicle's sides — took the world's fairgrounds and amusement parks by storm. For more on the history of the dark ride, see Luca, Bill. "Send 'Em Out Laffing!: William Cassidy and the Pretzel Amusement Ride Co." *Laff in the Dark*, n.d. Web. 6 Mar. 2012. <http://bit.ly/VOdBF3>. See also "Laughter in the Dark: A History

of Dark Rides." *Entertainment Designer – Theme Park and Museum Design News*, 18 Jul. 2011. Web. 6 Mar. 2012. <bit.ly/SOaKRC>.

2. So popular are the classic dark rides in Fantasyland that some guests grow up thinking of "the dark ride" as "the Fantasyland ride." That's especially true in Disneyland, where dark rides are even more plentiful. Those hardcore adherents are reluctant to acknowledge *anything* outside those boundaries as a proper "dark ride." The term just doesn't ring true to them otherwise. While that sentiment is understandable, it's probably silly to try confining the genre so narrowly. Not only did the dark ride antedate Disneyland, many of Disney's non-Fantasyland attractions like Pirates of the Caribbean, Buzz Lightyear's Space Ranger Spin, The Seas with Nemo & Friends, and Journey Into Imagination with Figment (among many others) clearly meet the criteria. Besides, even "Fantasyland rides" aren't always in Fantasyland. The Many Adventures of Winnie the Pooh, for instance, is a Critter Country attraction in California.

3. Disney's *Peter Pan* most directly descends from Scottish playwright J.M. Barrie's 1904 stage play, *Peter Pan, or The Boy Who Wouldn't Grow Up*, but the character's lineage is somewhat more complicated. He actually first appeared two years earlier than that as a small part of Barrie's 1902 adult novel, *The Little White Bird*. In 1906, the play having already been a smash on both London's West End and Broadway, the Pan portions of *White Bird* were excerpted, slightly reworked, and republished as *Peter Pan in Kensington Gardens*. Then, in 1911, the original play was novelized and released as *Peter and Wendy*, which is often retitled *Peter Pan* today. The script for the play itself was finally published in 1928, the same year Mickey Mouse made his debut. Each of those versions remains in print, having seen various abridgements, expansions, illustrations, and annotations over the years. Disney has itself continued the tradition with a new line of young adult novels that began in 2004 with *Peter and the Starcatchers*, written by Dave Barry and Ridley Pearson. Coming full circle, *Starcatchers* inspired a 2009 musical play that opened Off-Broadway in 2011 and transferred to Broadway in 2012, winning five Tony Awards. It closed January 20, 2013.

4. I define the First Golden Age of Disney Feature Animation as beginning in 1937 with *Snow White and the Seven Dwarfs* and concluding with *Bambi* in 1942; the Second beginning with *Cinderella* in 1950 and ending with *The Jungle Book* in 1967; and the Third beginning in 1989 with *The Little Mermaid* and ending with either *Tarzan* or *Fantasia 2000* in 1999. Accordingly, we might refer to the intervening eras as the First, Second, and Third Dark Ages of Disney Animation, respectively. Whether a Fourth Golden Age began in the late 2000s with *Meet the Robinsons*, *The Princess and the Frog*, and *Tangled* will probably best be answered by the passage of time. (I note that Pixar films are not a part of Disney's Feature Animation canon).

5. The Disney studio's decision to cast a boy as Peter Pan might seem natural now,
 but that wasn't necessarily true in the early 1950s. For nearly a half-century,
 Pan had been played on the stage by adult women. The first movie adaptation,
 Paramount's 1924 silent film, kept with tradition and chose actress Betty Bronson
 for the lead role (Bronson was in her late teens at the time). When Walt cast
 Bobby Driscoll, previously known for his lace collar and boyish charm in 1946's
 Song of the South, as the voice of Peter he broke from convention, presenting
 the public with a fully male Peter Pan for the first time. Walt's decision set the
 course for Hollywood in each of the major film adaptations that would follow.
 The silver screen's Peters include Robin Williams (*Hook,* 1991); Blayne Weaver
 (*Return to Neverland,* 2002); and Jeremy Sumpter (*Peter Pan,* 2003). On the stage,
 however, tradition has held firm. Arguably the most prominent theatrical take on
 the play is Broadway's *Peter Pan,* a musical first staged in 1954 (just one year after
 the Disney film). Mary Martin headlined the original production, which enjoyed
 several television broadcasts and an eventual home video release. Later, Sandy
 Duncan and then Cathy Rigby took over the role in a series of successful revivals.
 Rigby continues to star in the show's national tours. To date, Broadway has yet to
 welcome a man in Peter's role for any major staging of the play. But then on the
 other hand, the Disney parks use male cast members for Peter in all of their meet-
 and-greets, stage shows, and parades. It isn't quite clear why the cinema prefers
 men for Peter while the live theater has favored women. Perhaps the answer lies
 in the difficulty of keeping child actors on the stage for hours (a challenge other
 shows have managed to overcome), or in the power of tradition. Whatever the
 reason, the conundrum certainly adds to scholars' fascination with *Peter Pan.* How
 is it that a play long noted for its appeal to the masculine ego unfailingly casts a
 woman as its leading man?

6. The theme of masculinity probably rivals mortality/immortality and the transition
 from childhood to adulthood as the most-tackled issue in scholarship on *Peter
 Pan* (these discussions often segue into interrogations of femininity vis-à-vis
 Wendy and Tiger Lily and racial/ethnic bias with respect to the other tribal
 characters). One early work, "J.M. Barrie: a study in fairies and mortals" by
 Patrick Braybrooke, was published in 1924 and opened with an Author's Note in
 which Braybrooke asked only two things of Barrie: one, to finish another of his
 works, and the second, to never let Peter Pan be played by a woman again. "There
 is no character of Barrie's so essentially masculine as 'PETER PAN'," Braybrooke
 wrote, "yet the part is played by actresses who are in every sense horribly and
 inevitably grown up." Naturally, not all the scholarship shares Mr. Braybrooke's
 perspective. For a survey of *Pan* in its various academic contexts, including
 multiple considerations of the masculinity theme, see Barrie, J.M. *Peter Pan.* Ed.
 Anne Hiebert Alton. Toronto: Broadview Press, 2011. Print.

7. Disney often stylizes the attraction name as "it's a small world," using all lower-case letters. The company is hardly consistent with that — various Disney publications use capital letters — but the park maps, resort websites, and the signs on the attraction itself use the lower-case styling. Arguably, then, that's the official name. While that works from a branding perspective (emphasizing the "small" in the name), it doesn't make as much sense in a commentary on the attraction, so I will use capital letters for It's a Small World in this book.

8. In 2010, Magic Kingdom slightly rerouted the Small World queue so that the entryway now wraps behind the clock tower. As a result, guests' view of the smiling face is obstructed as they board the boats. Happily, the impressive display is still visible when guests walk in, and on a busy day, the line extends far enough to afford a great view to those waiting.

9. There is now one notable exception to the old rule that Magic Kingdom does not serve alcohol. Fantasyland's new Be Our Guest Restaurant serves select wines and beers, but only during evening table-service hours. Meanwhile, Disneyland Park remains dry with the exception of Club 33, a private, members-only VIP restaurant hidden inside the park. Alcohol has always been served in all of the other domestic Disney Parks.

10. Coca-Cola reigns supreme in Disney theme parks today, but it hasn't always been that way. When Walt Disney World opened, guests there (and at Disneyland) had their choice of Pepsi or Coke. Pepsi had sponsored a handful of Disney attractions in the past, the Country Bear Jamboree and The Golden Horseshoe among them. It wasn't until 1985 that the Disney Parks signed a global exclusivity deal with Coca-Cola, making the soda giant the resorts' sole provider of carbonated soft drinks. Legend has it that Disney was running low on syrup one weekend and called Pepsi for an emergency supply, but a company representative told the Mouse they'd have to wait until after the weekend. In a bind, Disney called Coke instead, who arranged for their delivery men to make an urgent shipment. Disney cut their ties with Pepsi on the spot, or so the story goes. That rumor, despite its persistence among Disney fans, almost certainly isn't true, but Coke nevertheless maintains its tight grip on Disney's soda fountains today. In the late '90s, Disney Regional Entertainment (DRE) inked a new deal with PepsiCo that gave the latter a hold on DRE's properties, which included Club Disney, DisneyQuest, and the ESPN Zone. DRE dwindled over the years, turning DisneyQuest over to the Parks and Resorts division and seeing most of its ESPN Zones either rebranded or handed off to third parties, dashing Pepsi's hopes of getting its foot back in Disney's door. Indeed, as I write this note, I'm sitting in Walt Disney World's ESPN Club restaurant, sipping an ice-cold Coca-Cola Classic.

 Even as Disney has distanced itself from the Coke-vending McDonald's fast food company, which once had a sizeable presence in Walt Disney World, Coke

products remain as visible and ubiquitous in the parks and dining districts as ever. The All-Star Sports hotel, for example, features giant, multi-story Coke cups (it would take 20 million soda cans to fill one of them) and Epcot is home to Club Cool, an attraction featuring free samples of Coca-Cola products from around the world. While Coke's Mickey monopoly will surely dismay Pepsi fans (and thrill Coke loyalists like myself), the affiliation of these two companies, each an iconic fixture of American culture, certainly feels appropriate.

11. There are two ways to spell "carousel" and the Magic Kingdom uses them both. In Tomorrowland, Walt Disney's Carousel of Progress uses the standard single-r spelling, while Fantasyland opts for the less conventional double-r with Prince Charming Regal Carrousel. The antiquated "rr" just feels so much more majestic, doesn't it? It fits Fantasyland's vibe.

12. Incidentally, Griffith Park is now home to Walt Disney's Carolwood Barn, often called "the birthplace of Imagineering." Walt used the barn as a machine shop for the Carolwood Pacific Railroad, a fully functioning, one-eighth scale locomotive track that ran in the backyard of his home in California. The train there eventually inspired the Disneyland Railroad and many of the train-based attractions in the Disney parks around the world. After Walt's death, his family had the barn relocated to Los Angeles' Griffith Park, where it's occasionally open to the public as a free-of-charge museum, the result of a collaboration between The Walt Disney Family Foundation, the Carolwood Foundation, the Carolwood Pacific Historical Society, the Los Angeles Live Steamers, and the City of Los Angeles.

13. Prince Charming Regal Carrousel's backstory may not be apparent to riders, but Disney did share it with the public on May 25, 2010, in a post on its online Disney Parks Blog.

14. In the U.S., *Blue Rhythm* is included in the Walt Disney Treasures: Mickey Mouse in Black and White (Volume One) DVD set. *The Opry House*, *The Jazz Fool*, and *Just Mickey* can all be found on Volume Two of the same. Both sets are, unfortunately, out of print, but often turn up on eBay, the Amazon Marketplace, and the like (and usually for a pretty penny).

15. Mickey Mouse's first appearance in color, *The Band Concert*, can be found on the Walt Disney Treasures: Mickey Mouse in Living Color (Volume One) DVD set, as well as the *Make Mine Music* DVD. Meanwhile, *Mickey's Revue* also has two U.S. DVD releases — Walt Disney Treasures: Mickey Mouse in Black and White (Volume One) and Vintage Mickey.

16. I note that some of these movies, like *Beauty and the Beast*, did in fact employ some early computer animation, though they were all primarily hand-drawn.

17. Mickey's PhilharMagic is sometimes described as a "4D film." 4D is simply a marketing term used for 3D films that employ synchronized, in-theater effects like the ones found in PhilharMagic (and all of Walt Disney World's other 3D movies).

There's no actual fourth dimension in the visual. To my knowledge, Disney themselves have never promoted PhilharMagic as being "4D," though they did briefly use that label for the Muppet*Vision 3D attraction at Disney's Hollywood Studios.

18. When Walt Disney acquired the rights to Milne's *Pooh* characters, his intention was to develop a feature-length film right away. During a staff meeting, however, the studio decided it might be best to administer *Pooh*'s simple, easy temperament to American audiences in smaller doses. Accordingly, they scrapped plans for an immediate feature-length project and embarked on a longer-term production schedule in which they would release a series of *Pooh* cartoon shorts over the course of several years. Ultimately, three cartoons premiered in theaters between 1966 and 1974 before the full-length *The Many Adventures of Winnie the Pooh* debuted in 1977. For an excellent history on Pooh's early development at Disney, as well as a guide to many other fantastic *Pooh*-related resources, see Gray, Richard "Loomis." "The Ultimate Guide to Pooh: Winnie the Pooh, From A.A. Milne to Disney – History, Commentary, and Filmography." *DVDizzy.com*, n.d. Web. 26 Nov. 2012. <bit.ly/UAwLPD>.

19. In the years after *Pooh's Grand Adventure*, Disney increasingly marketed Pooh & Co. to an exclusively preschool audience. That changed to some extent with 2011's *Winnie the Pooh*. Like *Grand Adventure*, the new *Pooh* is a sequel to the original *Many Adventures* film. It marks the first time that the Walt Disney Animation Studios (formerly called the Feature Animation division) created an all-new *Pooh* movie for theaters from beginning to end. Alas, it underperformed at the box office (thanks primarily to head-on competition from *Harry Potter and the Deathly Hallows – Part 2*), but as a hilarious and charming adventure with lovable characters, it succeeds beyond any other Hundred Acre Wood outing since the original. Its "Top Critics" rating on RottenTomatoes.com stands at a most impressive "97% fresh"!

20. The Skyway was an opening day attraction at Magic Kingdom, basically a clone of the same ride that opened in Disneyland in 1956. Gondolas traveled through the sky along a cable lift with guests riding inside them, offering a rare view of the park below. There were two stations: one beside It's a Small World (where it was called Skyway to Tomorrowland) and the other next to Space Mountain (Skyway to Fantasyland). Disneyland's closed in 1994 and Walt Disney World's in 1999. Both Magic Kingdom stations remained intact until Tomorrowland's was completely demolished in 2009. Fantasyland's followed suit in 2011 as part of the New Fantasyland project.

21. Mickey's Toontown Fair initially opened as Mickey's Birthdayland on June 18, 1988. It was renamed Mickey's Starland on May 26, 1990. Three years later, Disneyland opened its own Toontown on January 24, 1993. Then, on October 1, 1996, Florida's Starland became Mickey's Toontown Fair, where characters from Disneyland's much more lavish Toontown would supposedly come for

vacation. Magic Kingdom's Toontown was always intended as a temporary land, but somehow it stuck around for 13 years. Now it exists as Storybook Circus, no longer an independent land but rather an incorporated district within Fantasyland. Fairs and circuses are not dissimilar, so one can naturally still find remnants of the old Toontown Fair, but Storybook Circus has the look and feel of permanency that this part of Magic Kingdom never enjoyed before.

22. "Forced perspective" is one of Disney Imagineering's favorite and cleverest tricks. In a nutshell, they make an object appear bigger or smaller (or closer or farther away) than it really is by gradually changing the scale or angle of construction, or by surrounding it with things that are deceptively different in size. For example, the shops on Main Street look taller than they really are because the second story is actually shorter than the first and the third story smaller still. Likewise, the bricks and décor of Cinderella Castle shrink in size as they get higher, and the few trees near it are proportionally much shorter than the castle itself.

23. It may seem strange to find Dumbo back in a circus, now that he's a free elephant. Circus life was never very kind to him, after all. But then we see Mrs. Jumbo, his mother, watching over him. Indeed, golden busts of Mrs. Jumbo's loving face adorn the newly outfitted Dumbo hubs in Storybook circus. She is the mother who protected him. He is her "Baby Mine." Seeing her there reminds us of Dumbo's freedom and reassures us that the circus is a better home for him now than it was in the film.

24. The official entrance sign presents the attraction as The Barnstormer Featuring Goofy as the Great Goofini. Meanwhile, as this book goes to press, the Magic Kingdom park map and official website present it simply as The Barnstormer. For brevity's sake, I'll generally use the shorter title throughout this book, making reference to the lengthier locution as needed.

25. The attraction was almost always referred to as The Barnstormer at Goofy's Wiseacre Farm, including on Disney's park maps and websites and in several of its official books. The name painted in multiple places on the barn itself, however, used a slightly different locution, Goofy's Wise Acres Farms. Perhaps the idea was that Goofy couldn't get the name of his own barn right. Either way, most guests simply called it "Goofy's Barnstormer" (and many still do).

26. Mickey's PhilharMagic is also a Fantasyland attraction starring characters from "the fab five," but as previously noted, PhilharMagic's storyline is steeped in magic and fantasy.

27. That's largely thanks to John Lasseter's commitment to the short film format in his role as Chief Creative Officer at Pixar and Walt Disney Animation Studios. Lasseter also serves as Principle Creative Advisor for Walt Disney Imagineering.

28. While critics split over Burton's *Alice in Wonderland*, the movie fared well at the box office and on the awards stage. It was nominated for three Golden Globes and

three Oscars, winning two of the latter (Art Direction and Costume Design). As of late 2012, with a global gross of more than one billion dollars, it is the twelfth highest-grossing film of all time worldwide (and the 26th, domestically).

29. The "Cinderella" story was first published in the late seventeenth century and Disney's film can probably be assumed to be set during that time as well. However, Imagineers actually looked to many different castles from various eras when designing Cinderella Castle, some dating back as far as the thirteenth century. For more on the architectural inspirations for Cinderella Castle, see Mongello, Louis A. *The Walt Disney World Trivia Book: Secrets, History & Fun Facts Behind the Magic*. Branford: The Intrepid Traveler, 2004 : pp. 77-78. Print.

30. Charles Perrault (1628 - 1703) was a French author and one of the founding fathers of the fairy tale genre. The child of wealthy parents, he studied law and served as the secretary to Jean Baptiste Colbert, an advisor to King Louis XIV, before turning to writing later in life. In 1697, he published *Histoires ou contes du temps passé*, better known in English as *Mother Goose Tales* (some English printings use variations on that title). In addition to "Cinderella," *Mother Goose* included "Sleeping Beauty," "Little Red Riding Hood," and "Puss in Boots," among other well-known fairy tales. Though Perrault is frequently cited as the original author of "Cinderella," the story's origins undoubtedly predate him. The idea of a missing shoe that sparks a royal search for its wearer can be traced all the way back to ancient China and Greece, with variations on the tale emerging and evolving from different cultures over the centuries. "Cenerentola," written by Italian poet Giambattista Basile and published posthumously in 1634, appears to have inspired Perrault's version, but it is the latter who gave us the glass shoes, the fairy godmother, the bewitched pumpkins, and the enchanted animals as coachmen, all essential elements of the "Cinderella" story today.

31. The castle is now known as Cinderella Castle, but in accordance with the fairy tale and the Disney film, it belongs to Prince Charming and his royal family. (Renaming a palace after a princess is a historical anomaly, indeed, but how many people would travel to visit the Charming Castle?) Presumably then, the King's Gallery was a reference to Prince Charming's portly father, who isn't given a name but nonetheless plays a memorable part in Disney's *Cinderella*. He does actually handle a sword in one of his funniest scenes, a disagreement with the Grand Duke, but his silliness results in a few too many close calls with the blade. Actor Luis van Rooten voiced both the Grand Duke and the King.

32. Securing reservations at Cinderella's Royal Table requires greater diligence than any other dining experience at Walt Disney World. For more on exactly how to get yourself a seat, see Barrett, Steven M. *The Hassle-Free Walt Disney World Vacation*. Branford: The Intrepid Traveler, 2011 : p. 55. Print.

33. The Cinderella Castle Dream Suite is reportedly still used on occasion for VIPs

and the like, and I've even heard (unconfirmed) reports of Disney randomly surprising guests with an overnight stay in the years since the "Year of a Million Dreams" ended, but the suite is no longer part of any ongoing promotion and remains inaccessible to the general public.

34. Trying to situate Fantasyland within a single era or artistic/historical moment is probably as futile as it is silly. Cinderella Castle is the centerpiece and Perrault's "Cinderella" was published in France at the tail end of the Renaissance. However, Fantasyland's other story worlds come from many different periods, some having emerged as recently as the twentieth century (*Peter Pan*, *Dumbo*, and *Winnie the Pooh*, for example). Architecturally, the village festivals and fairs of the Medieval and Renaissance eras inspire much of the land, resembling at times a sanitized version of the modern-day Renaissance fair (which is typically set in either England or France). Jousting, a sport associated with both the Middle Ages and the Renaissance, appears as something of a motif throughout the area. But as previously noted, Cinderella Castle emulates a wide array of castles from various eras (see Mongello, above, pp. 77-78). And as for geography, while England and France are clearly important progenitors of Fantasyland's central storylines, other parts of Europe and even the United States show up, too. The Pinocchio Village Haus bears a distinctly German influence, and It's a Small World travels all around the globe. The land is probably best thought of as a primarily European pastiche of the Middle Ages, the Renaissance, and the Early Modern Era with an infusion of innumerable other geographies, eras, and styles, including Modern and Contemporary periods. Of course, it should be noted that there is no clear consensus among historians on a single chronology of the world's historical periods and that diverging movements and periods often overlap, making any definitive timeline for Fantasyland elusive.

35. With the New Fantasyland expansion, Magic Kingdom added additional castle courtyard walls, which open up to the Enchanted Forest behind them. I suppose that makes them a little more vulnerable to attack, but then surely Charming's guards could barricade the gates should any villains get too close for comfort!

36. "Masked characters" refers to those park characters whose faces are completely covered by a mask, as opposed to "face characters," who don't wear a mask at all (though face characters will often wear a wig and perhaps even a facial prosthetic of some sort). Examples of masked characters include Mickey and Minnie Mouse, Pinocchio, and the Queen of Hearts. Face characters include Mary Poppins, Cruella de Vil, and Peter Pan, among many others. Some characters, like Captain Hook and the *Sleeping Beauty* fairies, have alternated between "masked" and "face" status over the years. Unrestrained by a mask, the cast members appearing as face characters are usually free to engage guests in improvised dialogue, while masked characters can only mime along to a synchronized, pre-recorded audio

track. New technology allows characters to move their masks' mouths in sync with the audio, and sometimes even for the cast member behind the mask to speak extemporaneously in the character's voice, though these "NextGen" character interactions have been slow to make their way into the parks. Note that while both kinds of characters are "costumed," Disney actually uses the term "costume" to refer to any uniform or wardrobe piece its cast members wear at work. So that decidedly un-hip floral shirt with sort-of-matching green shorts you saw on the guy directing traffic in Fantasyland? That's a costume too!

Chapter 5: Tomorrowland

1. A version of this quote is on a plaque at the entrance to Disneyland's Tomorrowland, but it substitutes the word "ideas" for "ideals." It's a one-letter discrepancy, but it arguably changes Walt's meaning. A Tomorrowland focused on ideals (like "progress"), rather than on ideas (like "high-definition TV"), might be less prone to growing stale with the passage of time.

2. Some of those dioramas can now be seen along the path of the Disneyland Railroad.

3. The PeopleMover is still casually referred to by some as the "Skyway" in both Disneyland and Walt Disney World, but it should not be confused with the ski lift-style Skyway attraction that ran at both U.S. Resorts as well as Tokyo Disneyland until the 1990s. See also *Chapter Four*, Note 20.

4. While passing Walt Disney's Carousel of Progress, guests riding the TTA from 1994 to 2009 heard, "Paging Mr. Morrow, Mr. Tom Morrow, your party from Saturn has arrived. Please give them a ring." When the page returned on June 16, 2010, it was moved to inside the Space Mountain building, where you'll now hear, "Paging Mr. Morrow, Mr. Tom Morrow. Please contact Mr. Johnson in the Control Tower to confirm your flight to the Moon." Mr. Tom Morrow was a character in Flight to the Moon, the original attraction standing where Stitch's Great Escape is now. Mr. Johnson was a similar character (with the same voice actor, George Walsh) in Mission to Mars, an updated version of Flight to the Moon that ran from 1975 to 1993. Fans are divided on whether the new page is an acceptable substitute for the older one.

5. In keeping with Disneyland's PeopleMover Thru the World of *Tron*, I propose that Walt Disney World's ride be officially renamed the Tomorrowland Transit Authority PeopleMover Thru the Worlds of Space Mountain and Buzz Lightyear's Space Ranger Spin... WEDWay.

6. It would appear that Walt may have used the phrase at least twice in his public comments, once as part of a 1965 presentation entitled "Total Image," in which he said, "There's really no secret about our approach. We keep moving forward — opening up new doors and doing new things — because we're curious. And

curiosity keeps leading us down new paths." This line was quoted by former Disney CEO Michael Eisner in his introduction to *Walt Disney Imagineering: A Behind the Dreams Look at Making the Magic Real* (Disney Editions, 1998) as well as in *The Quotable Walt Disney*, compiled by Disney archivist Dave Smith (Disney Editions, 2001). The other instance is actually quoted using on-screen text in Disney's *Meet the Robinsons* — "Around here, however, we don't look backwards for very long. We keep moving forward, opening up new doors and doing new things... and curiosity keeps leading us down new paths," though the film offers no independent citation for this similar-but-different presentation of the quote.

7. "Animated Classic" is an objective categorization of animated (or at least predominately animated, as opposed to live-action) films from the studio's Feature Animation division (now known as Walt Disney Animation Studios). The company officially canonizes movies as part of its "Animated Classic" lineup, so when I refer to a movie with that label, I don't always mean that it's a film classic in the sense that *Citizen Kane* is one. Rather, a Disney film is an "Animated Classic" simply because Disney says so.

8. For more information about the 2003 "Save Disney" campaign that ultimately led to Eisner's eviction from the Mouse House in 2005, see *Chapter Two*, Note 12.

9. When entering the attraction, guests pass through what appear to be high-security clearance doors and walk through a long, narrow hallway. When they emerge, they sense that their proportions have changed. All around them are toys like the View-Master, Etch A Sketch, and the one and only Buzz Lightyear, each as tall or even taller than the guests themselves. The suggestion is that entering Space Command has shrunk the humans down to the size of a toy. Other visual cues, like a sprawling instruction sheet on the wall and a screwdriver head, reinforce that idea. Disney used similar tricks in other *Toy Story* attractions around the world, including Toy Story Mania and Toy Story Playland at Disneyland Paris.

10. Slightly different versions of Buzz Lightyear's Space Ranger Spin exist in Disneyland and Hong Kong Disneyland (as Buzz Lightyear Astro Blasters), Tokyo Disneyland (as Buzz Lightyear's Astro Blasters), and Disneyland Paris (as Buzz Lightyear Laser Blast). A different attraction, Buzz Lightyear's AstroBlaster, can be found at Walt Disney World's DisneyQuest (a five-story, interactive, indoor "theme park" located in Downtown Disney).

11. Ten years after Buzz Lightyear's Space Ranger Spin, Walt Disney World unveiled the next generation of the video game ride in its Hollywood Studios theme park. Inspired by the same series of films, Toy Story Mania! is a substantial advancement from Space Ranger Spin and has arguably rendered the Tomorrowland ride obsolete. Nevertheless, the Buzz Lightyear ride's unique story and charm help explain why it's still running, even if it might become a prime candidate the next time Magic Kingdom looks to replace an attraction.

12. It isn't necessarily clear in the *Toy Story* films whether, within their story world, Buzz Lightyear was first a video game (or cartoon) star who inspired a popular action figure, or vice-versa. Certainly, we see him in all those environments throughout the *Toy Story* saga. Even if, for the sake of argument, the character did not originate in a video game, his game identity nevertheless clearly contributes to his popularity with Andy and the other children in that fictional universe.

13. The term "laser tag dark ride" or "shooting dark ride" is sometimes applied to this hybrid, though one wouldn't be incorrect to simply refer to it as a "dark ride." Interestingly, an attraction like Toy Story Mania, which involves a backstory and gameplay similar to Space Ranger Spin's but puts less emphasis on a "front story" and doesn't use lasers, would probably still qualify as a "dark ride" and a "shooting dark ride" but certainly not a "laser tag dark ride," suggesting that this lattermost term is too specific to be helpful in classifying attractions by ride type.

14. Many of the roadways that today comprise the U.S. Interstates already existed but were not formally part of the Dwight D. Eisenhower National System of Interstate and Defense Highways until at least 1956.

15. In Disneyland, the Tomorrowland Autopia opened in 1955. It was followed by a similar ride in Fantasyland, Junior Autopia, in 1956. Junior Autopia closed in 1958 and reopened as the expanded Fantasyland Autopia in 1959. The latter was known as the Rescue Rangers Raceway from 1991 to 1992 (essentially the same ride, but with a "Rescue Rangers" overlay). It was then redubbed the Fantasyland Autopia until 1999, when both the Fantasyland and Tomorrowland versions were permanently closed. In 2000, the two tracks were reworked and combined to create the one and only Autopia existing in Disneyland today (officially a Tomorrowland-only attraction). In addition to those, a no-grown-ups-allowed version of the ride, called Midget Autopia, ran in California's Fantasyland from 1957 to 1966 (it was later donated to Walt's hometown of Marceline, Missouri, where it briefly ran until maintenance grew too costly). Around the world, one can also find Autopia-type rides in Disneyland Paris, Tokyo Disneyland, and Hong Kong Disneyland.

16. See *Chapter Four*, Note 21.

17. The spinning planet effect has been known to stop working for long periods of time.

18. Many fans have noted that, as abridged, the attraction name creates some unfortunate and unintentional acronymic innuendo… probably not something the average guest notices, but enough to keep fans on message boards plenty amused.

19. Snow White's Scary Adventures was a long-running dark ride that operated in Fantasyland from Opening Day until May 31, 2012. (Disneyland's version, which dates back to 1955, is still open.) Throughout its history, the attraction was revamped on both coasts to alter the degree to which it might scare its riders.

Magic Kingdom's original 1971 edition was markedly more frightening than the decidedly happier version that opened there in 1994.

20. The ExtraTERRORestrial Alien Encounter first opened for previews on December 16, 1994, but closed the next month for retooling after guests complained that the pre-show was too light when compared to the main presentation, which they also thought needed some enhancing. It reopened that summer, with the official grand opening on June 20, 1995.

21. Until the fall of 2011, Walt Disney's Carousel of Progress was the *only* attraction in Walt Disney World to bear Walt Disney's name in its official title. When The Enchanted Tiki Room reopened in August 2011, it added the visionary's name as a reminder that the original attraction personally belonged to Walt himself (for more, see *Chapter One*). Technically, the Walt Disney World Railroad does too, but the effect there is to designate the railroad as belonging to the Florida Resort, whereas Walt Disney's name in the Carousel of Progress is intended as a personal tribute to the man who created it.

22. A number of official Disney publications provide varying and conflicting dates for Space Mountain's official opening in Walt Disney World, ranging from early 1974 to early 1975. The January 15, 1975, date appears to be the most widely cited and is consistent with major newspaper reports.

Chapter 6: Main Street, USA

1. Out of deference to Disneyland's most faithful fans, I note that "The Happiest Place on Earth®" is a term first applied to the Disneyland park and is the California resort's official tagline. Magic Kingdom's tagline, meanwhile, is "The Most Magical Place on Earth." Despite that technical distinction, the former slogan is part of the national vernacular and is often applied to Magic Kingdom, too, in the media. While I acknowledge Disneyland's more credible claim to that title, I think it's fair to use the two interchangeably, at least in the course of common conversation. Both parks seem plenty happy *and* magical to me.

2. In fact, the entire area surrounding the train station is themed as Carolwood Park, a fictional public park that has supposedly been taken over by the Storybook Circus. The bathrooms next door are located behind a Carolwood Fire Dept façade. The Carolwood name comes from Walt Disney's own Carolwood Pacific railway, which also inspired the Carolwood Barn (a fact that makes The Barnstormer's location in Storybook Circus especially appropriate). For more on these connections and the history of the Carolwood Pacific, see *Chapter Four*, Note 12.

3. Notably, two of Disney's most popular sorcerer characters, Sorcerer Mickey and Yensid, both of *Fantasia* (1940), do not figure prominently in Sorcerers of the Magic Kingdom. Each appears on a separate spell card in the game, but they are

not otherwise part of the storyline and they never appear on any portal screens. Perhaps the Imagineers wisely decided that with all the attention paid to *Fantasia* and its "The Sorcerer's Apprentice" segment elsewhere in the Disney theme parks, it was appropriate to focus on less ubiquitous properties here.

4. I don't mean to imply that Disney intentionally created or designed Sorcerers of the Magic Kingdom in order to replicate or even borrow from the *Harry Potter* experience. Nor do I suspect that the Imagineers developed Sorcerers as a means of competing with Universal Orlando's Wizarding World of Harry Potter. Rather, I think that the relationship between the game and Rowling's franchise is coincidental in nature, and has more to do with the *Potter* books and films than with its theme park rides. Unintentional as it may be, Sorcerers manages to tap into a shared, underlying pop-cultural desire to live out the *Potter* fantasy. It may be that the game's development and popularity are simply symptomatic of the profound impact *Potter* has had on the world.

5. Kyle Burbank of *The Disneyland Gazette* podcast presented me with a brilliant idea while touring Magic Kingdom — affixing Sorcerers playing cards to the tip of the Potter wands sold inside Universal's Wizarding World for ultimate spell-casting legitimacy.

6. There have actually been other small additions to SpectroMagic. Sebastian was tacked on to the existing King Triton float (both characters are from *The Little Mermaid*), for example, and Jiminy Cricket to the finale float. But *Aladdin* is the only film represented in the current version of the parade that wasn't a part of the original. The Genie character took the place of Roger Rabbit.

7. See *Chapter Four*, Note 4 for more on the "Golden Ages" of Disney animation.

Index

Acknowledgements

This book would not have been possible without the support and encouragement of so many people in my life. I would first like to thank Kelly Monaghan and Sally Scanlon at The Intrepid Traveler for believing in this project, helping to bring it into reality, and making a dream come true. I would also like to thank my in-park research assistants – Joshua Aguilar; Rev. Courtney Lambert; Reuben Gutierrez; and Rebekah Mlinarcik – as well as the other great friends who have traveled to the Disney Parks with me over the years and helped inspire my ponderings there: Aaron and Krista Berlin; Devon Derrow; Christopher Disher; Josh and Drea Harper; Casey Jennings; Laura A. Jones; Dr. Selena Lane; Adam Lutterloh; Claire Nader; Jenna Pennell; Lindsay Purnell; Emily Thornton; and Lily Wagner.

I must also acknowledge my writing teachers, especially Erin Mackie and Daniel Wallace, for helping me find and understand my writing voice, as well as Dr. Laurie Langbauer at the University of North Carolina at Chapel Hill, for encouraging me to investigate the academic dimensions of Disney's productions when so many scholars scoffed at the idea and for first sparking my critical interest in the parks' written-word roots with her scholarship in children's literature.

I would not have been in the position to write this book if not for the opportunities afforded me by Luke Bonanno and the staff at DVDizzy.com; Jesse Obstbaum, who gave me my first podcasting gig and helped paved the way for my own unofficial Disney discussion show; Jeff Falvo and Michael Fenyes, who've made me a part of the wonderful community of producers at The Disney Podcast Network; and my regular co-panelists on *The Hub Podcast*: Matt Osborne, Keegan Cooke, Greg McNaughten, Will Jen-

sen, Michael Fenyes (Mike from *MiceCast*), and "Earl," as well as all of our recurring and special guests.

Writing is a fulfilling but lengthy and demanding process. Thank you to all of those who provided me emotional support, words of encouragement, feedback, or just a friendly ear during this undertaking: My family, especially my parents, sister, grandmother Dolores Finger, and aunt Debra Finger; everyone at The Law Offices of Amos & Kapral, LLP; the entire student and professional staff of Wake Forest University Residence Life and Housing, and especially Nicole A. Rodriguez-Pastor for her friendship and ongoing support in so many arenas of my academic, professional, and personal life; the many baristas who took such a friendly and genuine interest in my work as I toiled for endless hours with a latté in hand; and all of my amazing friends, especially the Aguilar family, Kyle Burbank, the entire Disney Podcast Network family; Matthew Fletcher, Amy Gates, Blake Gates, Adam Jass, the Lambert family, Anthony Lane, Emily Mabry, Luke Manning and the entire staff at *The Disneyland Gazette*, Alexandra McVetty, Renata Olson, Caitlin Overend, Nikki Pollard, Tommy Sanford, Katrina Schaffhouser, Patrick Westmoreland, and so many others.

Finally, I want to thank: you, the reader, for taking this adventure with me; every listener and fan of my other work in print and online; the entire Disney fan community for being so warm, accessible, embracing, and friendly; the Cast Members of the Disney Parks around the world for excellence in magic making; and Roy O. Disney and his younger brother, Walt, for a legacy that has meant the world to me and so many others in it.